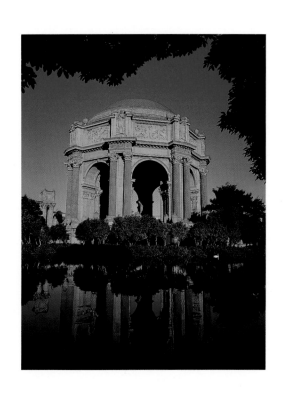

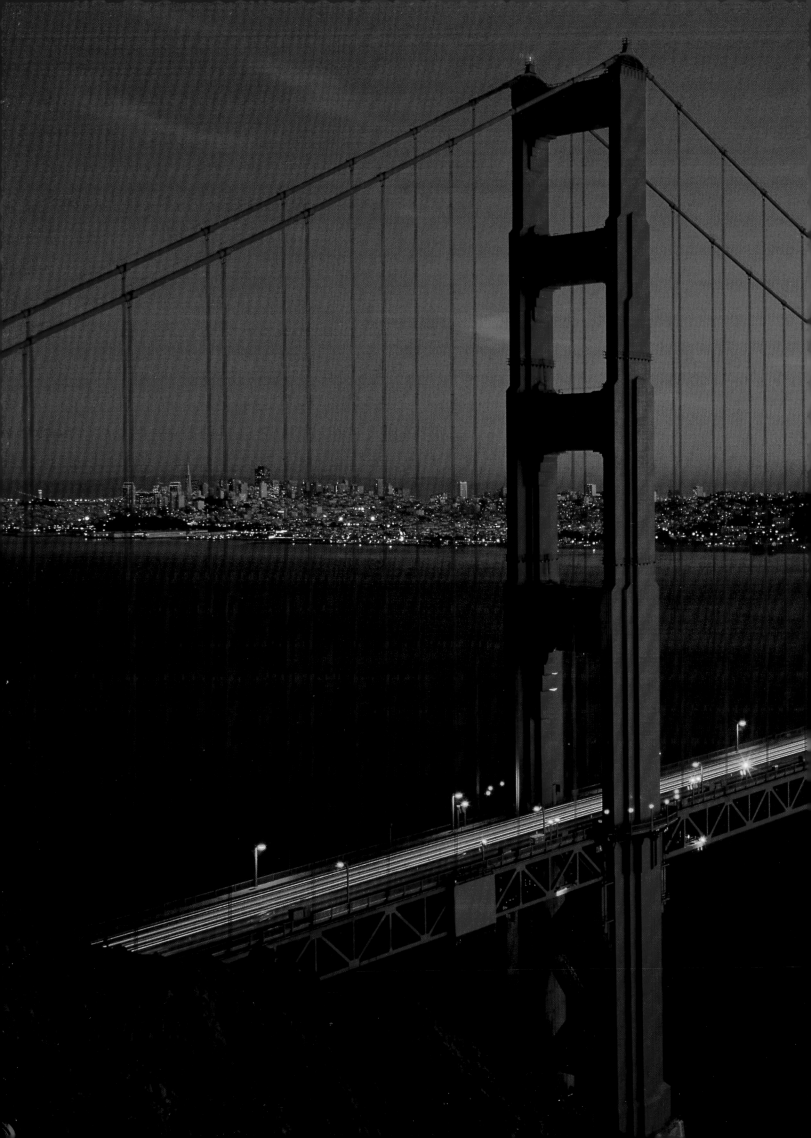

SAN FRANCISCO

A PHOTOGRAPHIC CELEBRATION

COURAGE
BOOKS

AN IMPRINT OF RUNNING PRESS
PHILADELPHIA • LONDON

Photography Credits

© Franklin Avery: p. 126 (top)

© Richard Dunoff: pp. 59 (top), 65, 89

© Kerrick James:
Cover photographs, front and back flaps, and pp. 1, 5, 8, 9 (bottom left and right), 17, 18–19, 21 (top and bottom), 25 (bottom), 27, 30–31, 32 (bottom), 39 (bottom right), 43, 44–45, 47 (bottom), 48–49, 50, 51, 52–53, 55 (top and bottom), 58, 61, 62–63, 64, 68–69, 71 (top and bottom), 72–73, 74, 77, 78, 80 (top), 82–83, 84 (top right and bottom), 85, 86–87, 90–91, 93 (top right and bottom), 94–95, 96, 98–99, 100, 101 (top and bottom), 102–103, 104 (bottom), 106, 107 (top left and bottom), 117, 119, 120–121, 128

H. Armstrong Roberts:
© J. Blank: pp. 37 (top), 39 (top), 81
© Michael Berman: p. 88
© Gerald L. French: pp. 16, 56–57, 76 (bottom), 115
© M. Gibson: p. 20
© A. Griffin: p. 116 (bottom)
© Bruce Kliewe: pp. 14–15, 22–23, 110–111, 118 (top)
© Ralph Krubner: pp. 12, 13, 26 (top, bottom left and right), 29 (top), 40–41, 42 (top and bottom), 66, 67, 80 (bottom), 104 (top), 108, 112, 113
© R. Matassa: pp. 105, 123 (top)
© J. Messerschmidt: pp. 24, 25 (top), 32 (top left)

© H. Sutton: p. 79 (top right)
© K. Wyle: p. 118 (bottom)

International Stock:
© International Stock: p. 93 (top left)
© Scott Barrow: pp. 54, 76 (top), 116 (top left and right), 123 (bottom)
© Mark Bolster: pp. 28, 29 (bottom)
© John G. Cardasis: p. 75 (bottom)
© Tom Carroll: pp. 32 (top right), 39 (bottom left)
© J. G. Edmanson: p. 36 (top)
© Chad Ehlers: pp. 10–11, 122, 124–125
© Frank Grant: p. 92
© Tom and Michelle Grimm: p. 79 (bottom)
© Cliff Hollenbeck: p. 84 (top left)
© Michael J. Howell: pp. 9 (top left and right), 34–35, 70, 114
© Andre Jenny: pp. 33, 37 (bottom)
© Peter Krinninger: p. 36 (bottom)
© Randy Masser: p. 79 (top left)
© Lindsay Silverman: pp. 46, 47 (top)
© Paul Thompson: p. 38
© Hilary Wilkes: pp. 2–3, 59 (bottom)

ThePhotoFile:
© Gerald L. French: pp. 60, 97, 109, 127
© Sam Sargent: pp. 75 (top), 107 (top right)
© Tom Vano: p. 126 (bottom)

Printed in China

9 8 7 6
Digit on the right indicates the number of this printing

Library of Congress Cataloging-in-Publication Number 98-70512

ISBN 0-7624-0387-X

Cover and interior design by Corinda Cook
Photo research by Susan Oyama
Set in Belucian, Caslon, and Felix Titling

This book may be ordered by mail from the publisher.
But try your bookstore first!

Published by Courage Books, an imprint of
Running Press Book Publishers
125 South Twenty-second Street
Philadelphia, Pennsylvania 19103-4399

(half-title page) Palace of Fine Arts.

(title page) Golden Gate Bridge and San Francisco from Marin headlands.

(p. 5) Transamerica Pyramid, Coit Tower, and Alcatraz Island from the Mandarin Hotel.

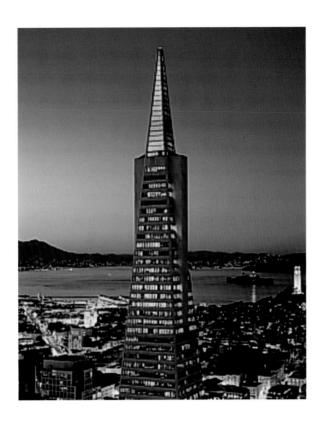

SAN FRANCISCO OFFERS its visitors a treasure trove of sights and experiences: the majestic vistas of a pennisula on the Pacific ocean, the vibrant history of the city, the unique sense of style that is immediately evident to even the first-time visitor, and the amazing mix of cultures that makes San Francisco one of the most diverse urban centers in the world. These are vestiges of the city's original spirit—the same spirit that has captivated visitors and San Franciscans alike for two centuries.

From its earliest beginnings as a Spanish Mission (the Mission Dolores is still the oldest intact building within the city), San Francisco was an obscure dot on the most distant horizon of the western frontier. However, with the discovery of gold at the mill of John Sutter in 1849, the settlement became a magnet for fortune seekers the world over, and almost overnight the great rush of 49'ers turned San Francisco seemingly over night from a small, tent-filled outpost on the edge of the continent to a rambling, bustling city that offered promise, if not fulfillment, to all who could make the arduous journey. The gold rush made San Francisco into a 'boomtown.' Many who came to town looking for the precious metal left within a few years disappointed, while others found something quite different, but equally precious—San Francisco. As news of the gold rush spread, the city became an immigration center, and within a few years of the initial lucky strike,

San Francisco boasted a multicultural population second to none on the globe—Chinese, French, Spanish and scores of other languages could all be heard from the increasingly busy streets of the bay city.

California was admitted to the union as a free state only a few days after gold was discovered; as a result, the culture that developed in the following years was not so much a product of America as it was of San Francisco, and the unique factors that spurred its development. By the mid-1850's, San Francisco was thriving not so much upon the gold, which was quickly vanishing from the hills, but upon those who came for it. Miners, just like everyone else, needed to be clothed, fed, housed, and occasionally entertained, and San Francisco cut its teeth as a city catering to these needs. And while the city was certainly rough around the edges, it soon came into its own as a center of commerce, trade, and culture. During this time, San Francisco began to show signs of an unconventionality that would come to dominate its image as a major city, and that would also define its development for the century to come.

Perhaps the earliest manifestation of the 'go for it' spirit of San Francisco is evident in San Francisco's long history of colorful and often eccentric personalities. In September of 1859, Joshua Norton made the first of his Proclamations, in which he declared himself to be the 'Emperor of these U.S.,' and went on in later proclamations to order the U.S. Congress to convene the following February in the San Francisco Musical Hall in order 'to make such alterations in the existing laws of the Union as may ameliorate the evils under which the country is laboring.' Emperor Norton I, as he is known to many in San Francisco, went on to make more than thirty more such proclamations, ranging in topic from the abolition of Congress and the term 'Frisco' to issues of genuine importance— Emperor Norton was one of the earliest, and most vocal, proponents of the construction of bridges between San Francisco and the mainland. It is a testimony to the City's peculiar open-mindedness that when Norton died in 1880, as many as thirty thousand mourners paid their respects to the regal eccentric.

Emperor Norton is just one of faces behind San Francisco's rich history of trend-setting. In the last fifty years alone, San Francisco has generated literary, artistic, and cultural movements that later caught the attention of the entire country and beyond—the 'beat' scene of the 1950's brought literary giants Allen Ginsberg, William S. Burroughs, and Jack Kerouac into the national limelight; the hippie generation made the city its Mecca and found its own anthems in the music of the Grateful Dead and Jefferson

Airplane; and, since the 1970s San Francisco has enjoyed being the cornerstone of the Gay Pride movement. As a result, the city today stands as a symbol of tolerance and freedom for all, regardless of one's particular tastes or background. San Francisco prides itself on offering something for everyone—no matter how strange one's desires may be; from this, it is easy to understand that the American 'norm' has little place in the city that defiantly marches to the beat of a different drummer. For its dwellers, it is this slightly quirky overtone that makes them stay and delight in San Francisco's unique and diverse city culture. The simple truth, as many San Franciscans will willingly admit, is that no one moves to the city without knowing of its eclecticism and anything-goes mentality.

San Francisco is set amongst some of the most spectacular sights afforded to any city in the country, and perhaps the world. Sprawling over seven hills, San Francisco doesn't just take up space—it dominates it. Of course, the Golden Gate Bridge is the most recognizable feature of the San Franciscan landscape, but when it is taken into consideration that the city is crammed onto a peninsula that has undergone minimal expansion since the city lines were drawn 150 years ago, it's astounding how many things there are to see in the city that has been called 'the Mother of California.' The architecture alone could provide months of exploration, with Spanish, Victorian, Art Deco, and all manner of contemporary styles adding to the diversity and beauty of San Francisco's cityscape. Many of the city's numerous museums, such as the Palace of Fine Arts and the San Francisco Museum Of Modern Art, are equal to the collections they contain as structural works of art. And then there are the sights to be seen from San Francisco: from Mt. Tamalpais to Alcatraz, from Coit Tower to the Mission, no city of its size can compare to the sheer array of San Francisco's landmarks.

San Francisco has lost little of the allure that charmed the original 49ers—besides the gold. With an economy thriving on technology, tourism, and commerce, the original rush has dwindled to a steady flow of new city-dwellers, making San Francisco one of the densest metropolitan regions in the country, with housing filled to 99% capacity. While many of these new inhabitants have moved here for specific reasons, it is not uncommon to meet those who moved here simply to be here, called to the end of the continent by the same mysterious voice that has guided so many others. San Francisco is still the end of the frontier, still the edge of the continent, and always the cutting-edge of culture. San Francisco has earned its fame as one of the most beautiful—and unique—cities in the world.

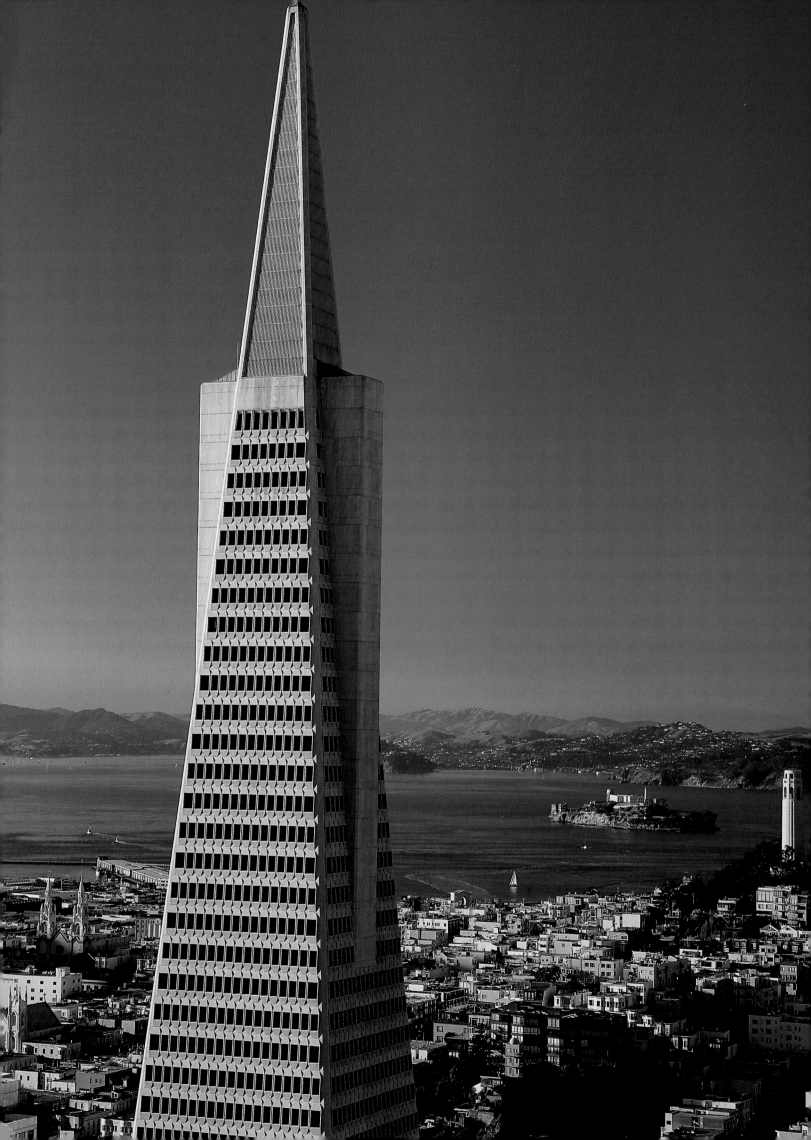

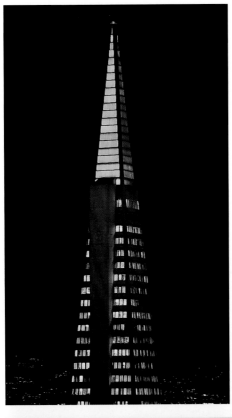

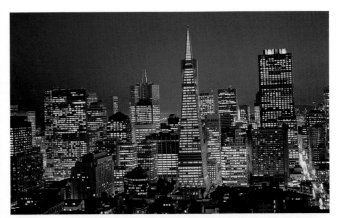

"E ast is East, and West is San Francisco, according to Californians."

—O. Henry, "A Municipal Report"

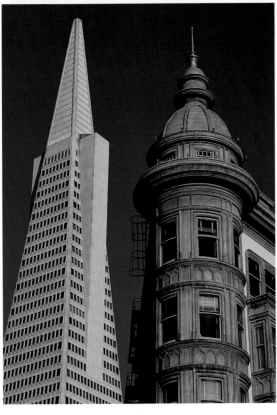

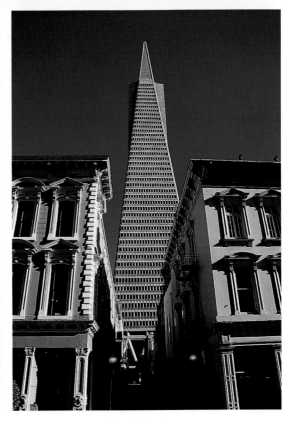

(left) Transamerican Pyramid with Alcatraz and Coit Tower in the background.

(above) Views of the Transamerican Pyramid.

(overleaf) Downtown skyline.

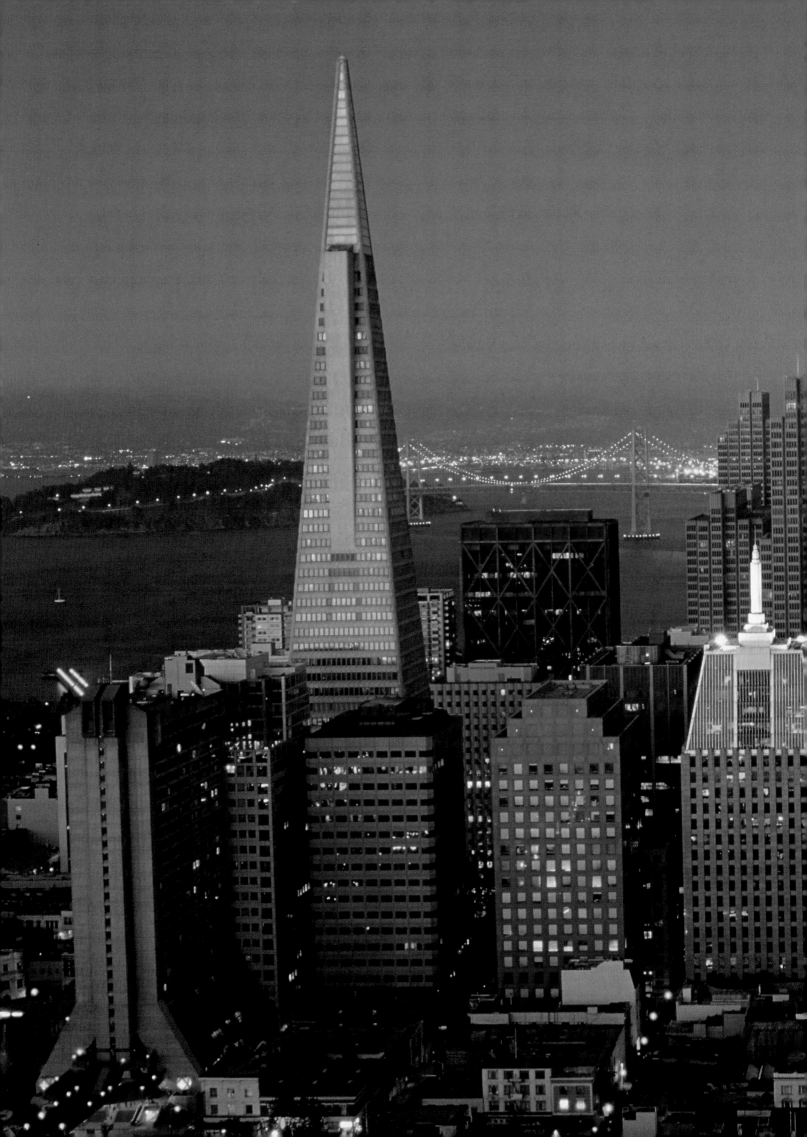

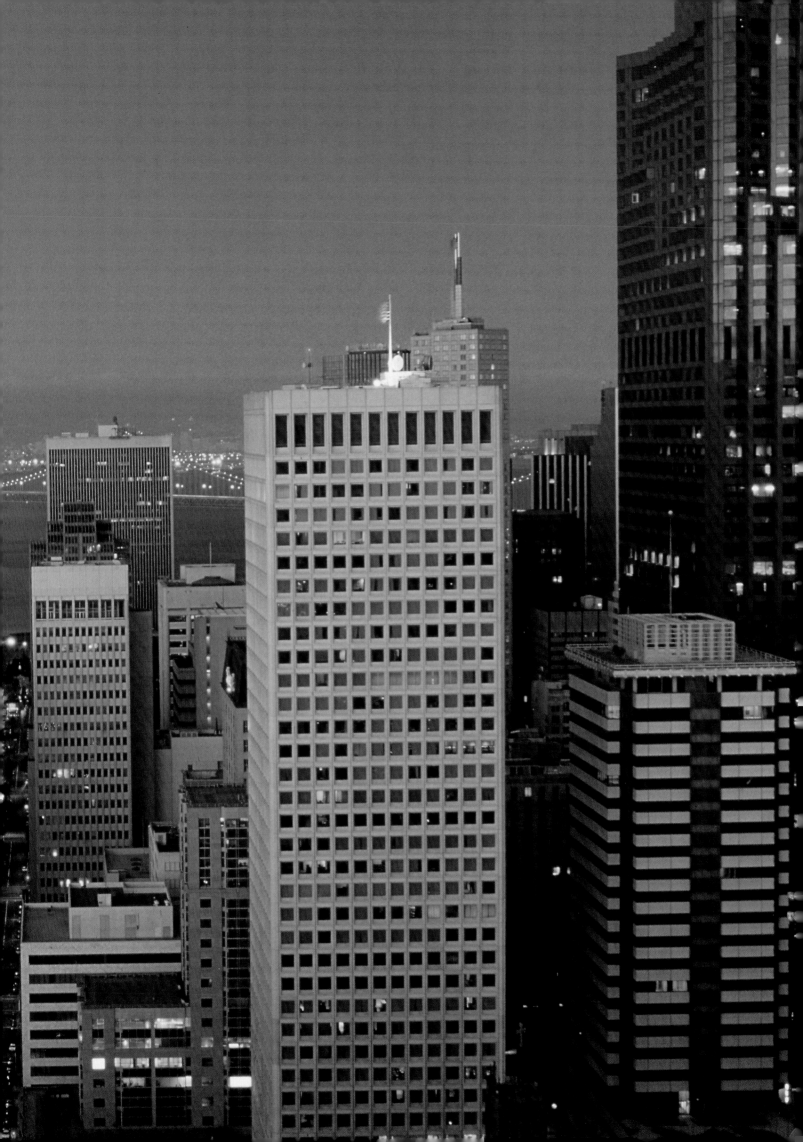

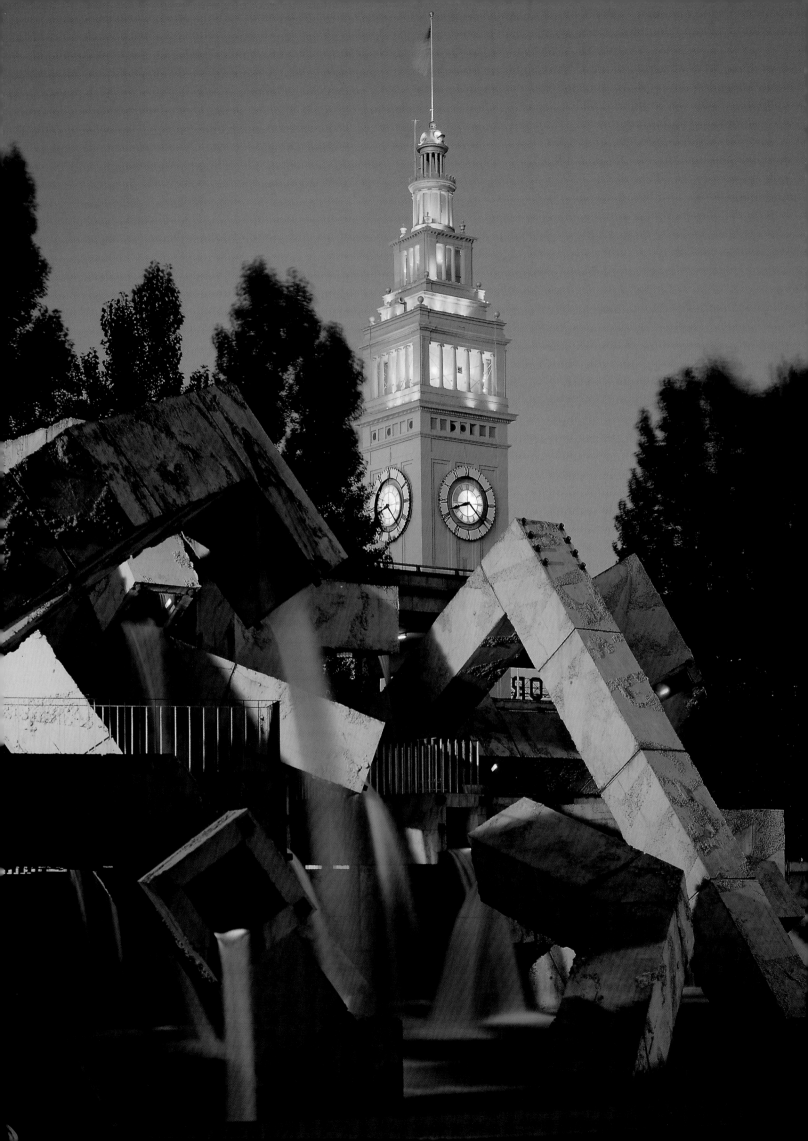

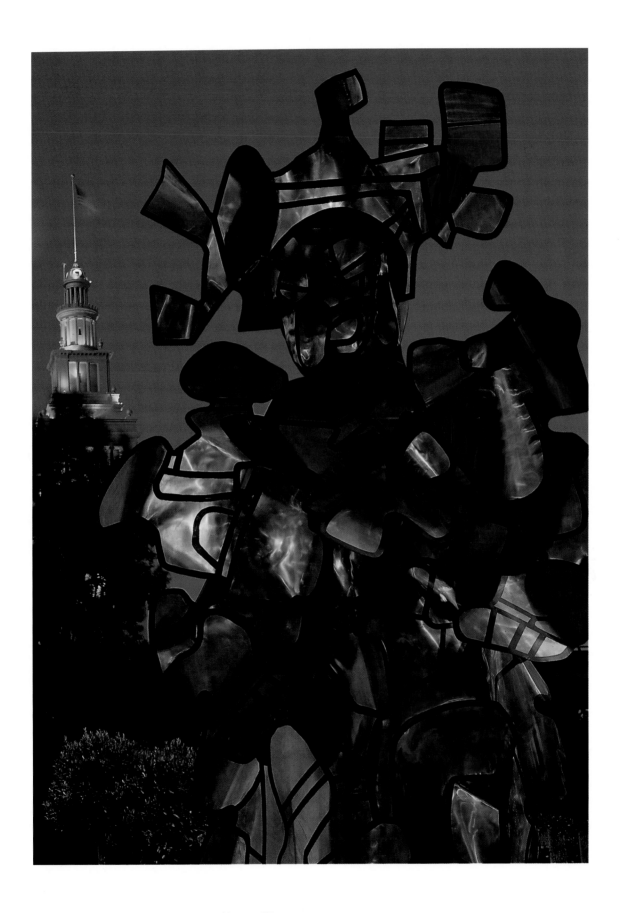

(left) Vallaincourt Fountain and the Ferry Terminal Tower.

(above) Du Buffet Sculpture "La Chiffroniere" at Justin Herman Plaza.

(overleaf) Ferry Building at Christmas time.

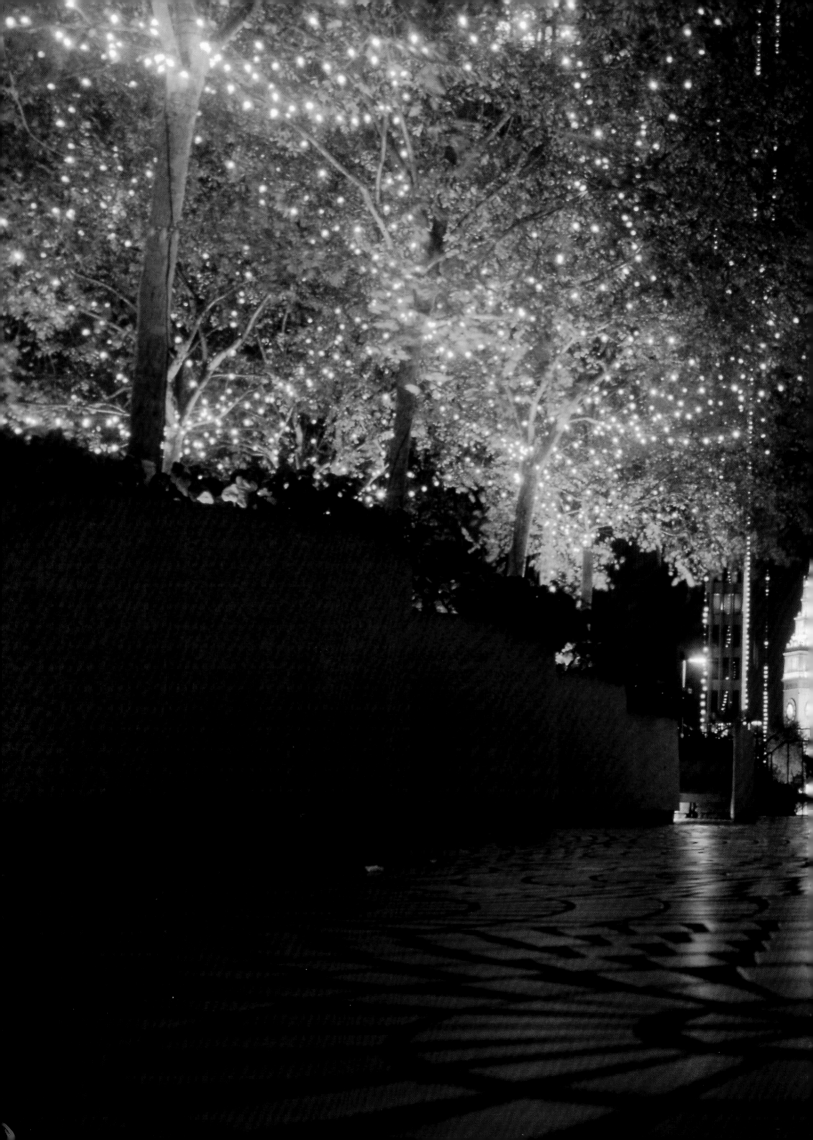

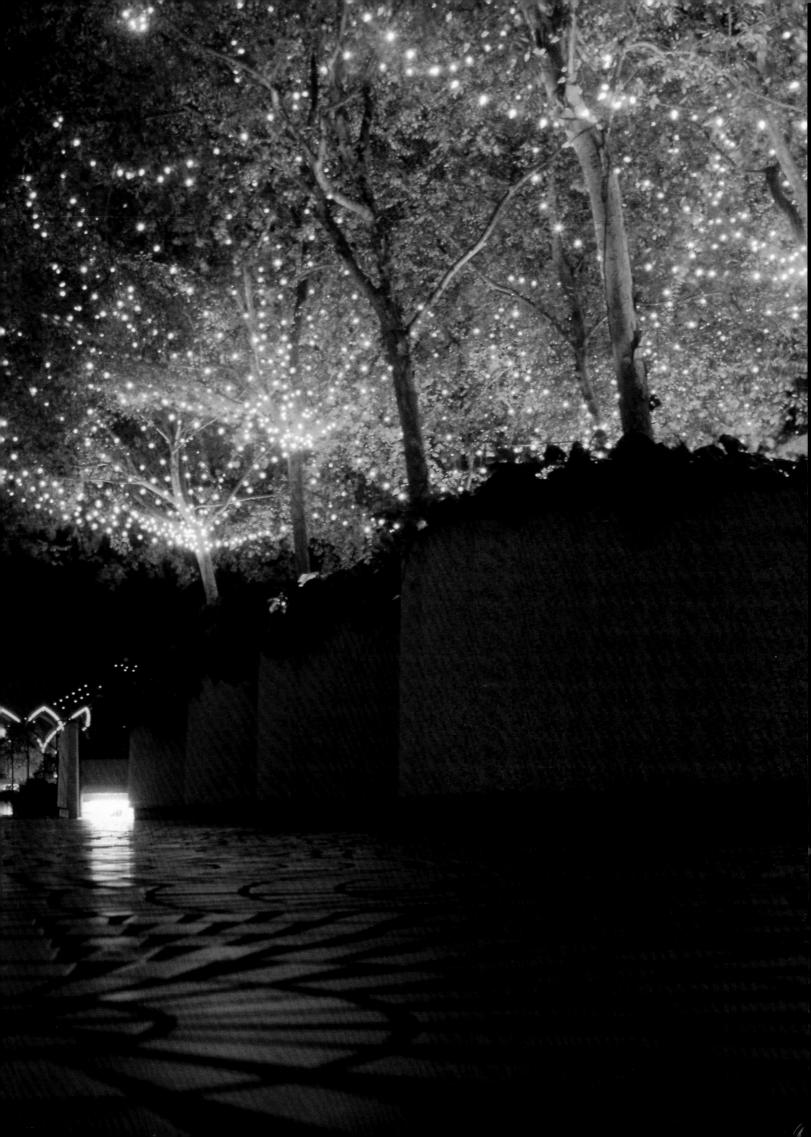

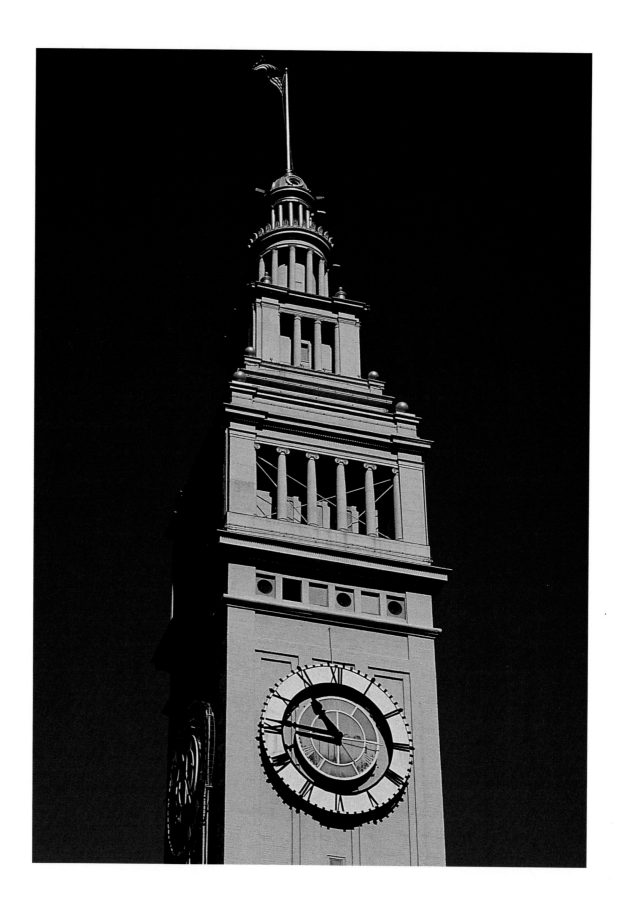

(above) Ferry Building Tower.

(right) Iron sculpture at Yerba Buena Gardens and the San Francisco Museum of Modern Art.

(overleaf) Yerba Buena Gardens and the San Francisco Museum of Modern Art. Designed by architect Mario Botta and opened in 1995, the SFMOMA is one of the newest modern landmarks in downtown San Francisco.

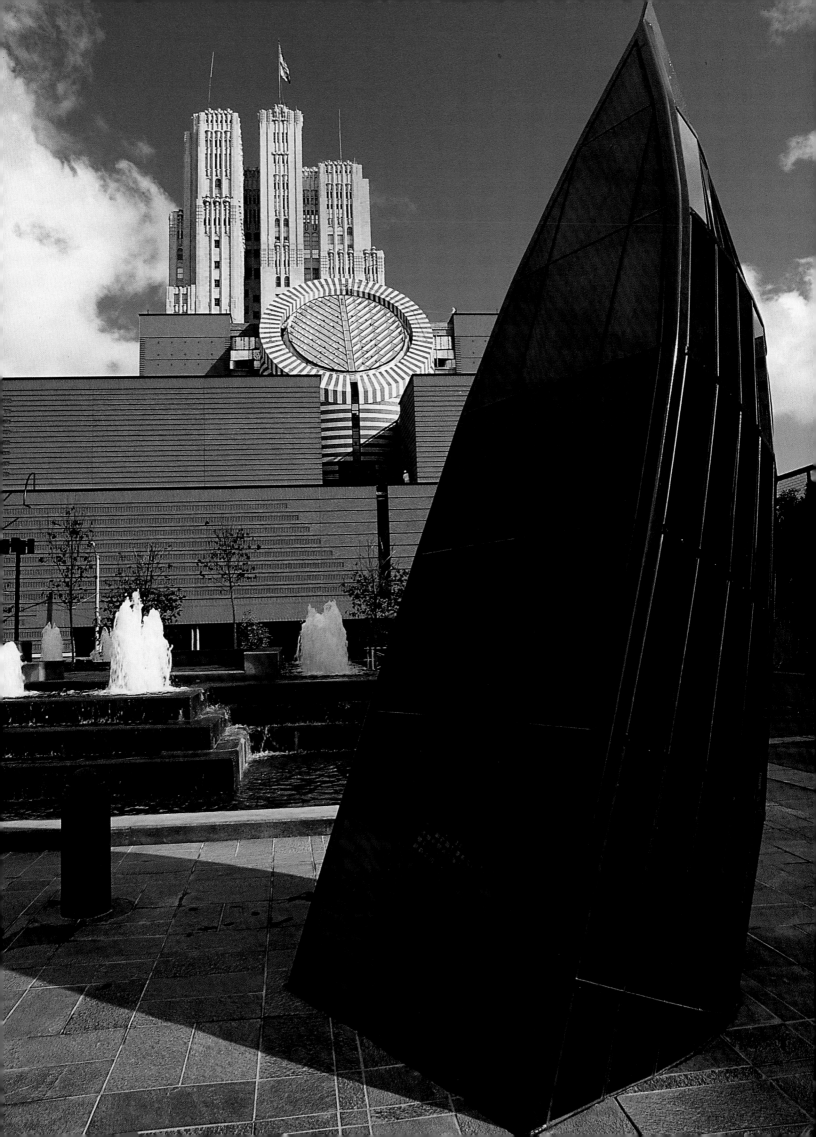

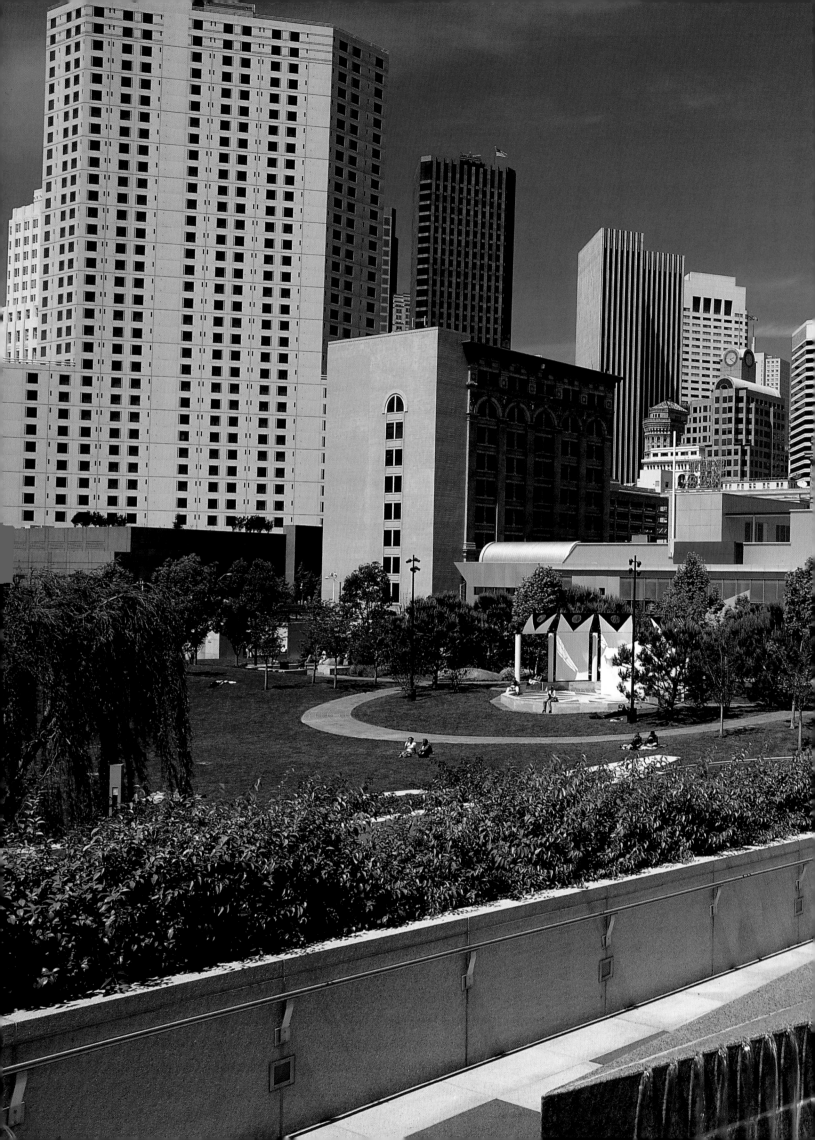

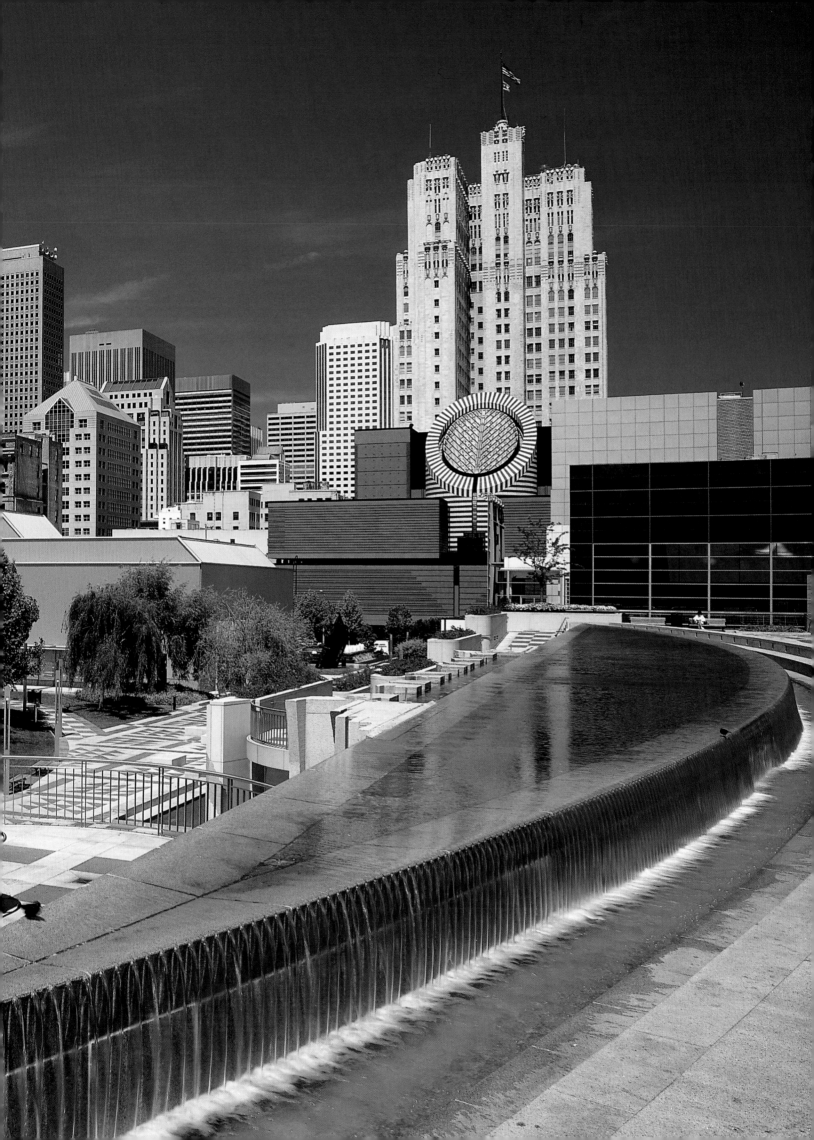

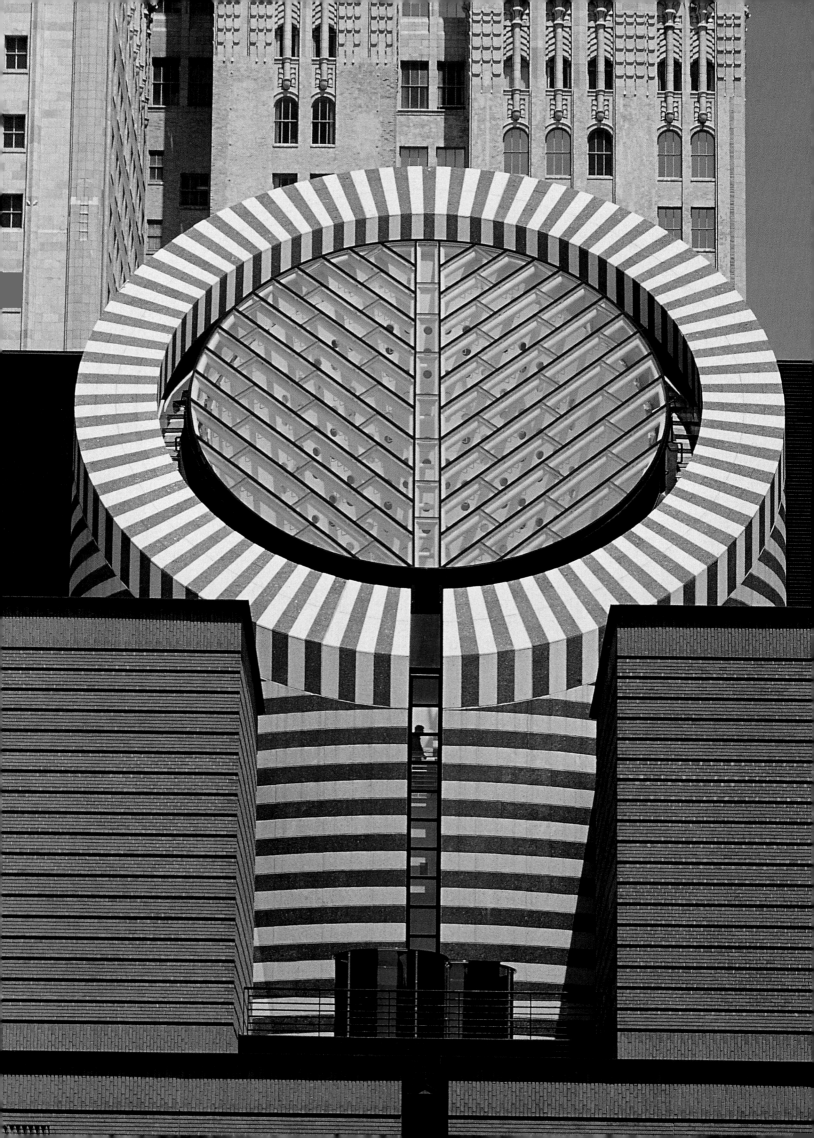

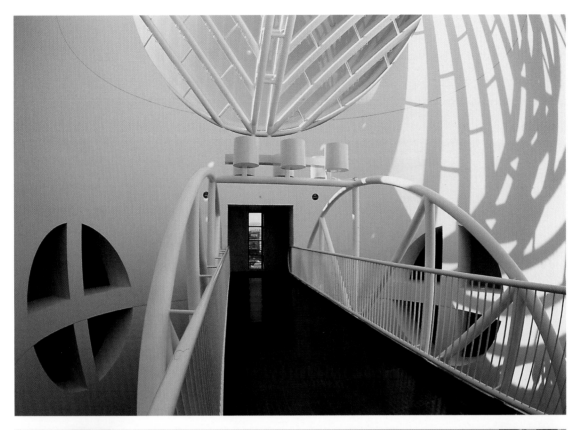

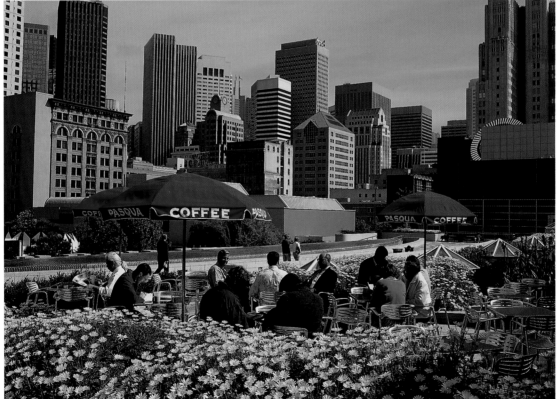

(left) The San Francisco Museum of Modern Art.

(above, top and bottom) The San Francisco Museum of Modern Art interior and a cafe.

(overleaf) The Halladie Building.

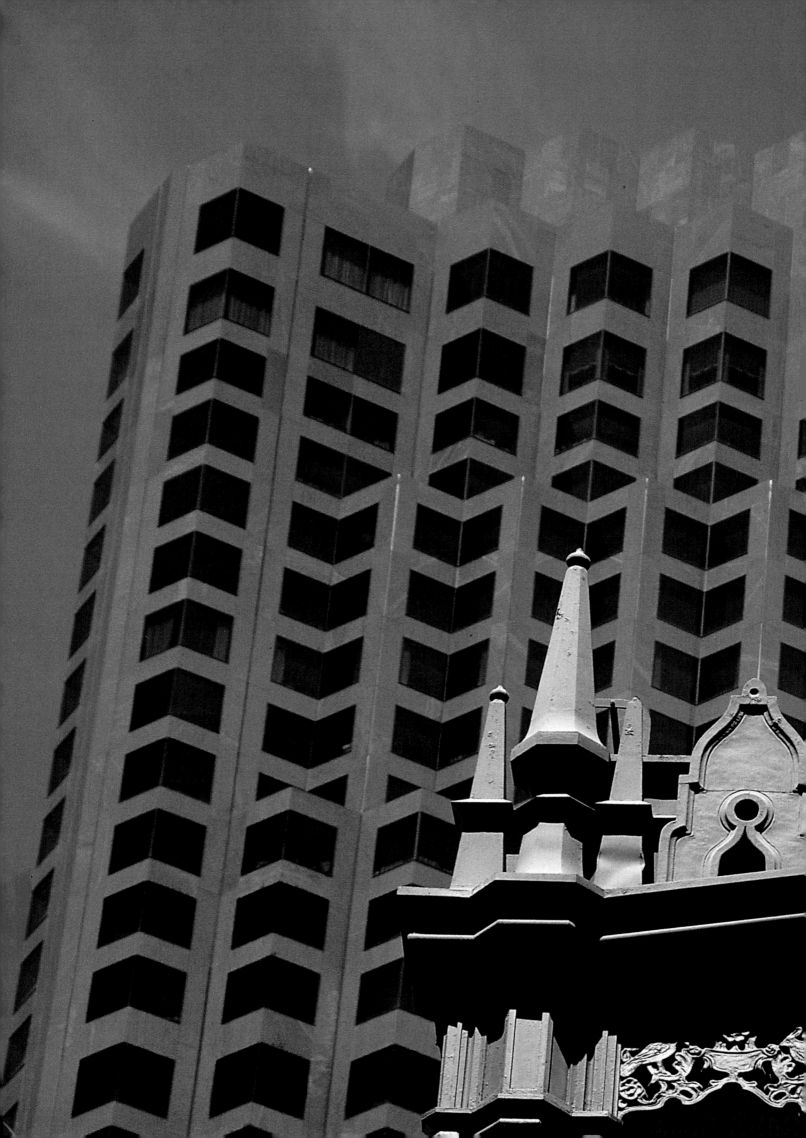

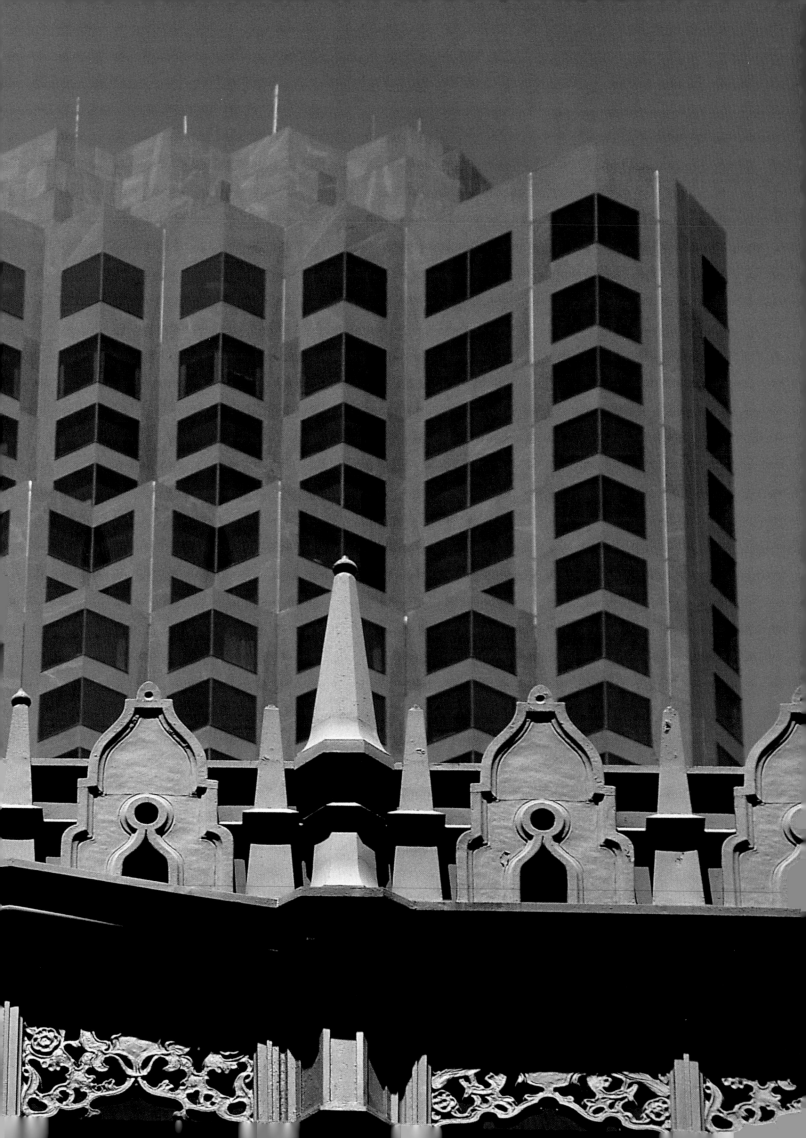

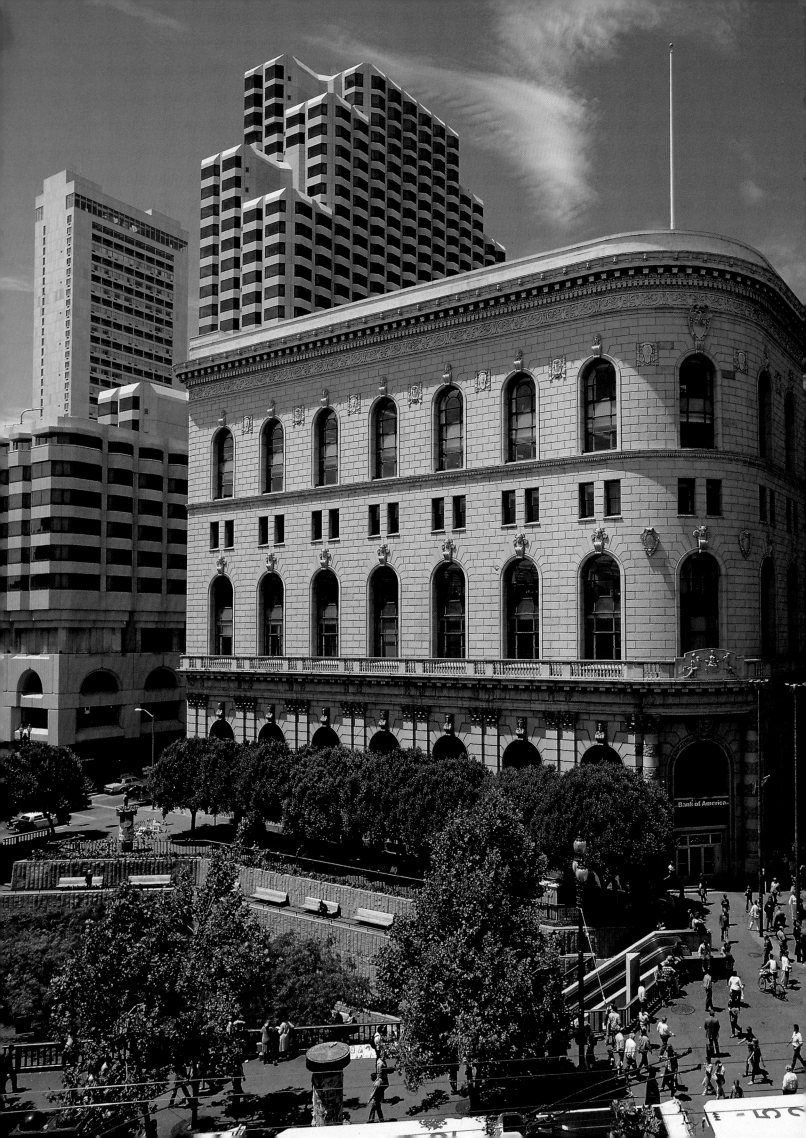

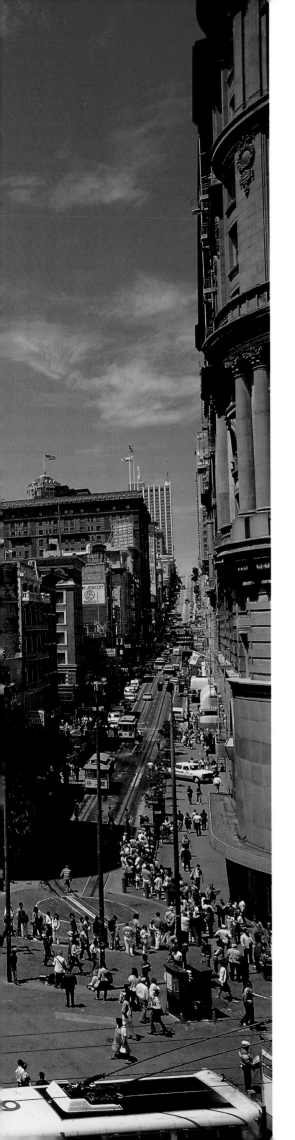

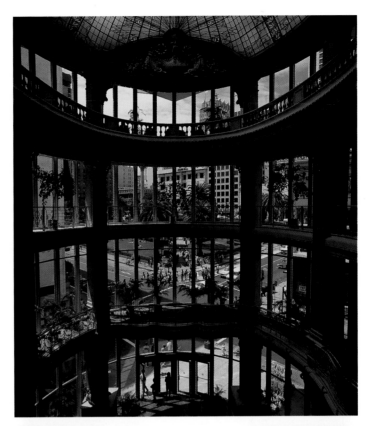

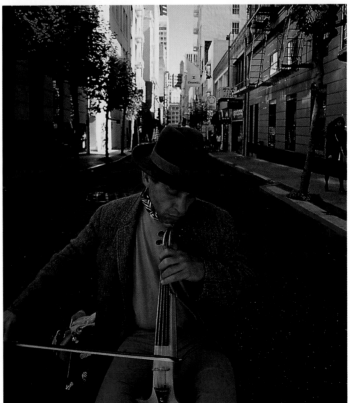

(left) Downtown Market and Powell Street.

(above, top and bottom) Neiman Marcus at Union Square and a street musician playing in Maiden Lane off of Union Square.

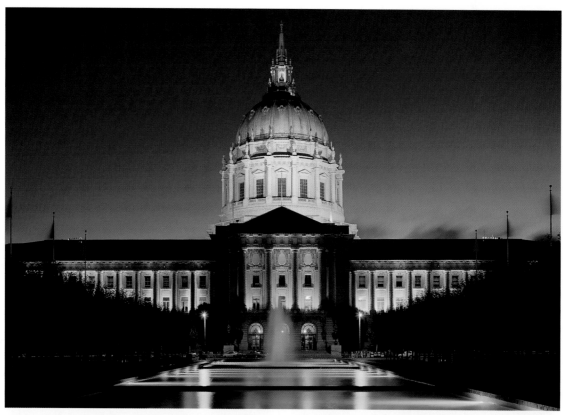

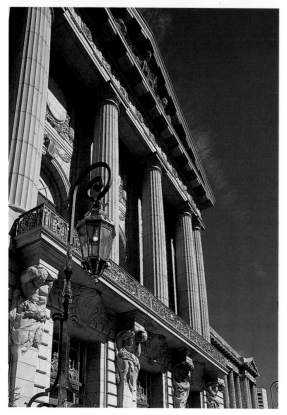

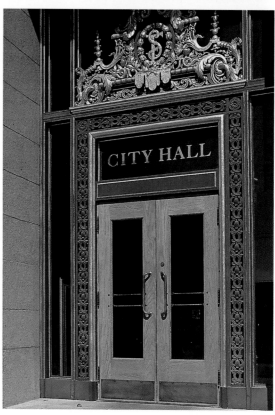

(above) Views of City Hall.

(right) City Hall.

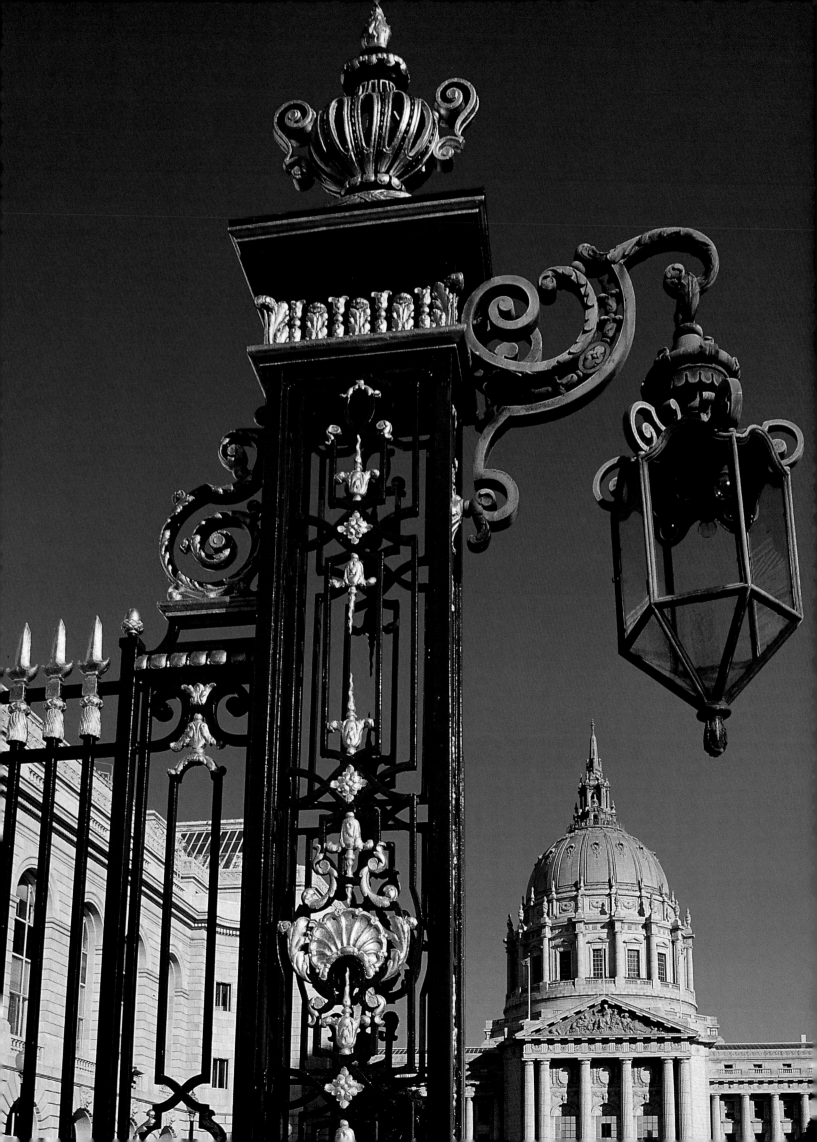

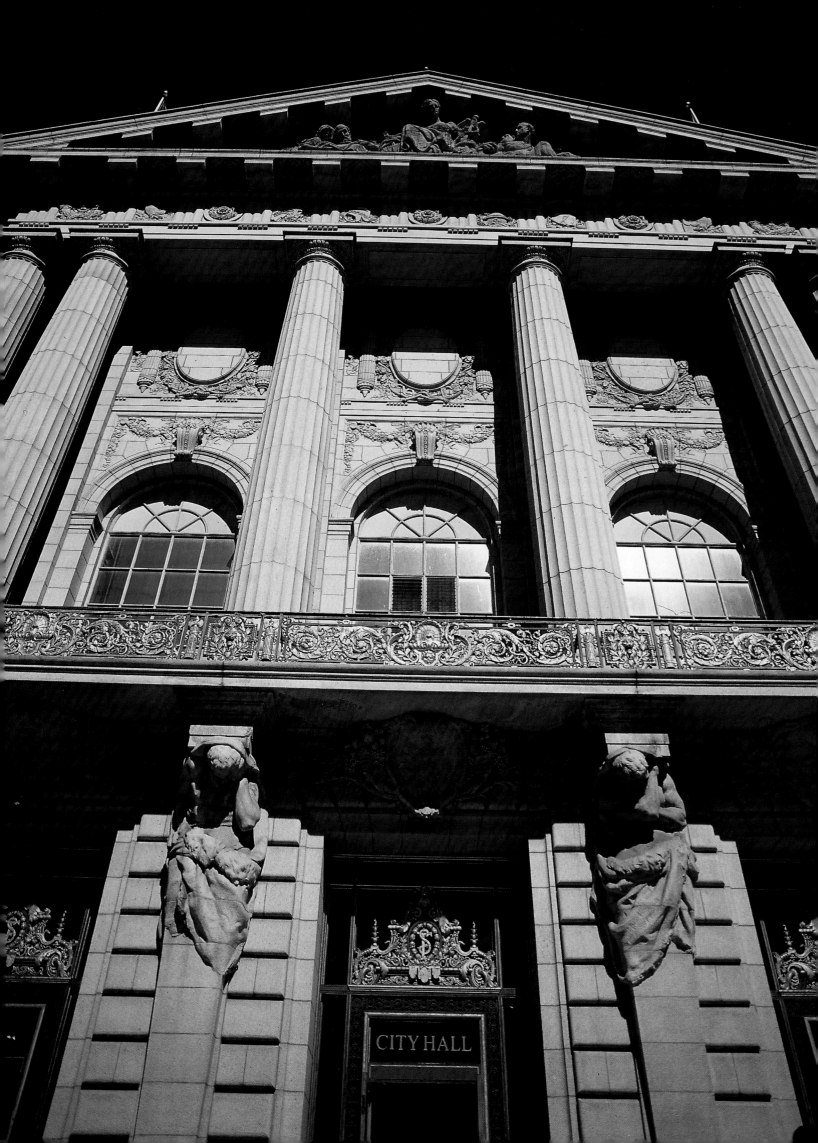

CITY HALL

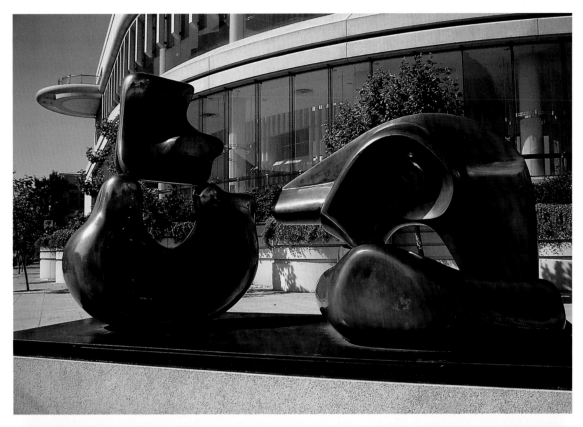

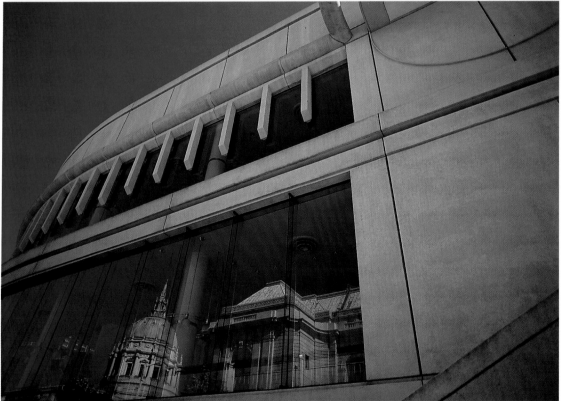

(left) City Hall.

(above, top and bottom) Henry Moore sculptures and the Louise M. Davies Symphony Hall at the Civic Center.

(overleaf) Downtown Skyline from Pier 7.

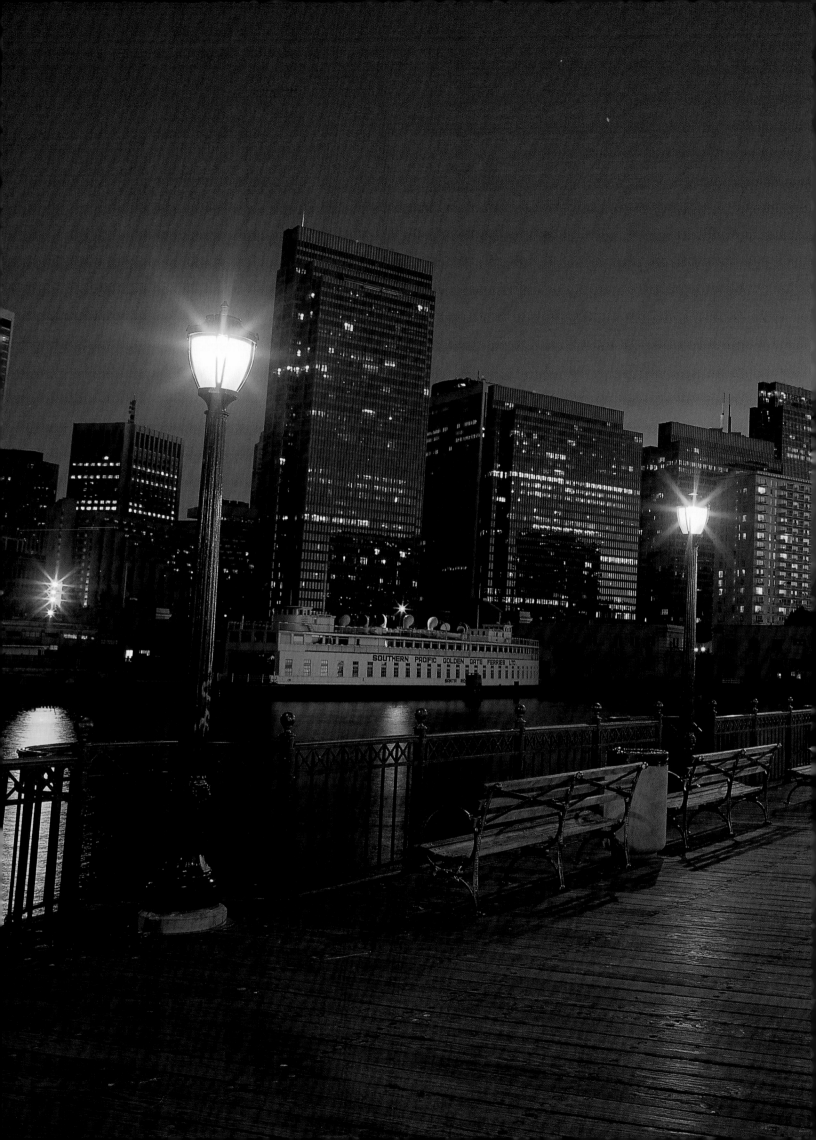

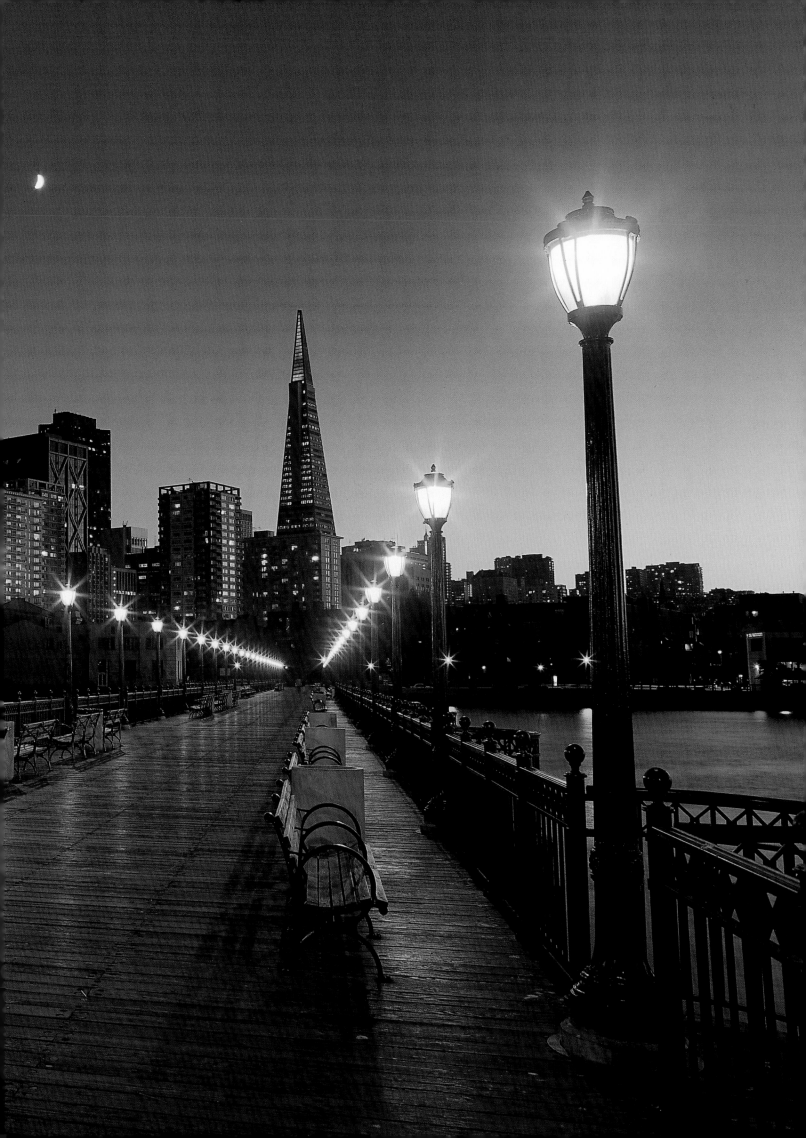

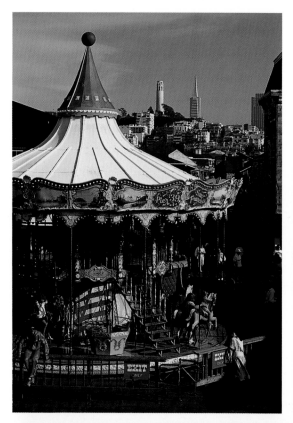 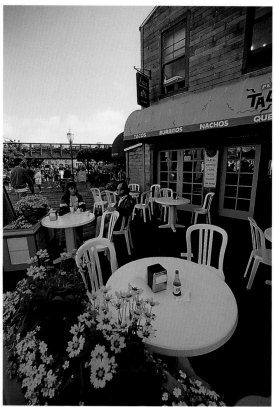

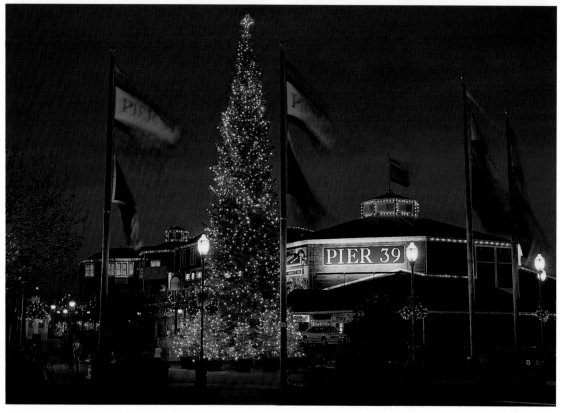

(above, clockwise from top left) Carousel at Pier 39. Cafe at Pier 39. Christmas time at Pier 39.

(right) Sculpture at Pier 39.

(overleaf) Trolley at Pier 39.

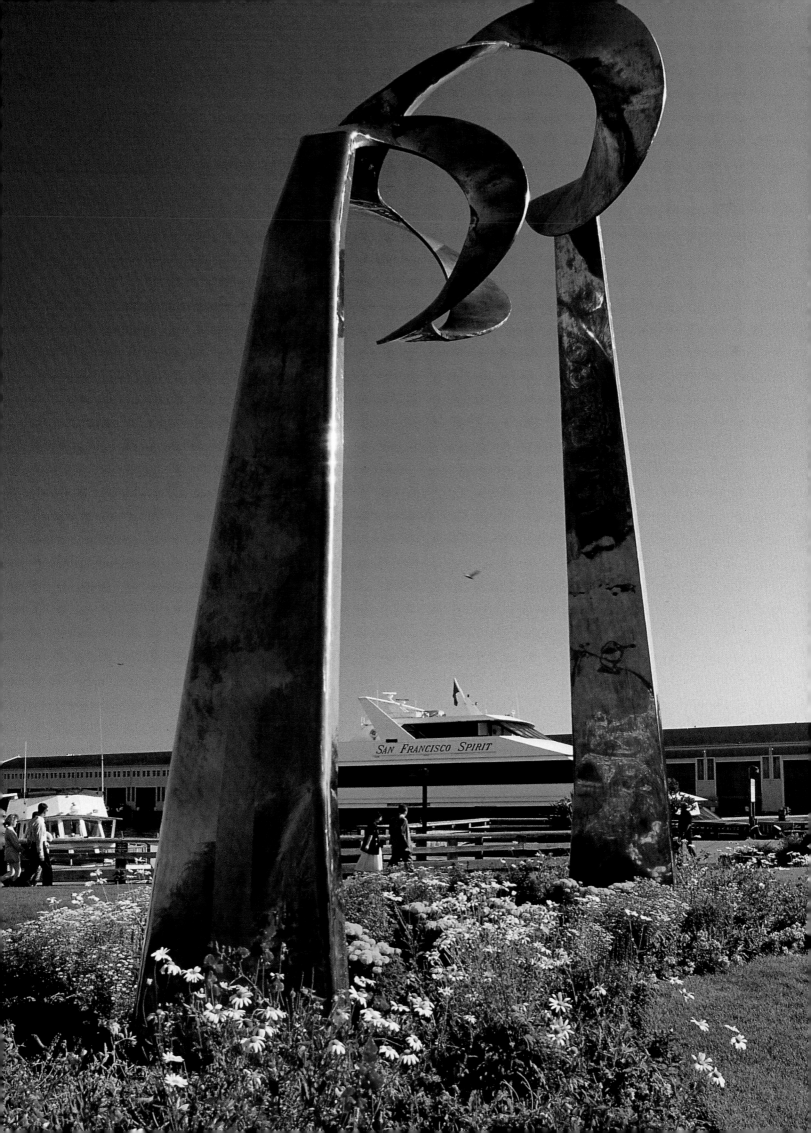

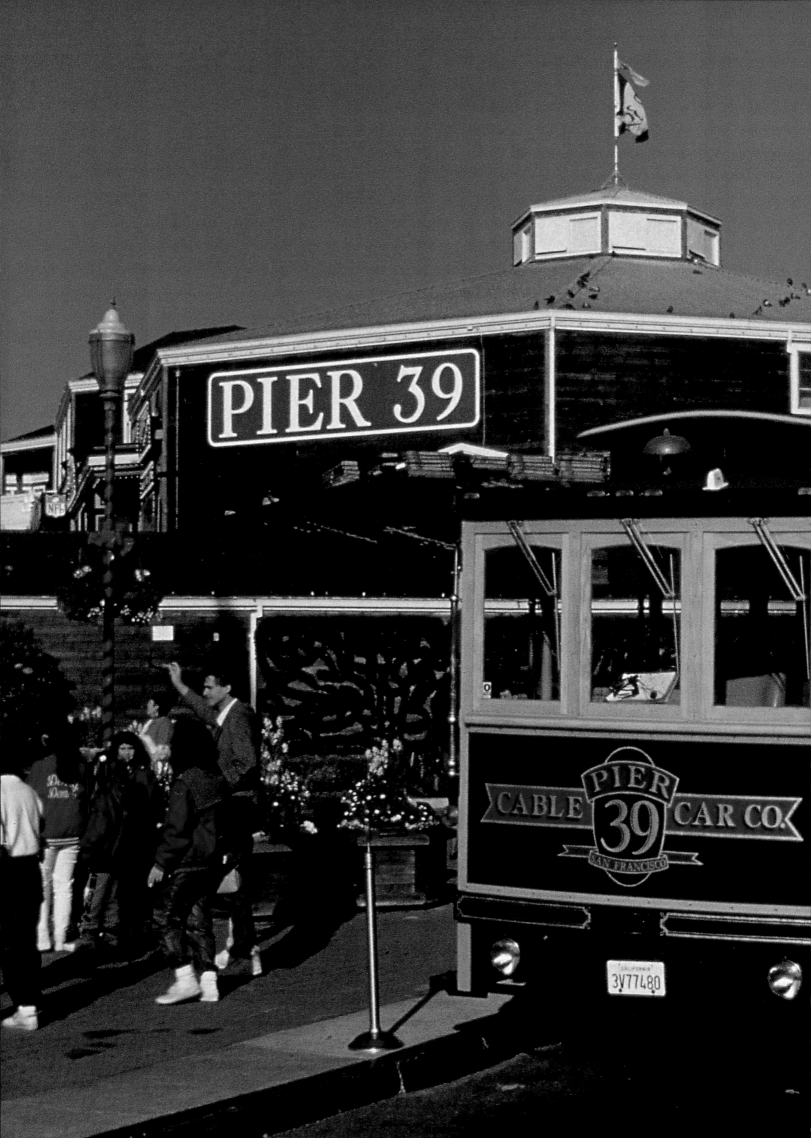

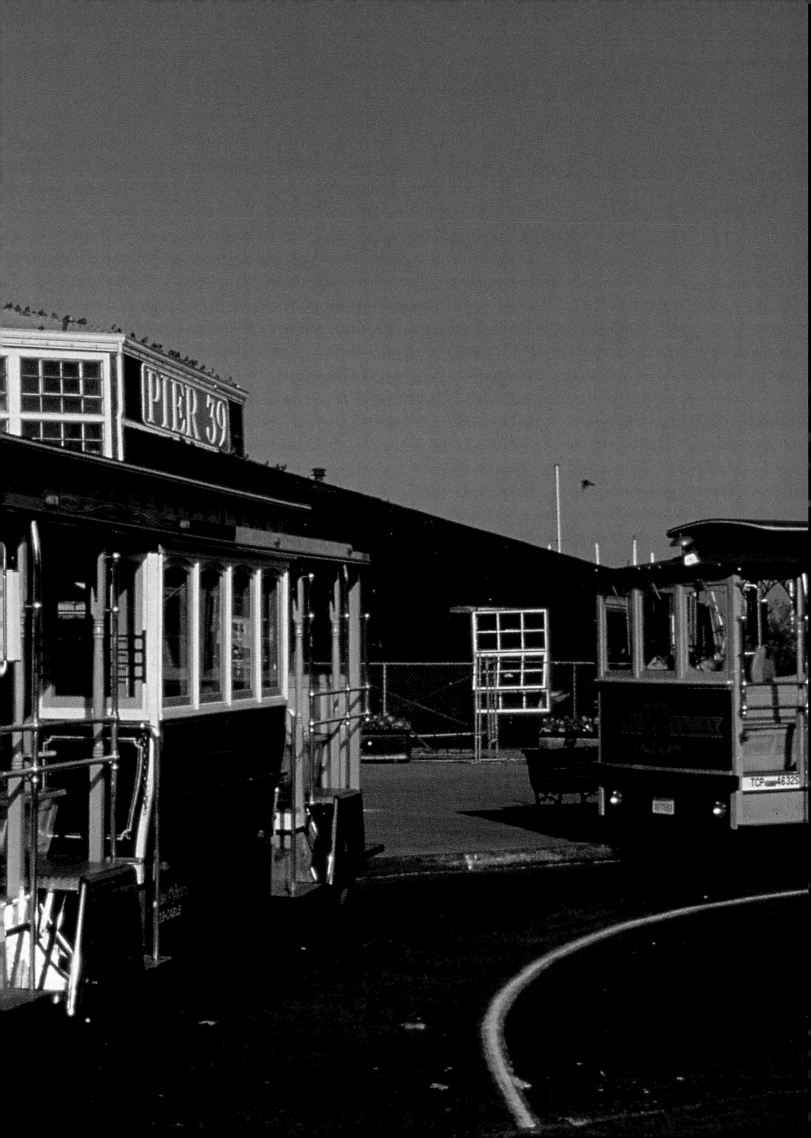

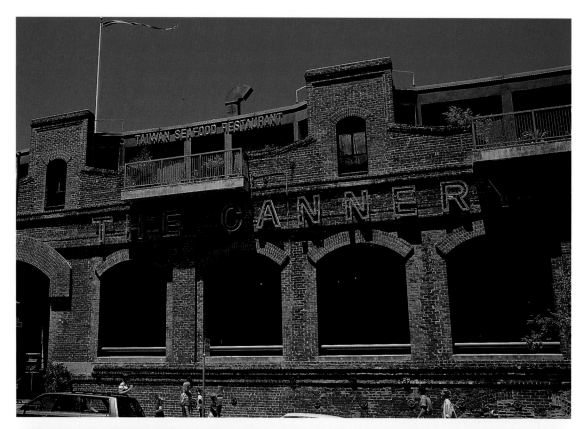

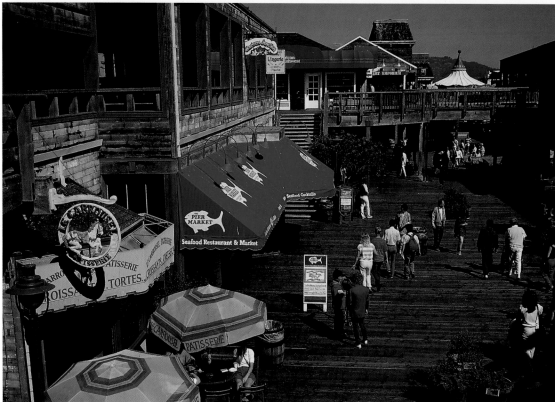

(above, top and bottom) The Cannery at The Museum of the City of San Francisco and Pier 39.

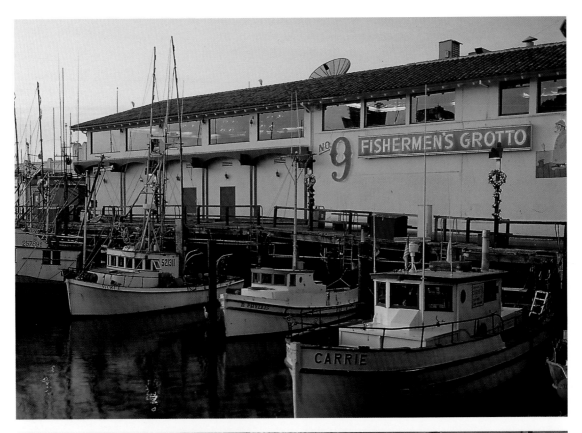

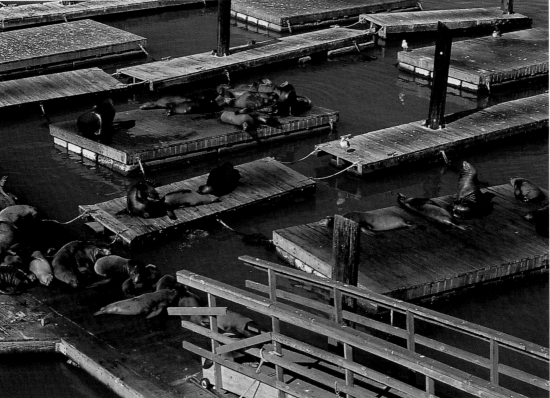

(above, top and bottom) Fisherman's Wharf and the docks with sea lions.

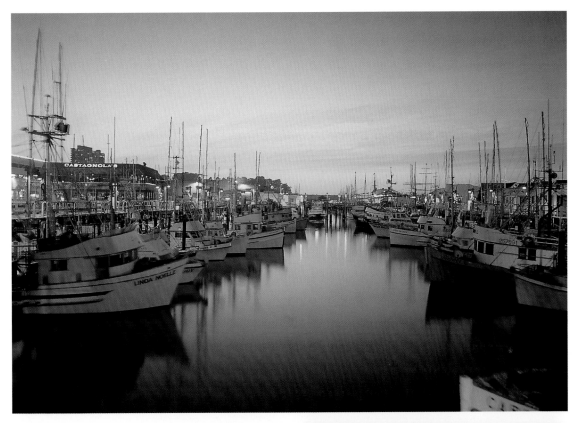

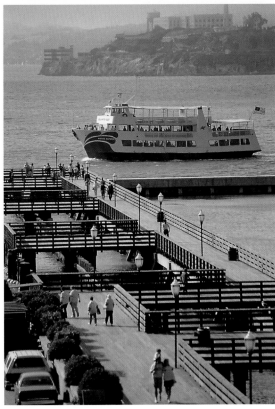

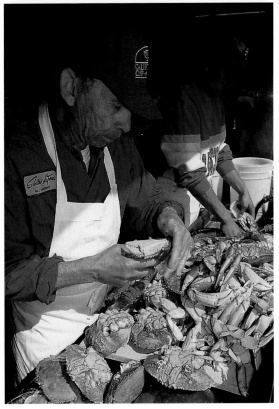

(left and above) Fisherman's Wharf.

(overleaf) Ghirardelli Square. Once simply a gourmet chocolate factory, Ghiradelli Square has developed into an upscale shopping and dining area that draws both residents and visitors.

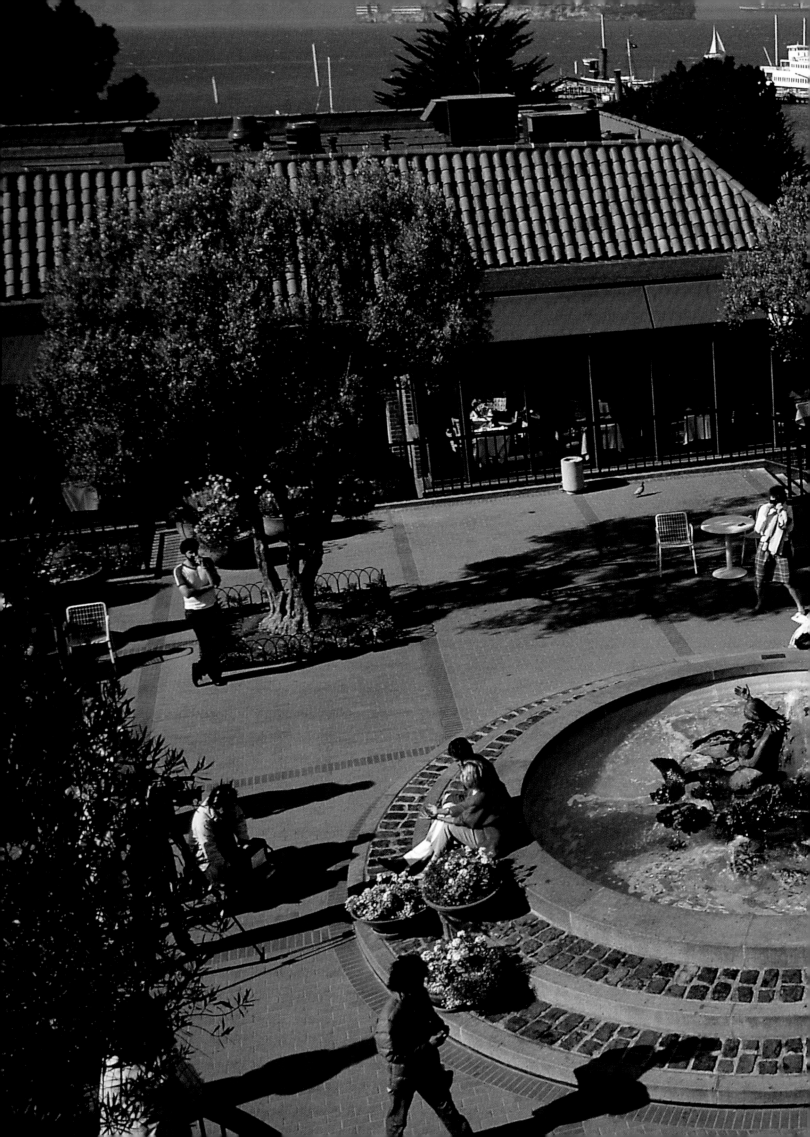

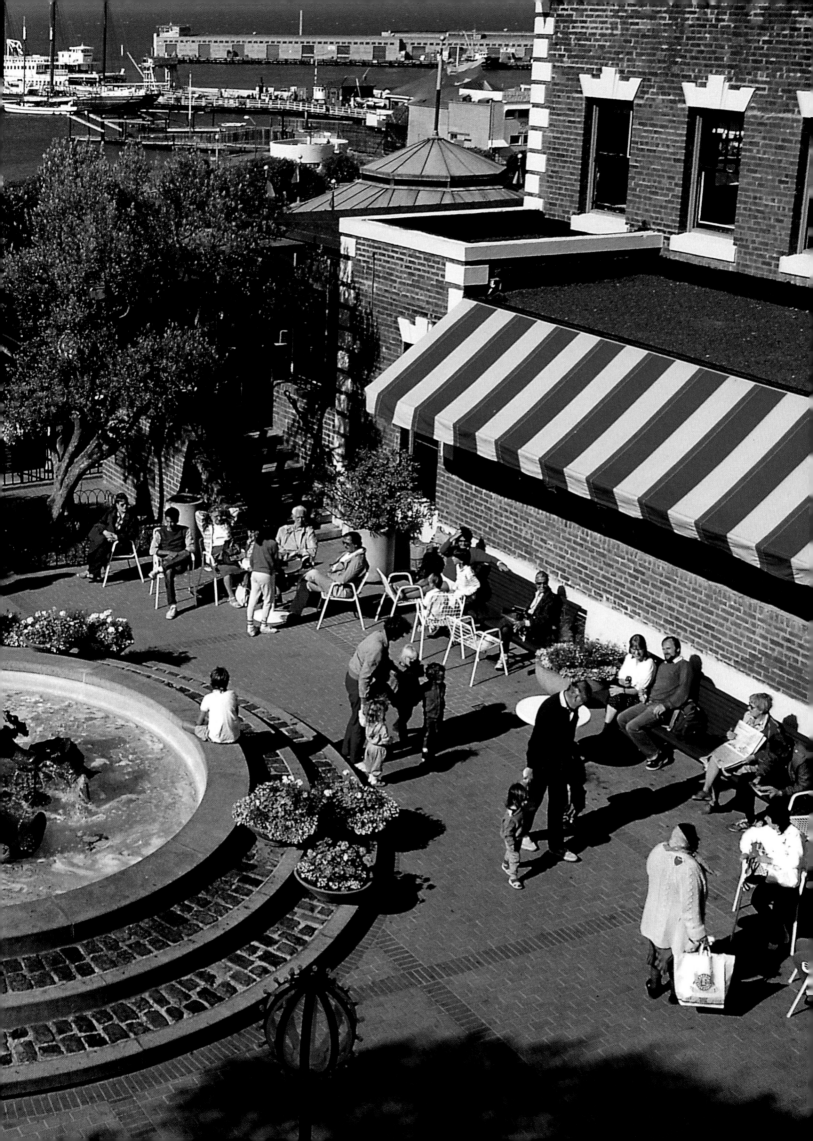

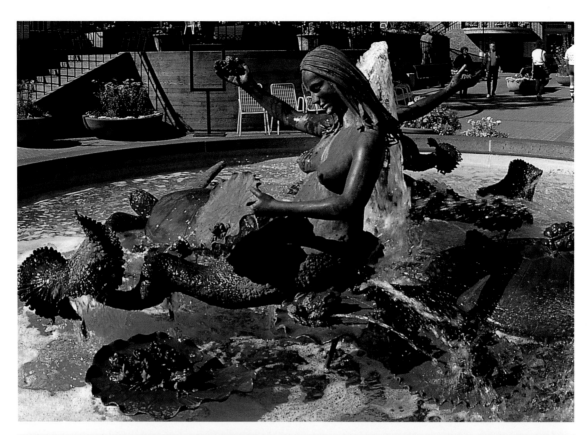

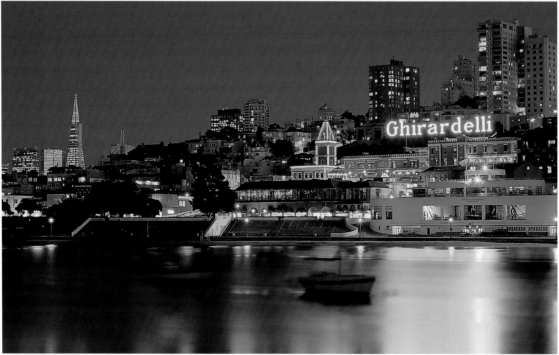

(above, top and bottom) Fountain at Ghirardelli Square and waterfront at night featuring Ghirardelli Square and Russian Hill skyline.

(right) Bow at the Maritime Museum.

(overleaf) Coit Tower and Alcatraz.

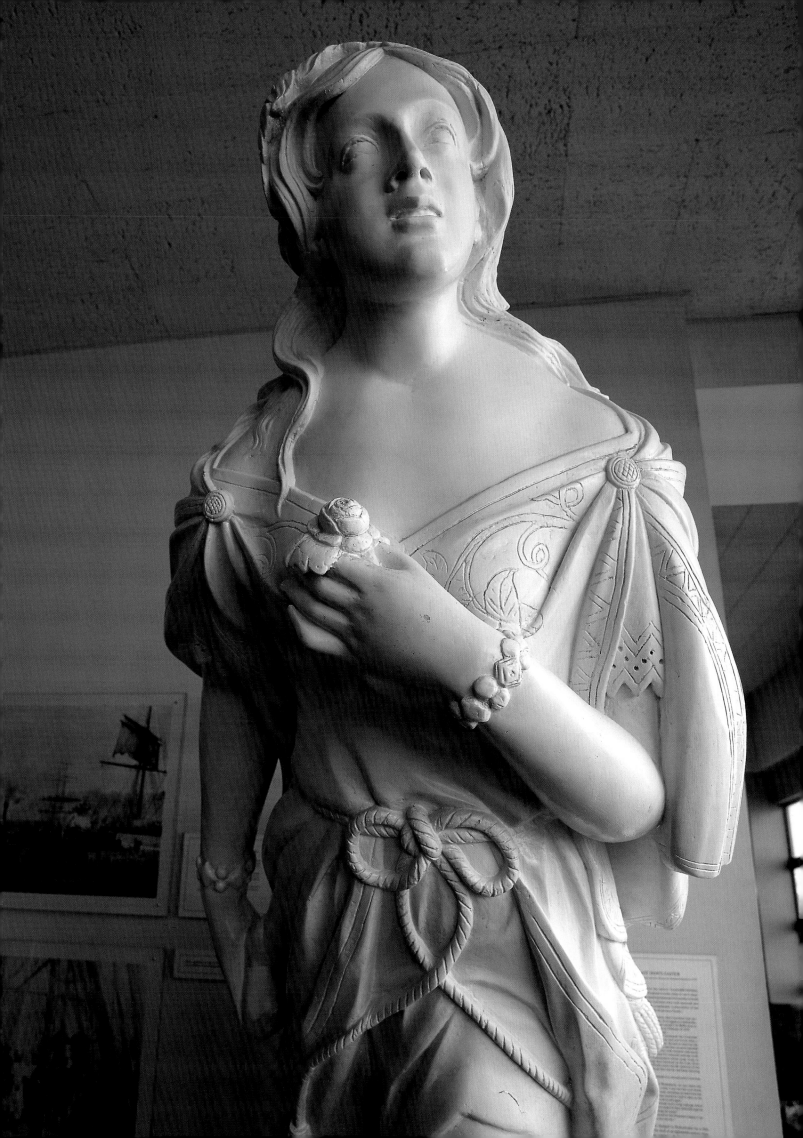

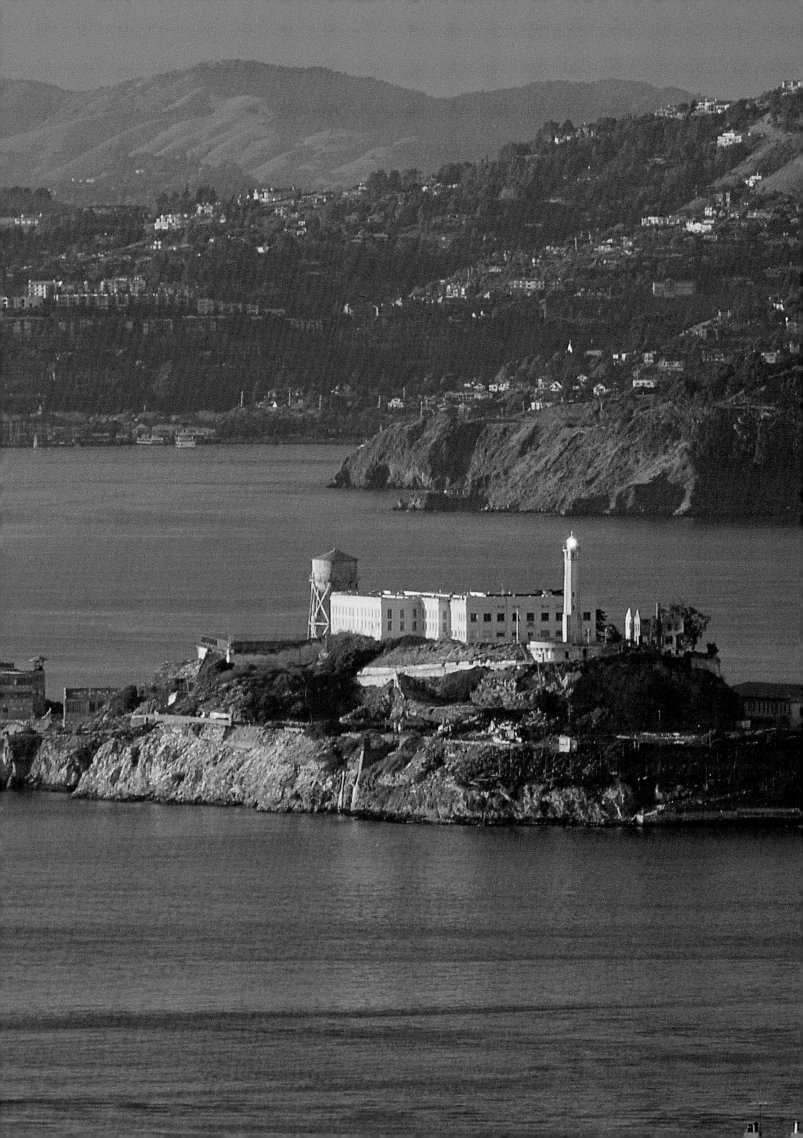

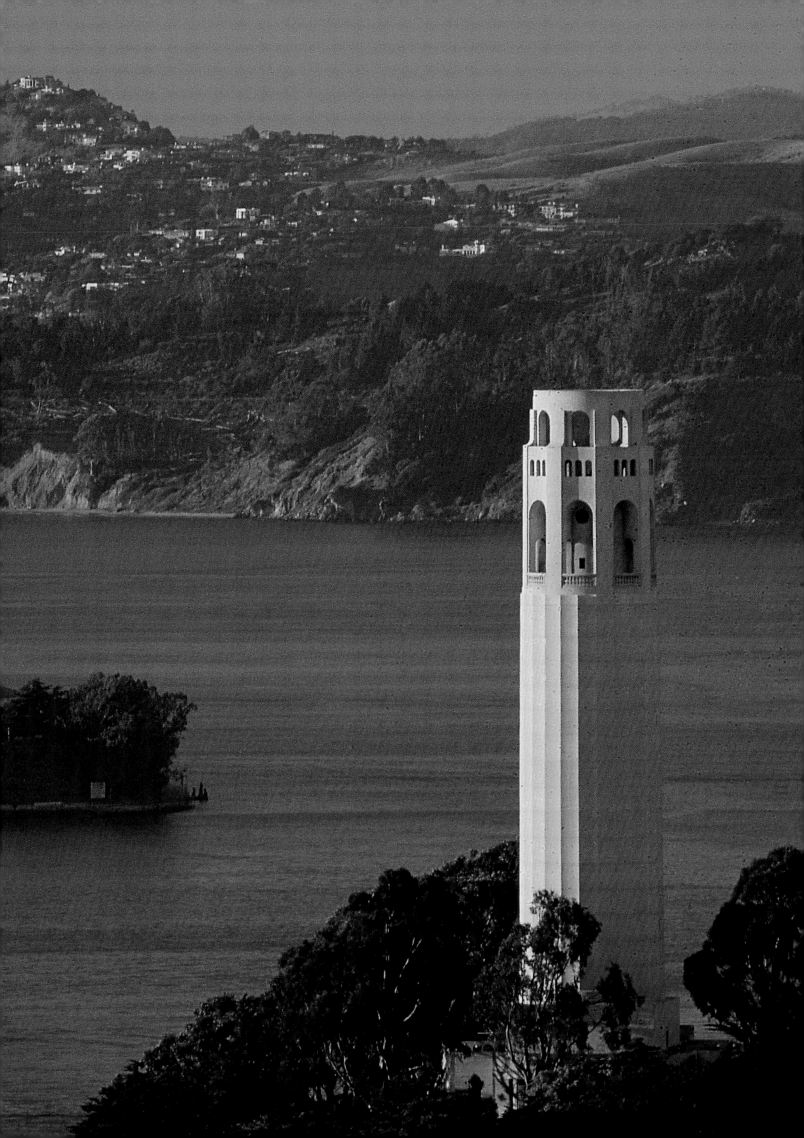

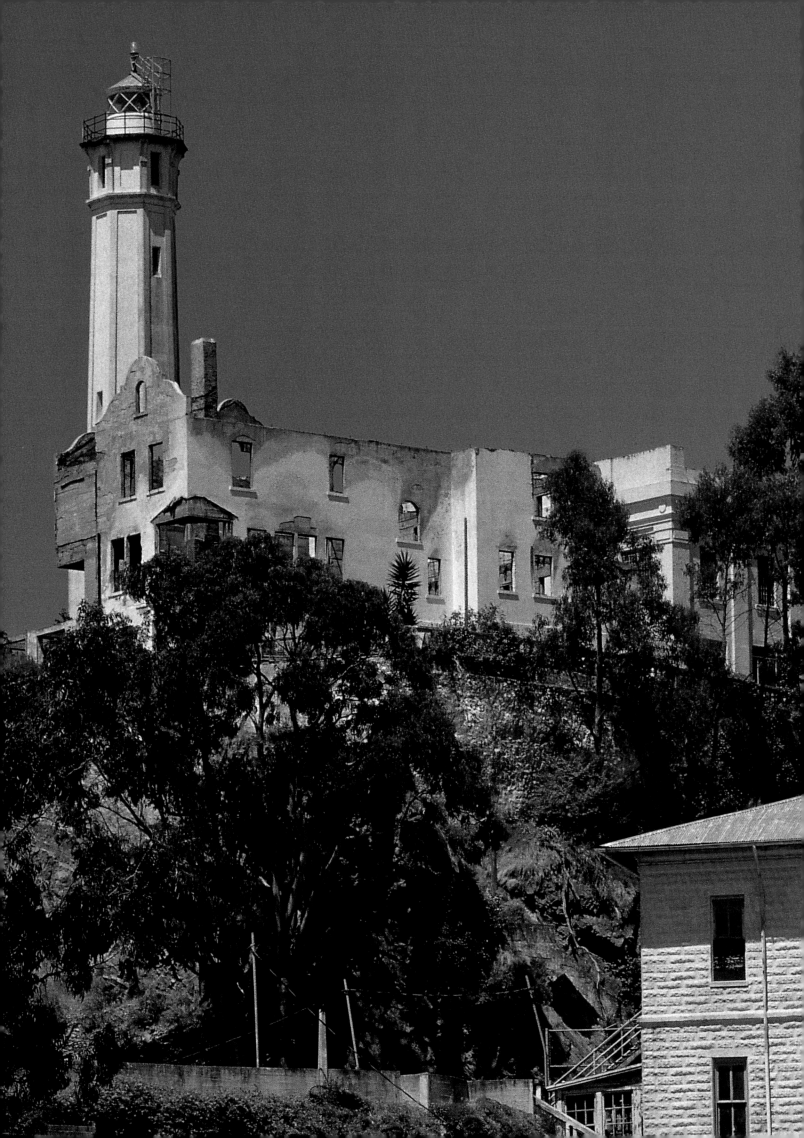

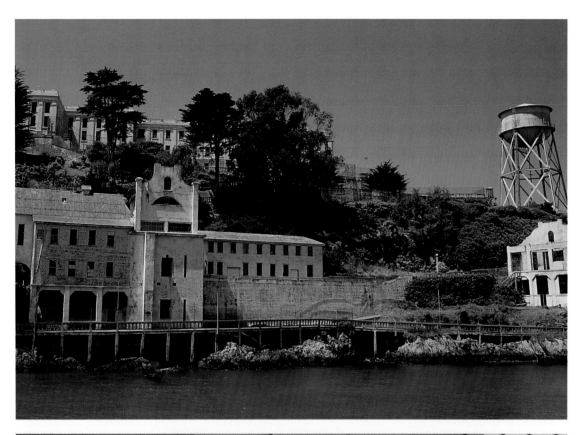

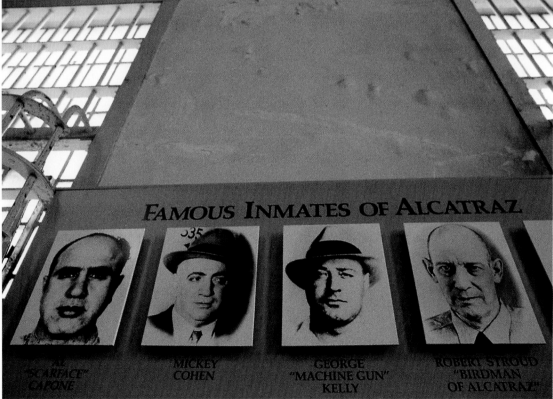

(left and above) Alcatraz, the island prison home to some of the 20th century's most notorious criminals, including 'Scarface' Al Capone, was open as a prison for less than fifty years, yet its legend and history continues to draw thousands of visitors every year.

(overleaf) Morning ferry from Lakespur.

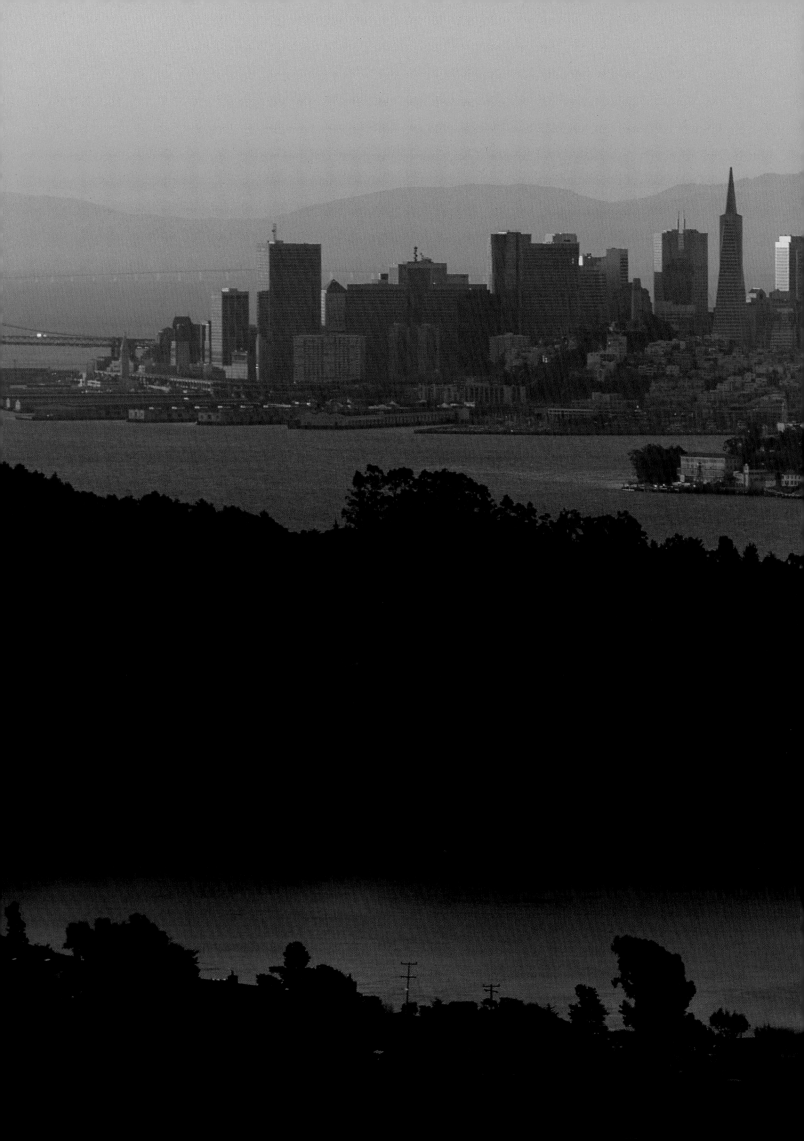

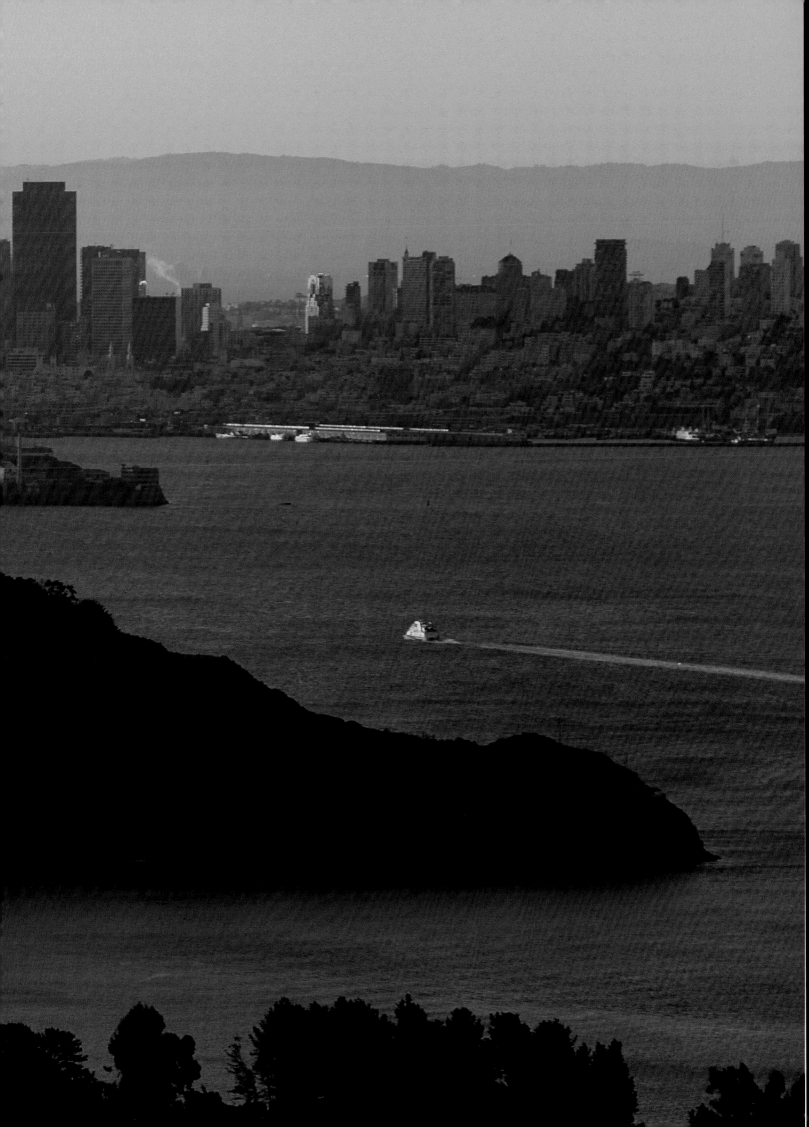

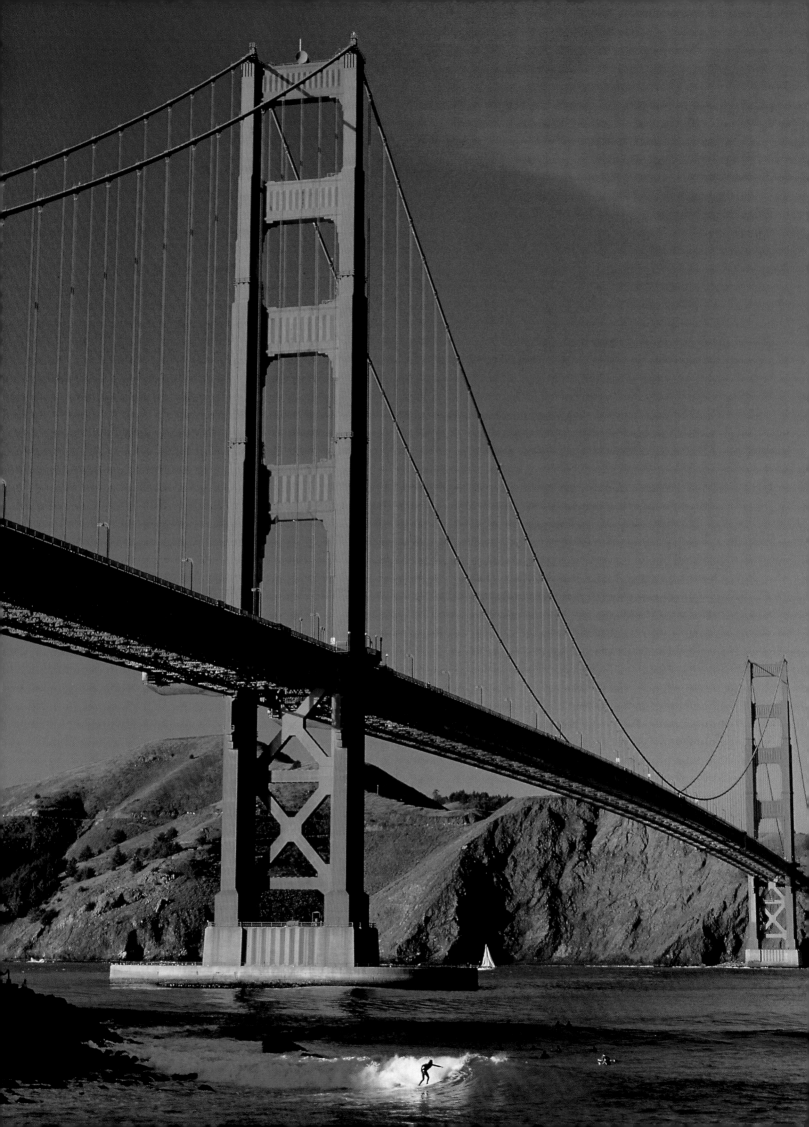

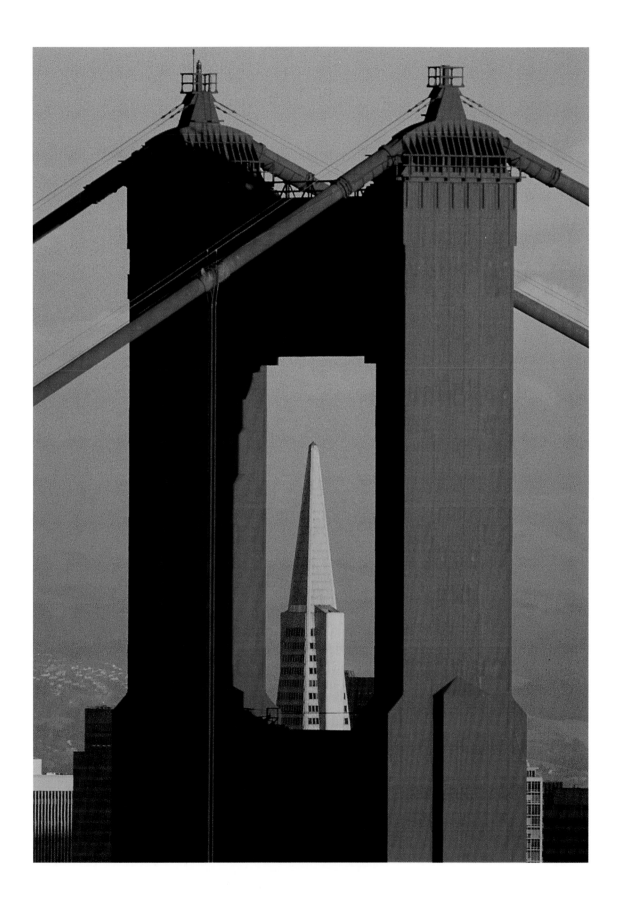

(left) Surfing under the Golden Gate Bridge.

(above) Close-up of the Golden Gate Bridge with the Transamerican Pyramid.

(overleaf) View looking down the south tower of the Golden Gate Bridge.

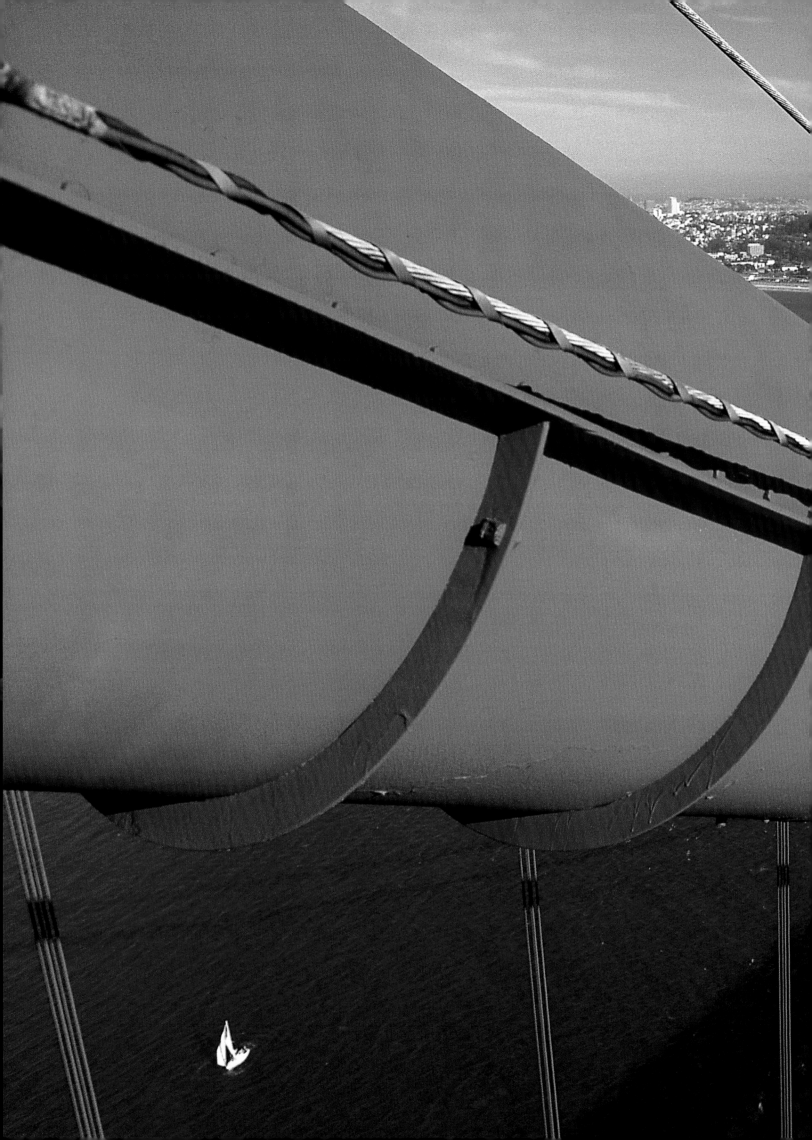

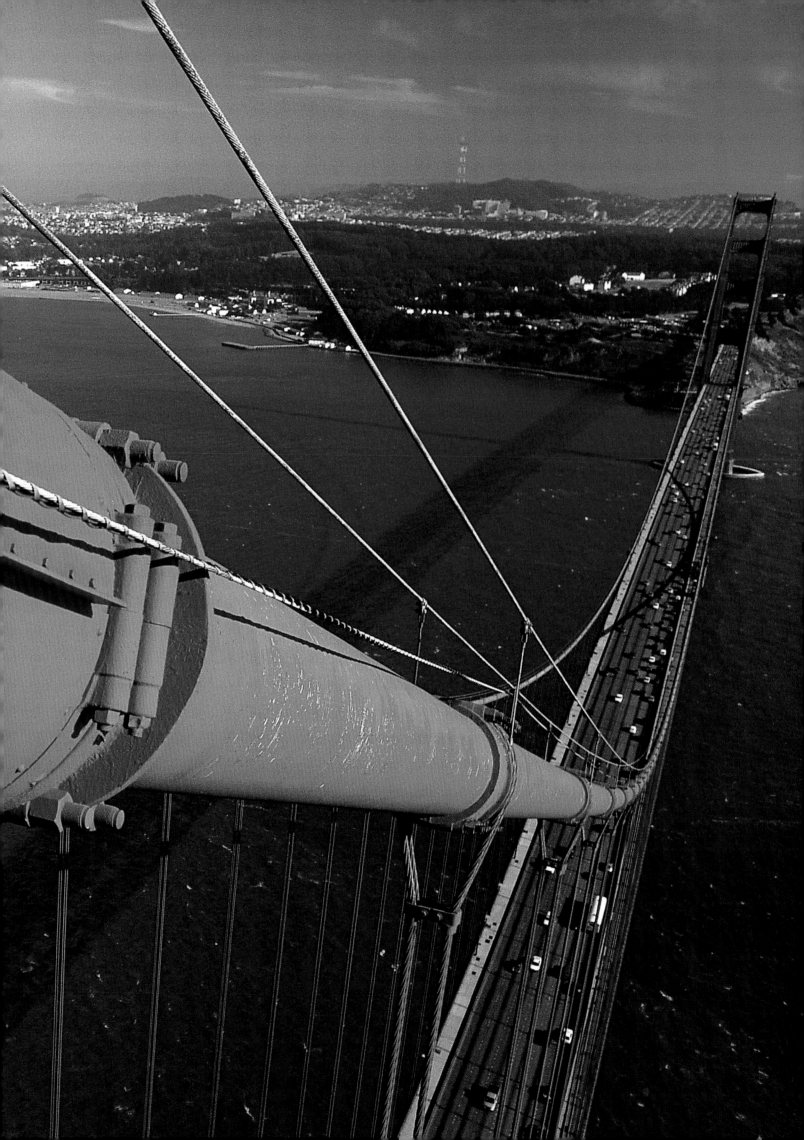

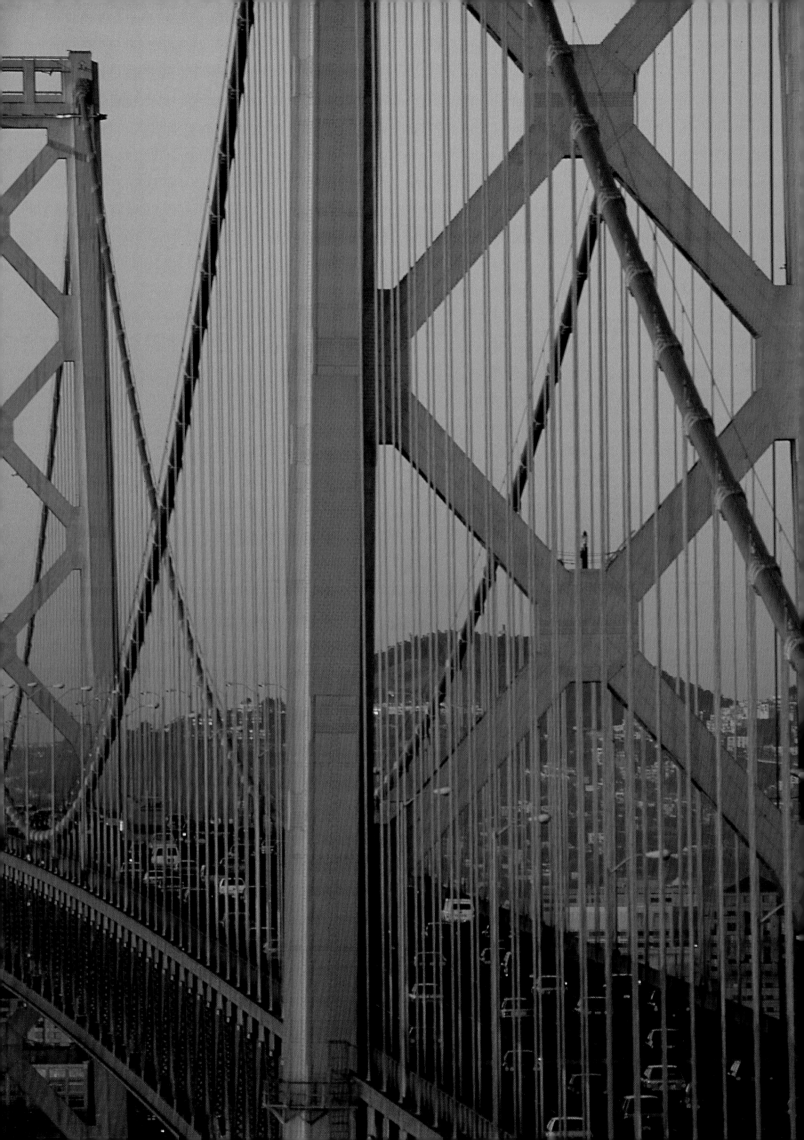

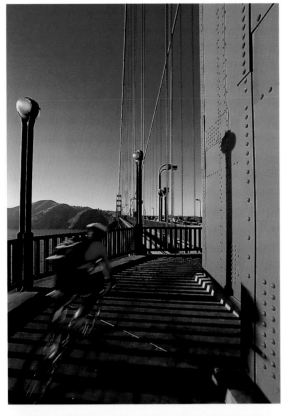

I went to San Francisco

I saw the bridges high,

Spun across the water

Like cobwebs in the sky."

—Langston Hughes

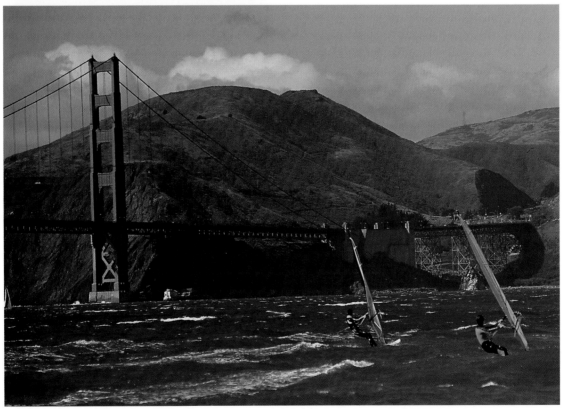

(left) Golden Gate Bridge. After six decades of planning and four years of construction, the Golden Gate Bridge has been open to traffic since 1937.

(above, top and bottom) Cycling on the Golden Gate Bridge and windsurfing by the Golden Gate Bridge.

(overleaf) Golden Gate Bridge at night.

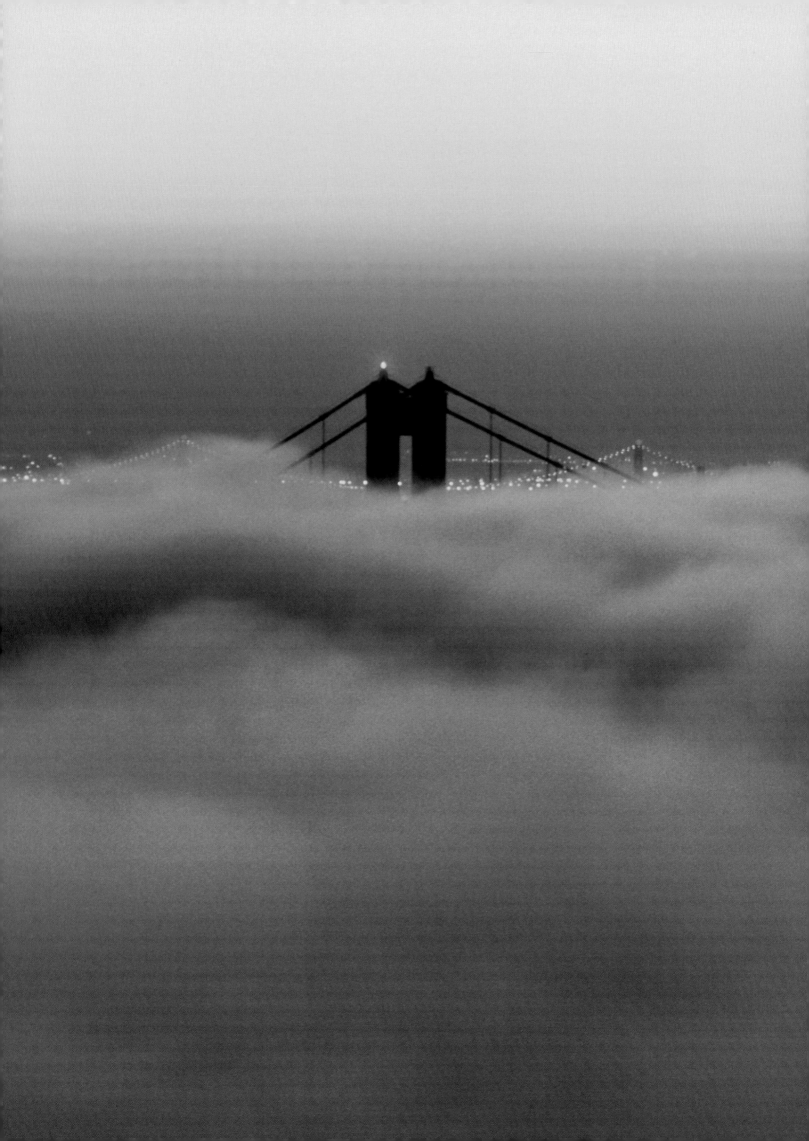

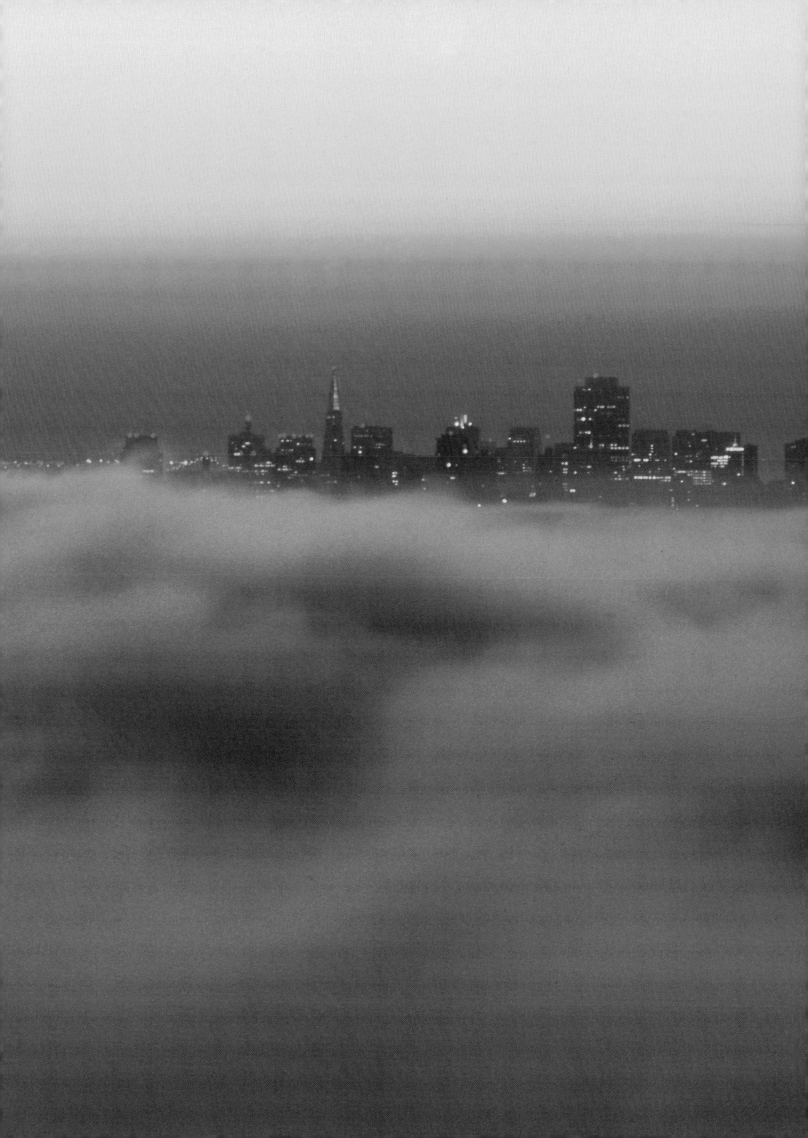

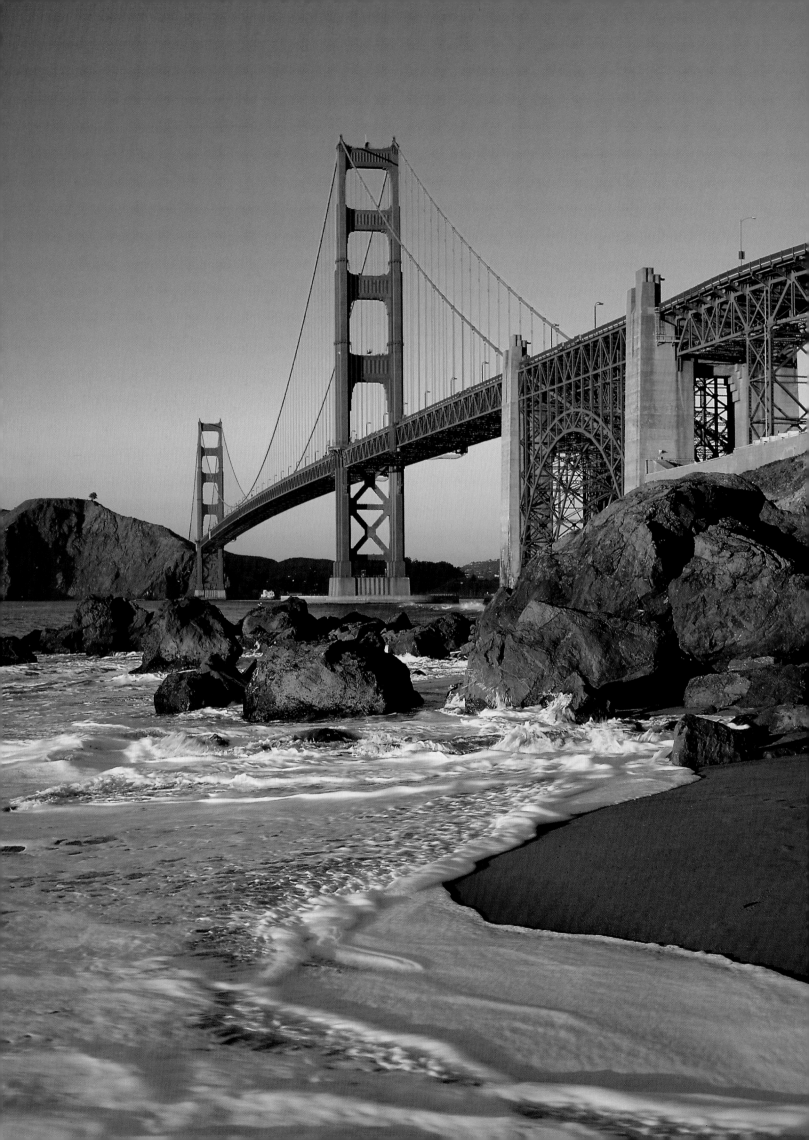

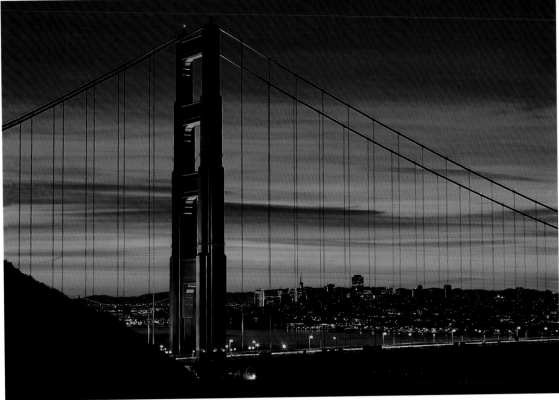

(left) Golden Gate Bridge as seen from Baker Beach.

(above, top and bottom) View of Sausalito and the Golden Gate Bridge.

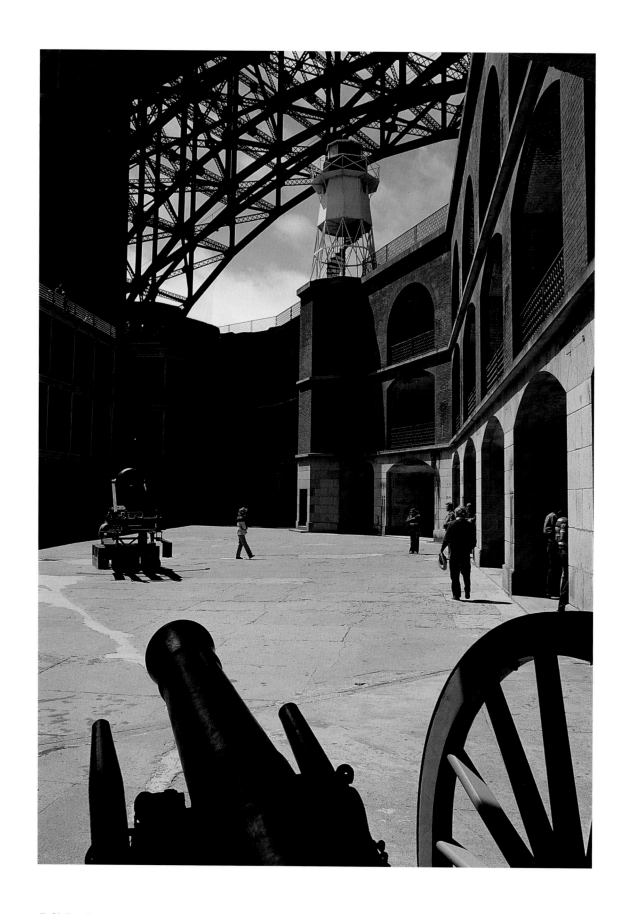

(left) Fort Point with cannon.

(right) Fort Point with Golden Gate Bridge.

(overleaf) Palace of Fine Arts.

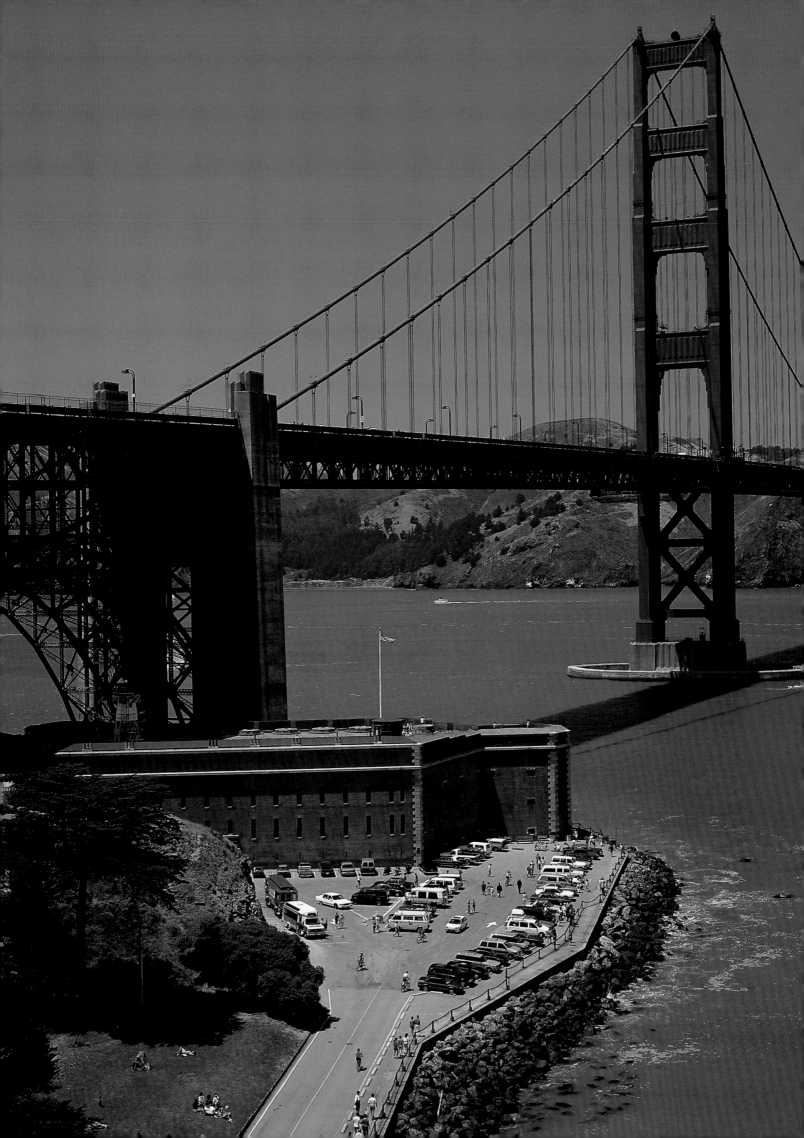

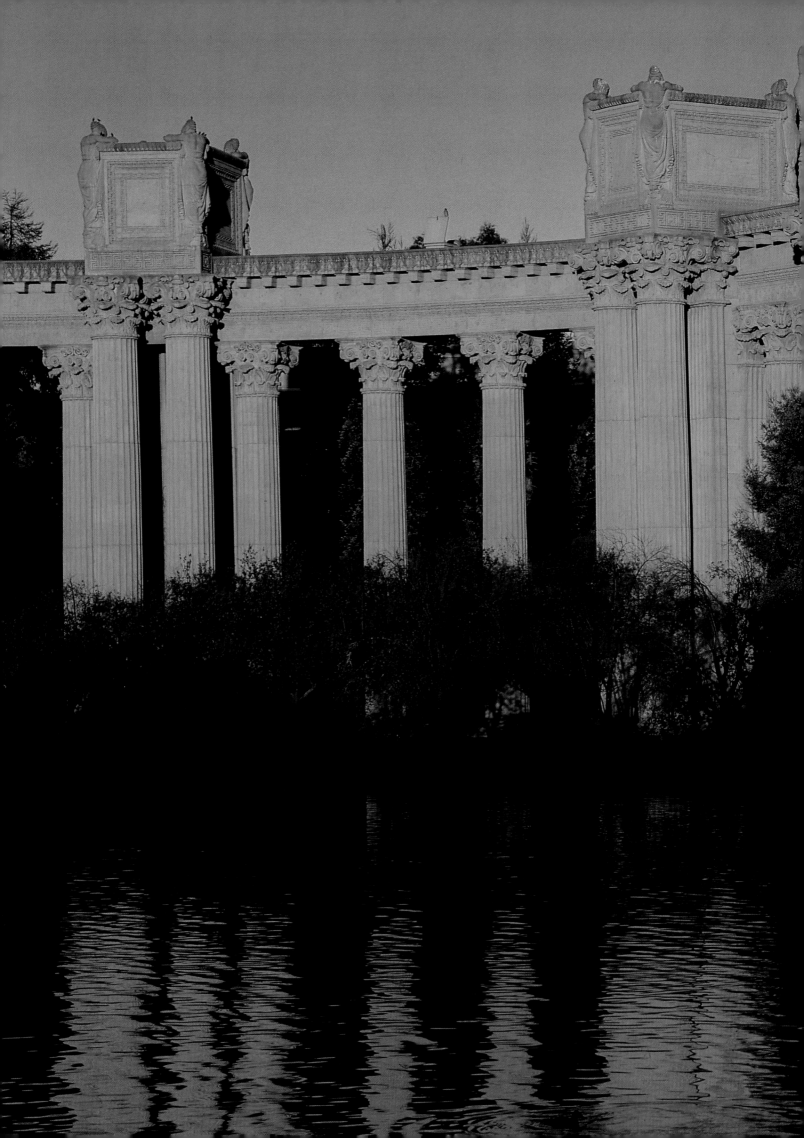

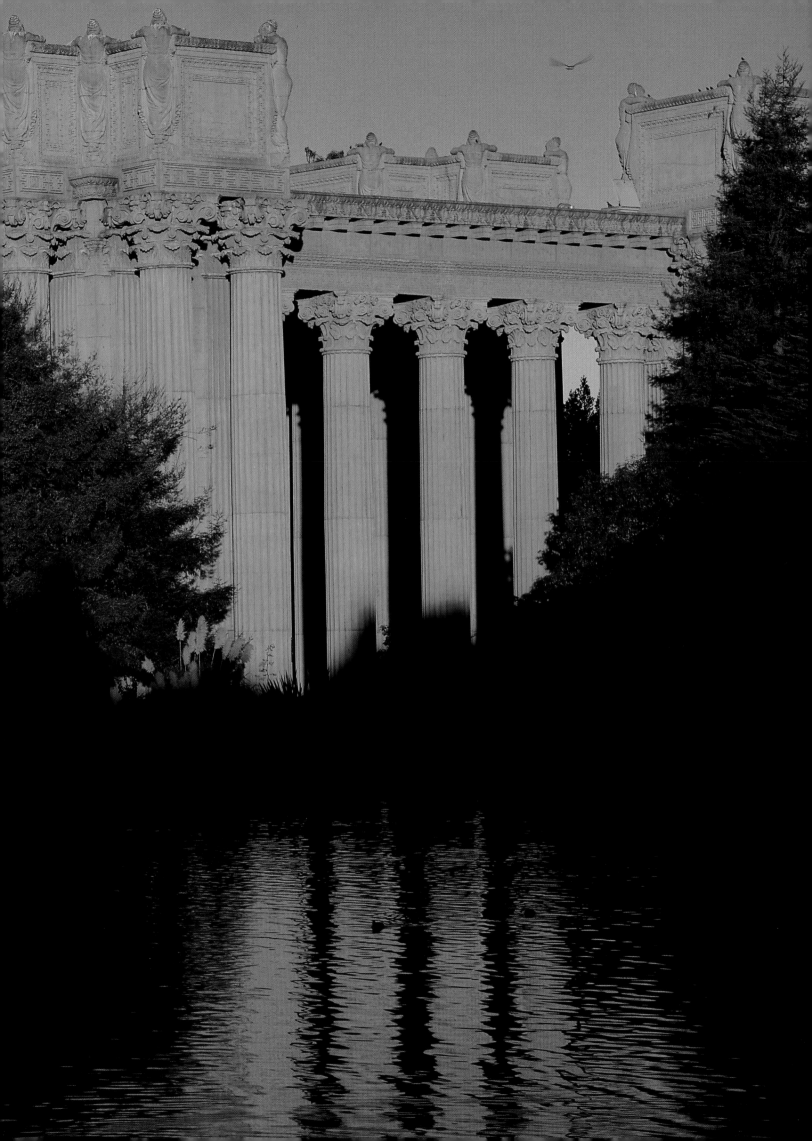

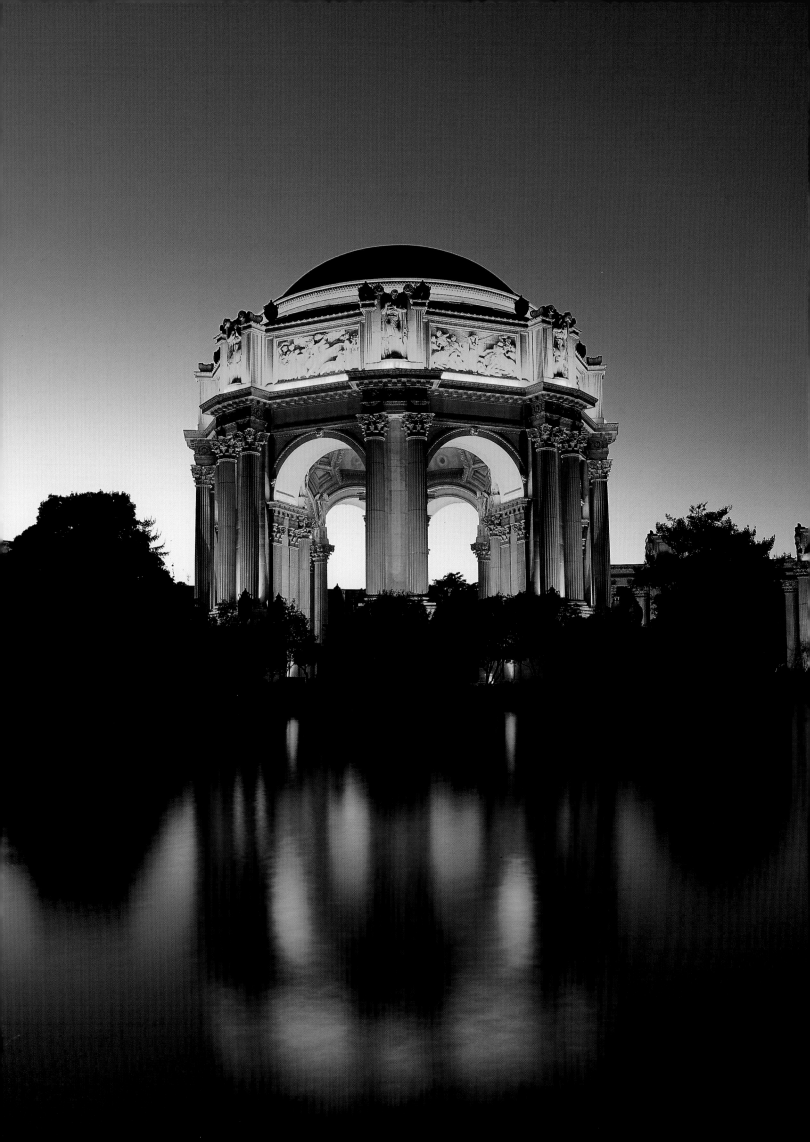

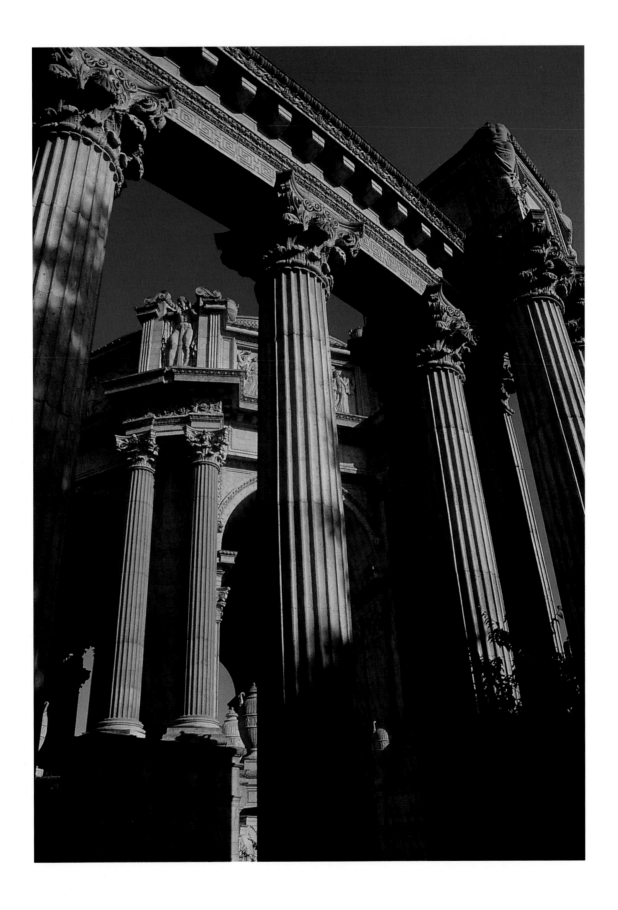

(left) Palace of Fine Arts at twilight.

(above) Palace of Fine Arts.

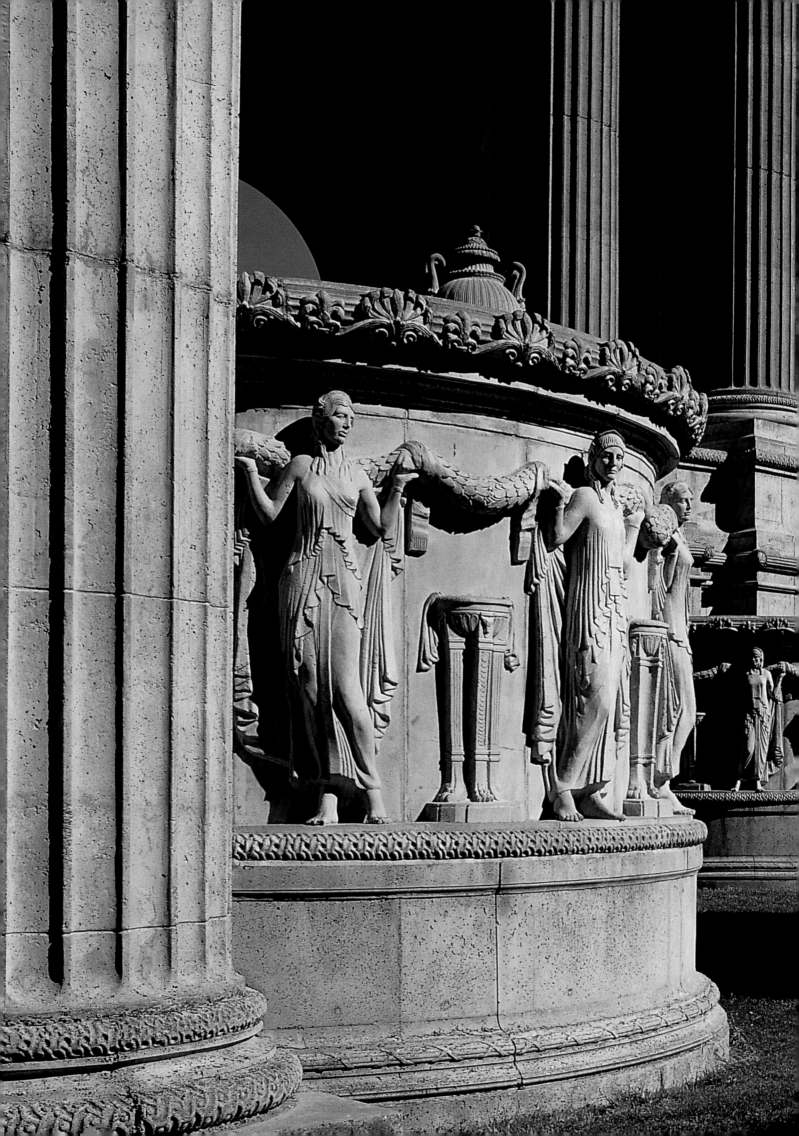

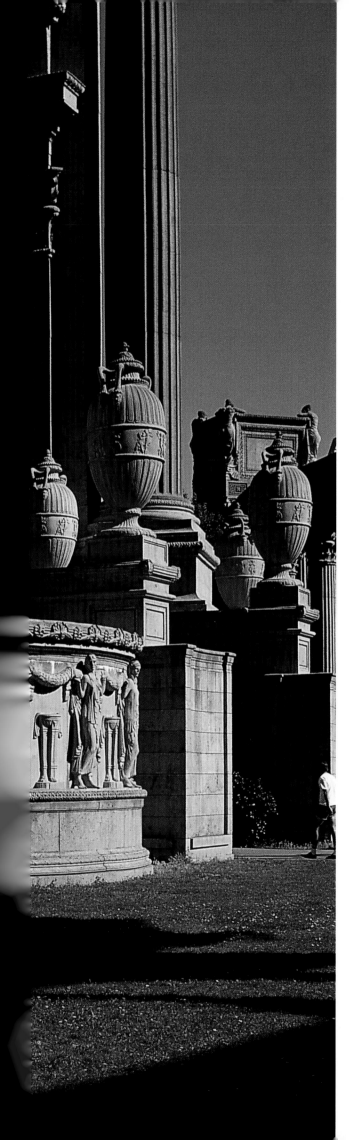

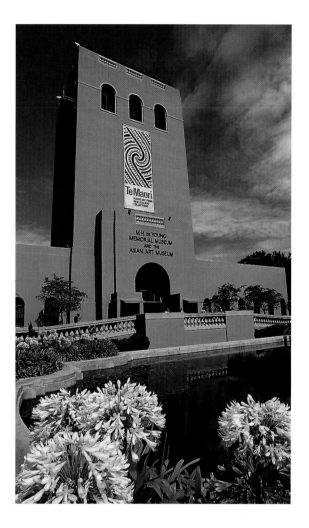

S uch a beautiful city,

people have to make excuses

for not living here."

—Garrison Keillor

(left) Palace of Fine Arts.

(right) MH de Young Memorial Museum.

(overleaf) Moonset over downtown from Treasure Island.

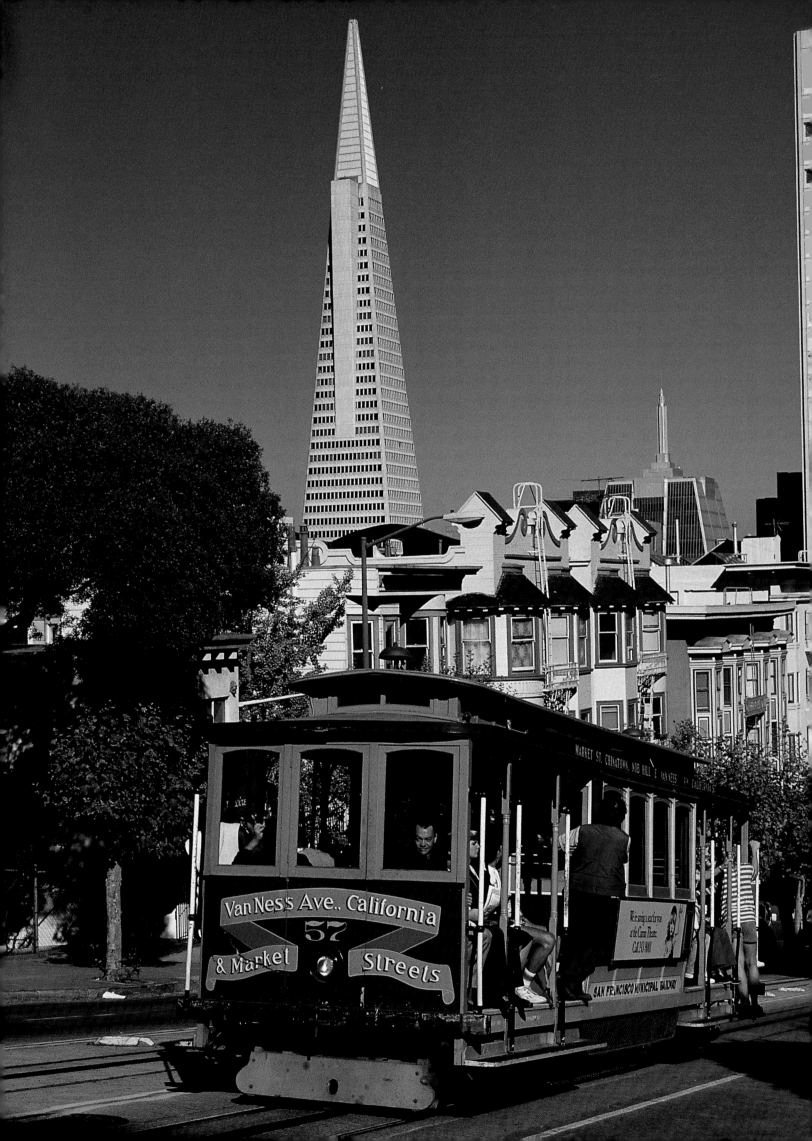

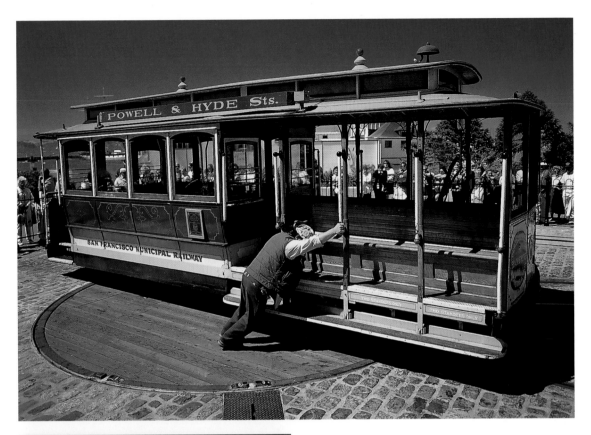

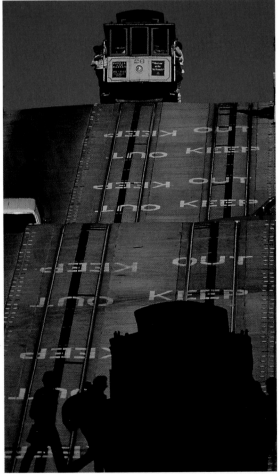

I t's an odd thing,

but anyone who disappears

is said to be seen in San Francisco."

—Oscar Wilde

(left) Trolley and Transamerican Pyramid.

(above, top and bottom) Trolley on Powell Street, ascending Nob Hill, and Cable Car at Aquatic Park.

(overleaf) Cable car on Russian Hill.

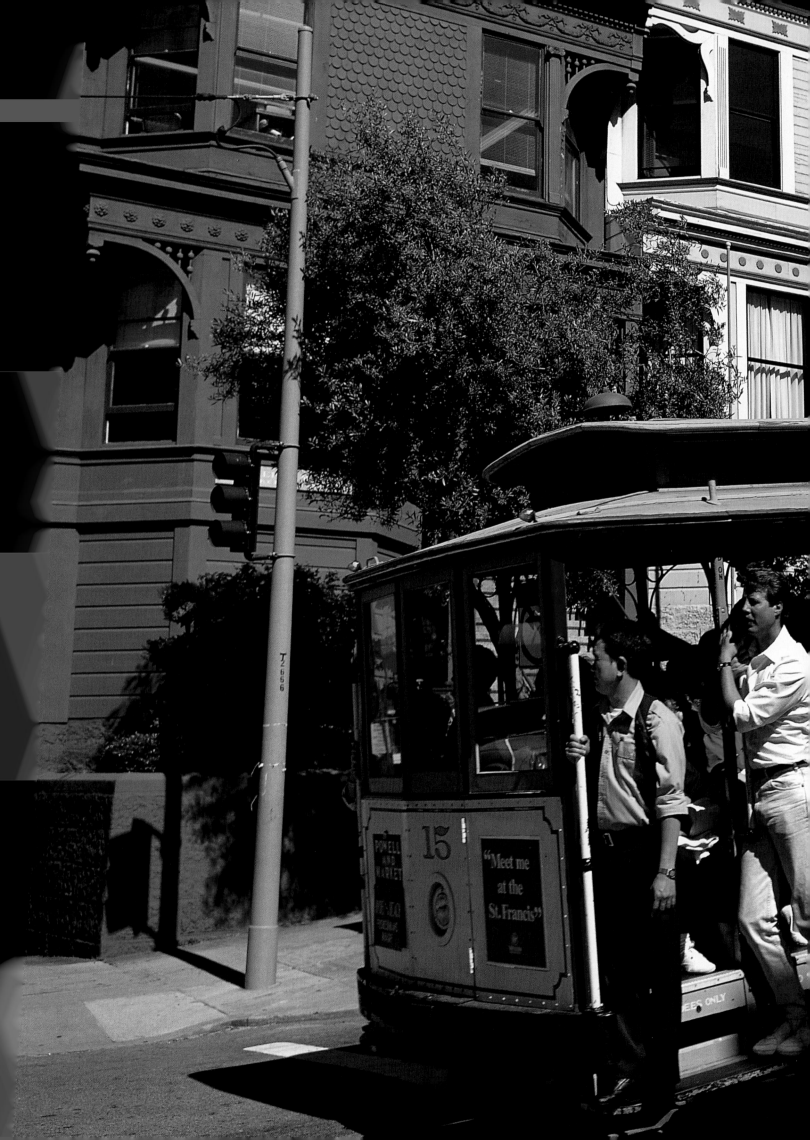

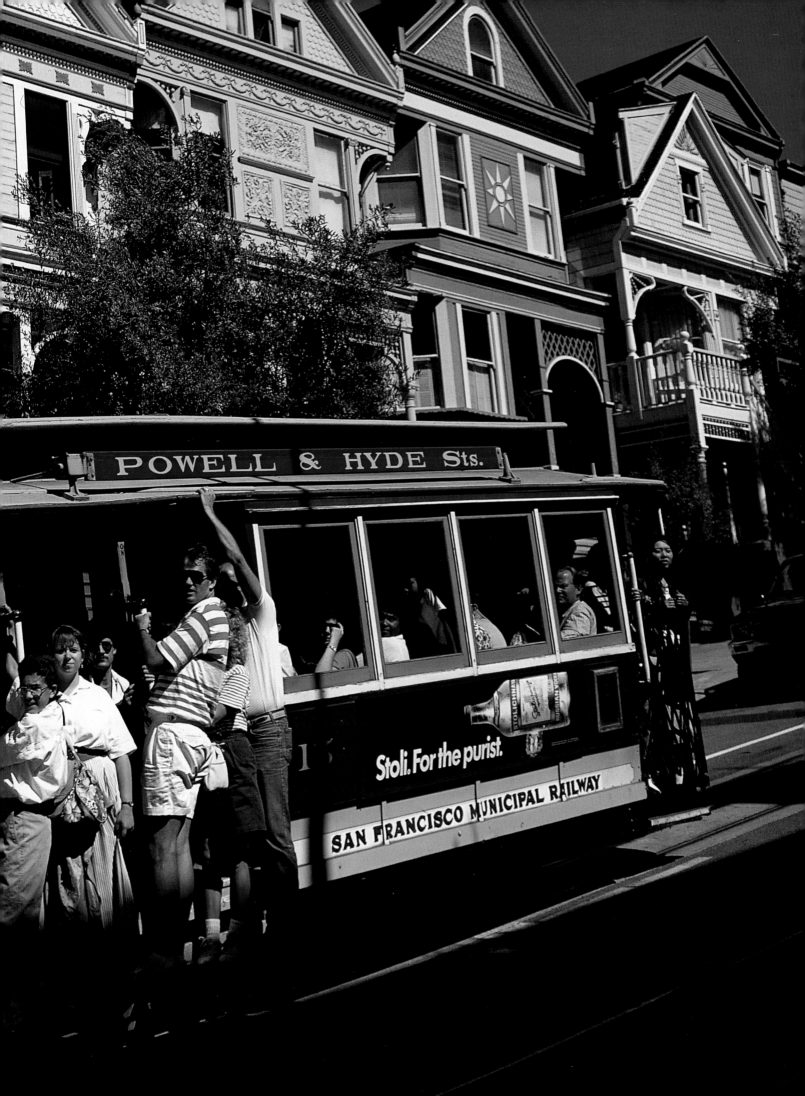

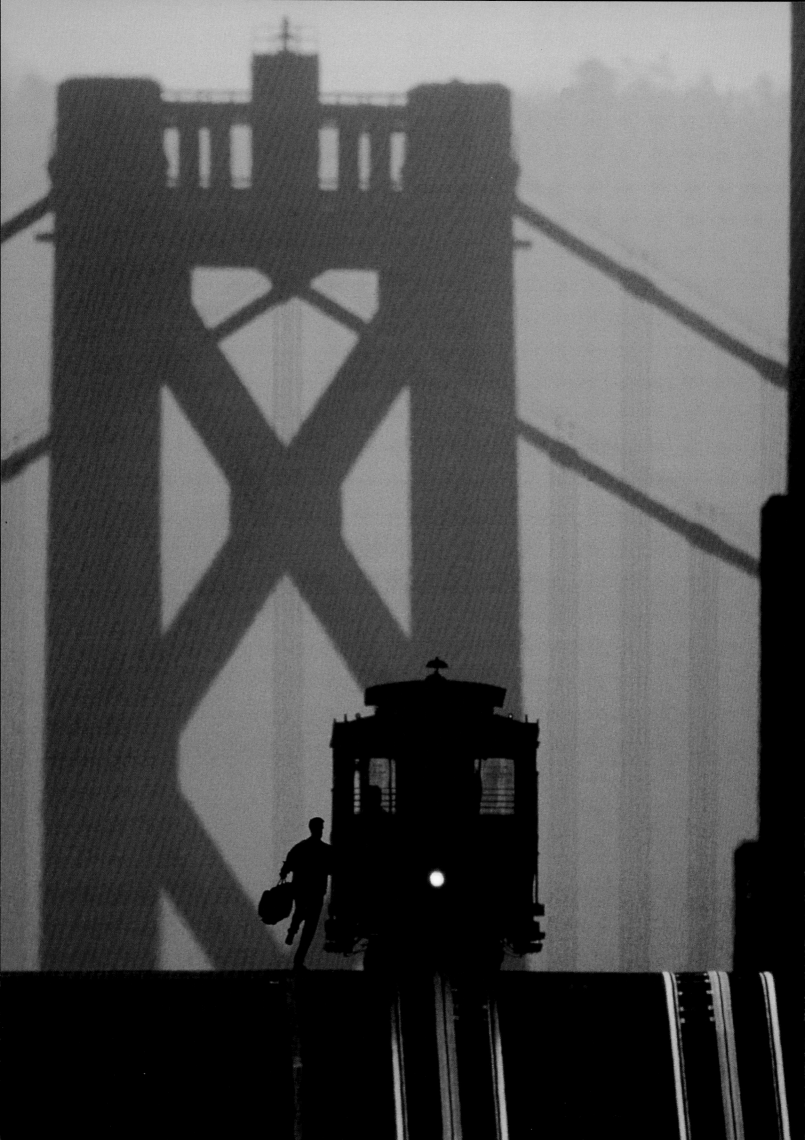

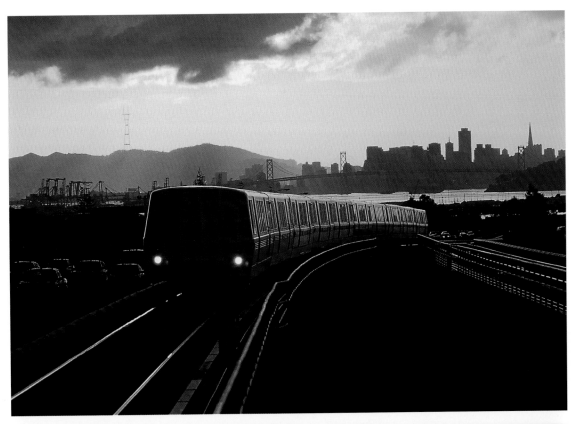

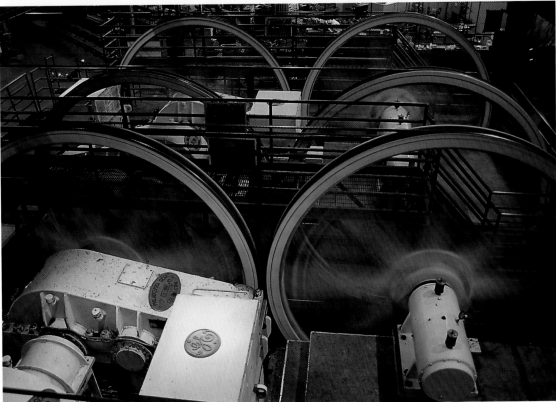

(left) Cable car and Bay Bridge.

(above, top and bottom) Rockridge BART Station in Oakland and wheels of cable cars at the San Francisco Cable Car Barn and Museum.

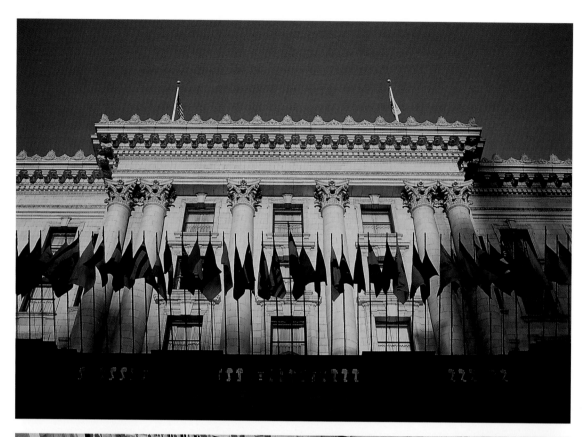

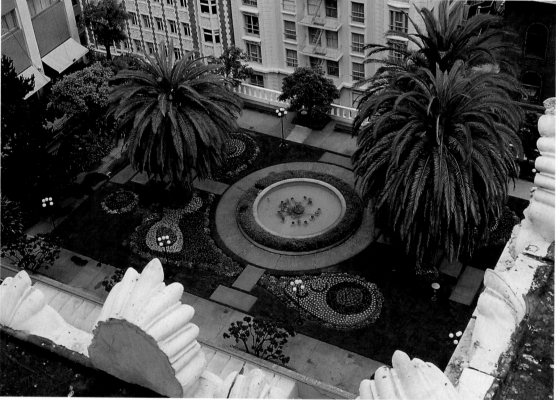

(above, top and bottom) Fairmont Hotel on Nob Hill and a view from the penthouse of the hotel.

(right) High tea at the Fairmont Hotel.

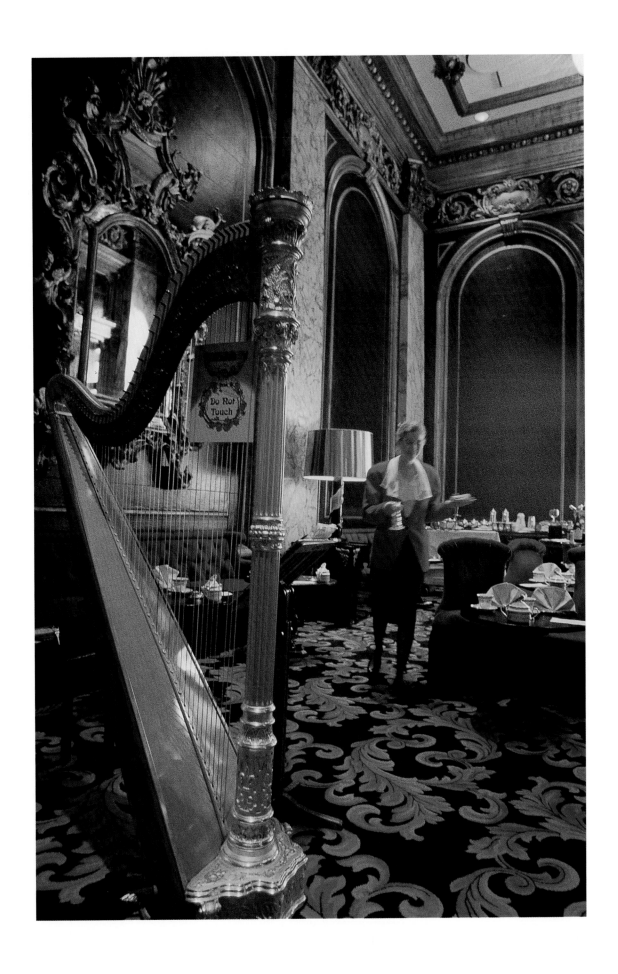

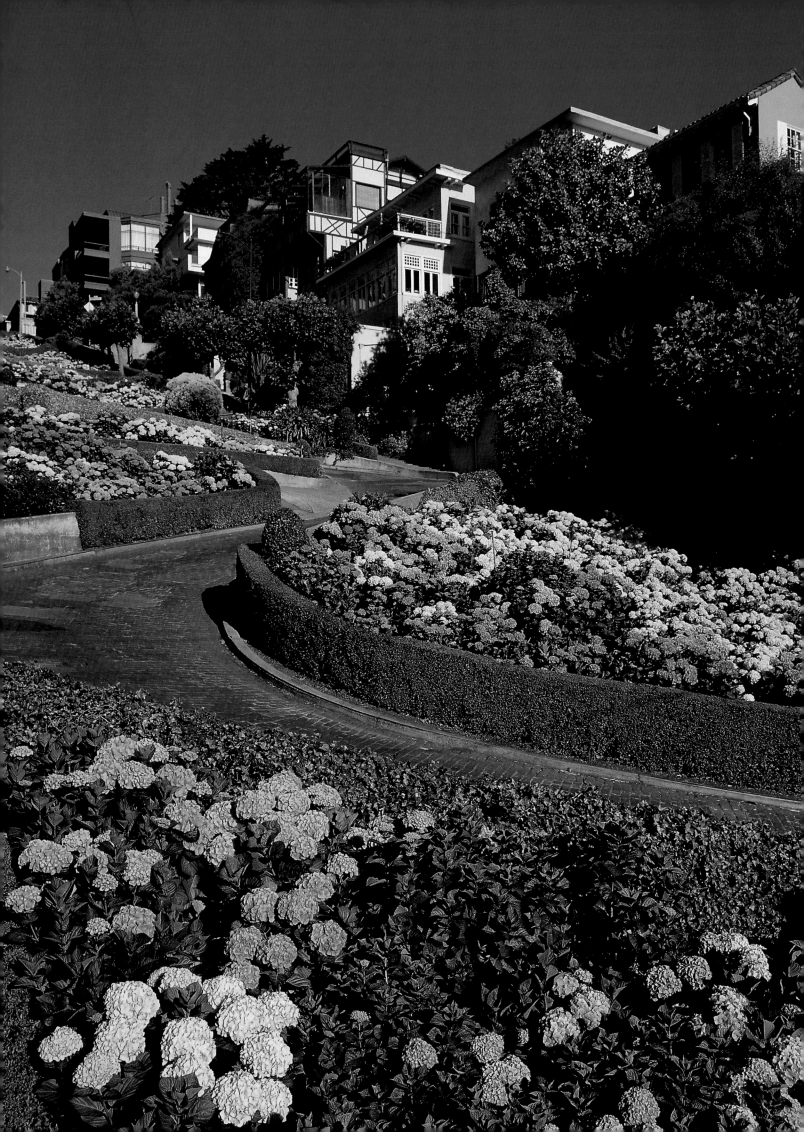

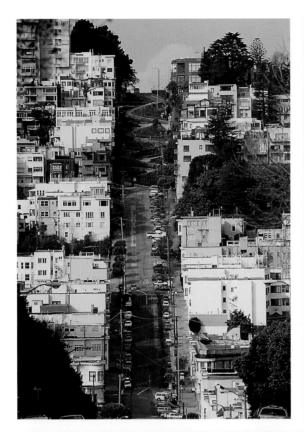

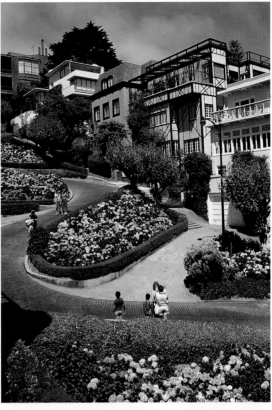

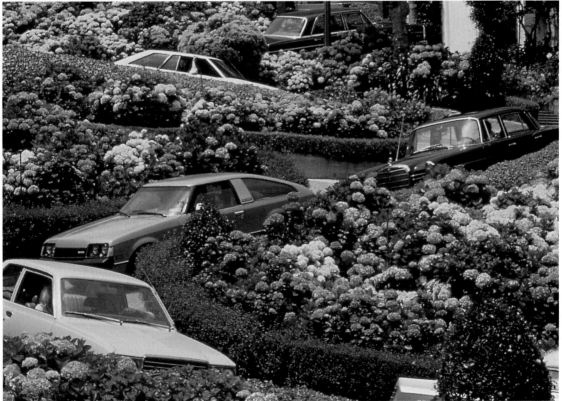

(left) Lombard Street.

(above) Views of Lombard Street.

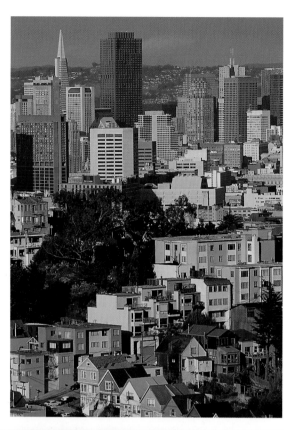

W hen you get tired of walking

around San Francisco,

you can always lean against it."

—Transworld Getaway Guides,
1975-76.

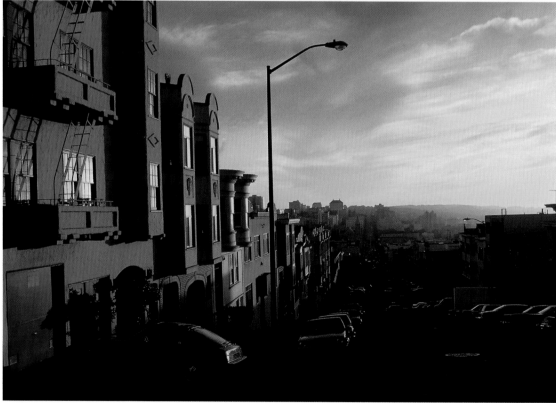

(top) View of downtown from Diamond Heights.

(left and right) Russian Hill.

(overleaf) The City Lights Bookstore. Founded by poet Lawrence Ferlinghetti in 1953, the bookstore continues to embody the spirit of the San Francisco beat poetry, and has hosted some of the most famous literary personalities of our time, including Allen Ginsberg and Jack Kerouac.

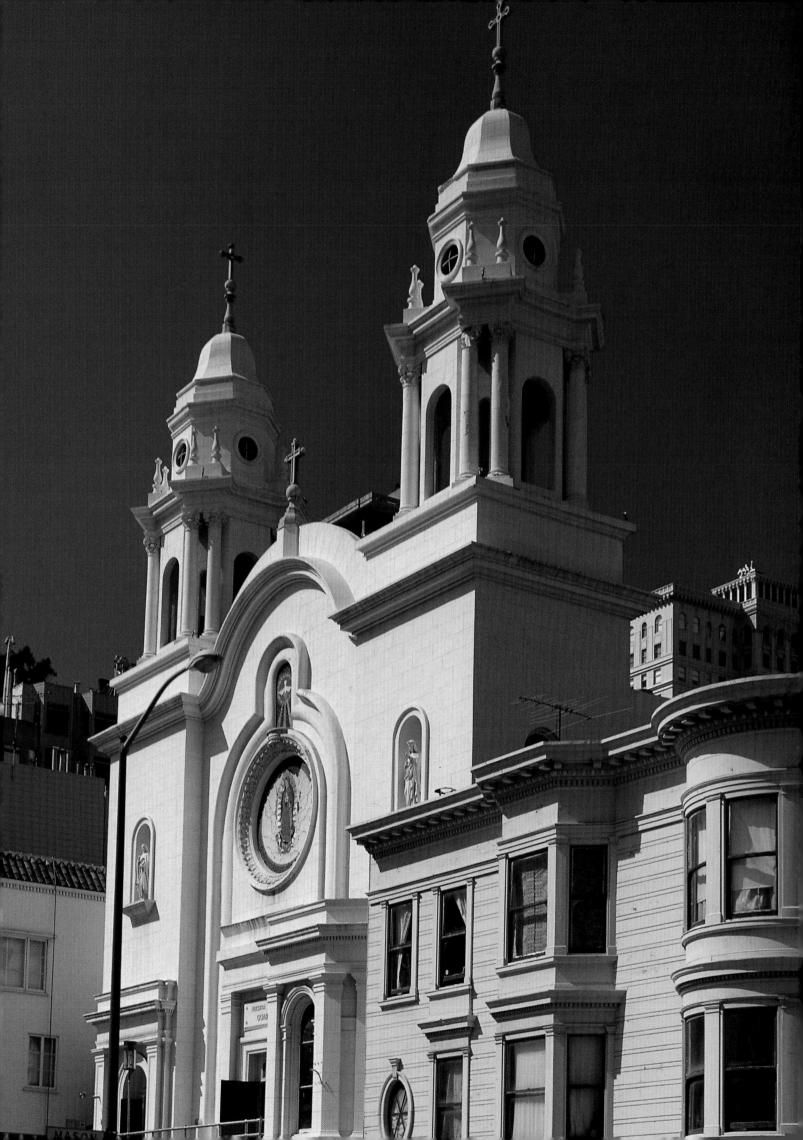

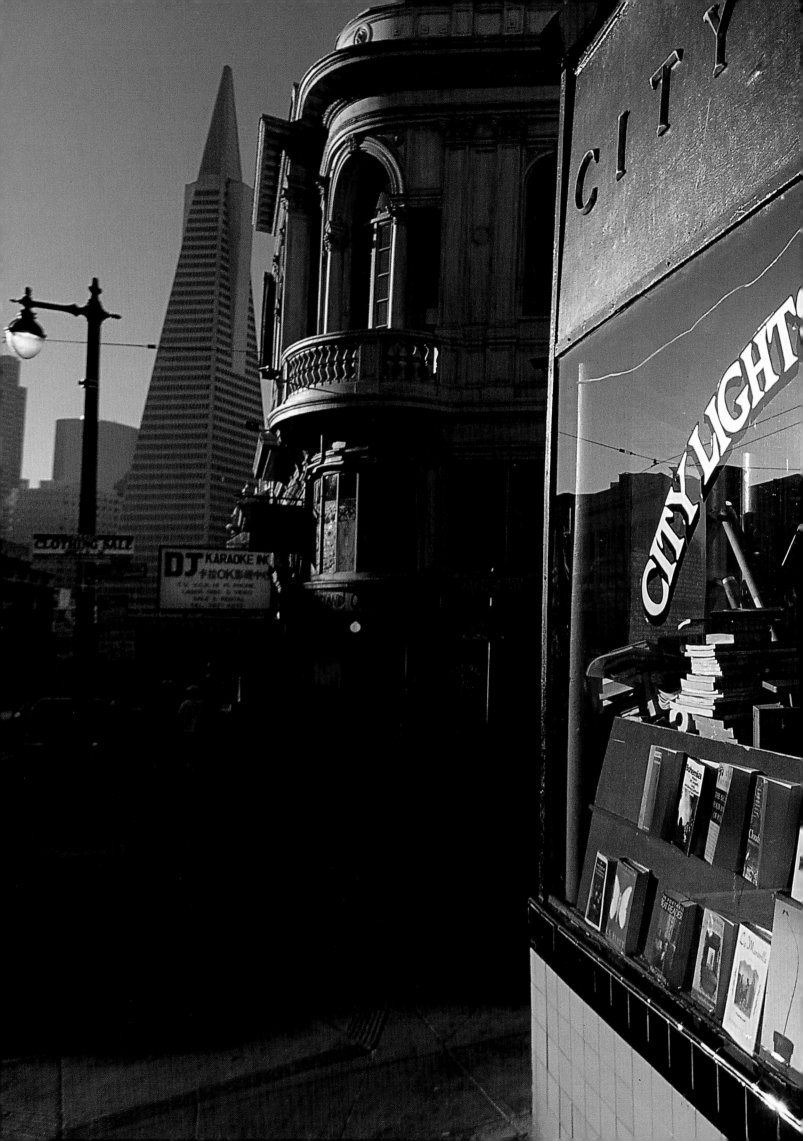

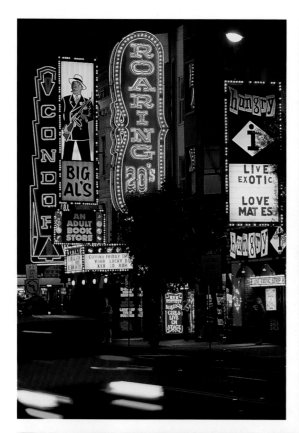

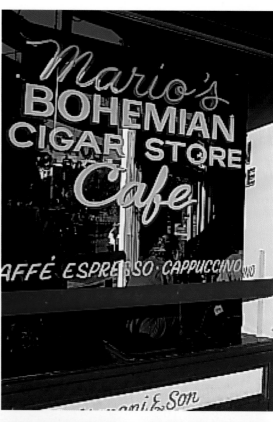

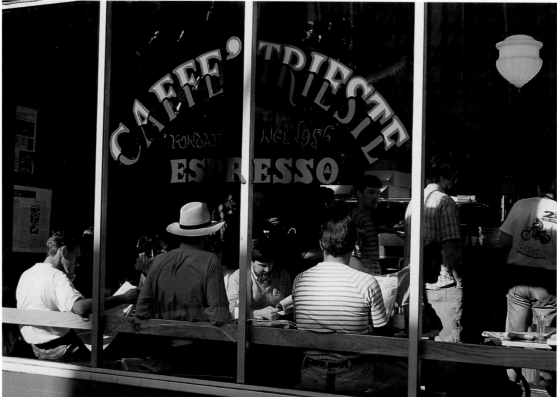

(above, clockwise from top left) Broadway, Mario's Bohemian Cigar Store Cafe and Cafe Trieste—all in North Beach.

(right) Grace Cathedral.

(overleafs) Bay windows on Telegraph Hill.

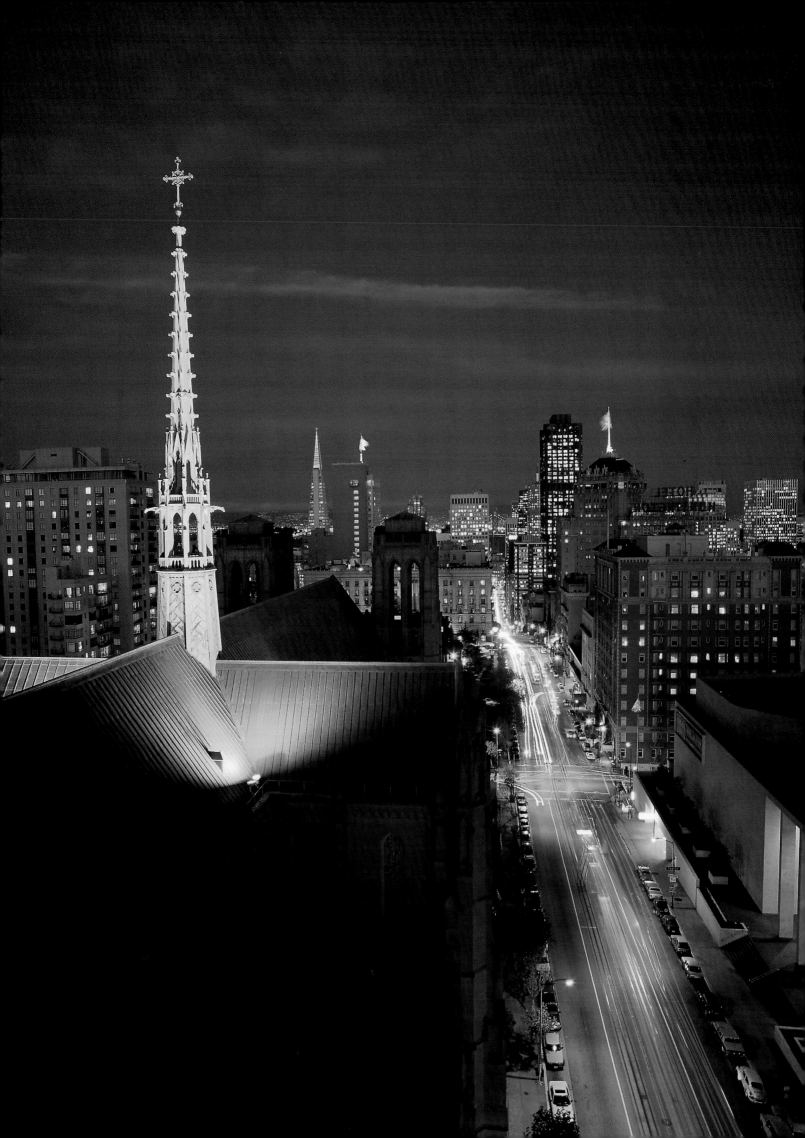

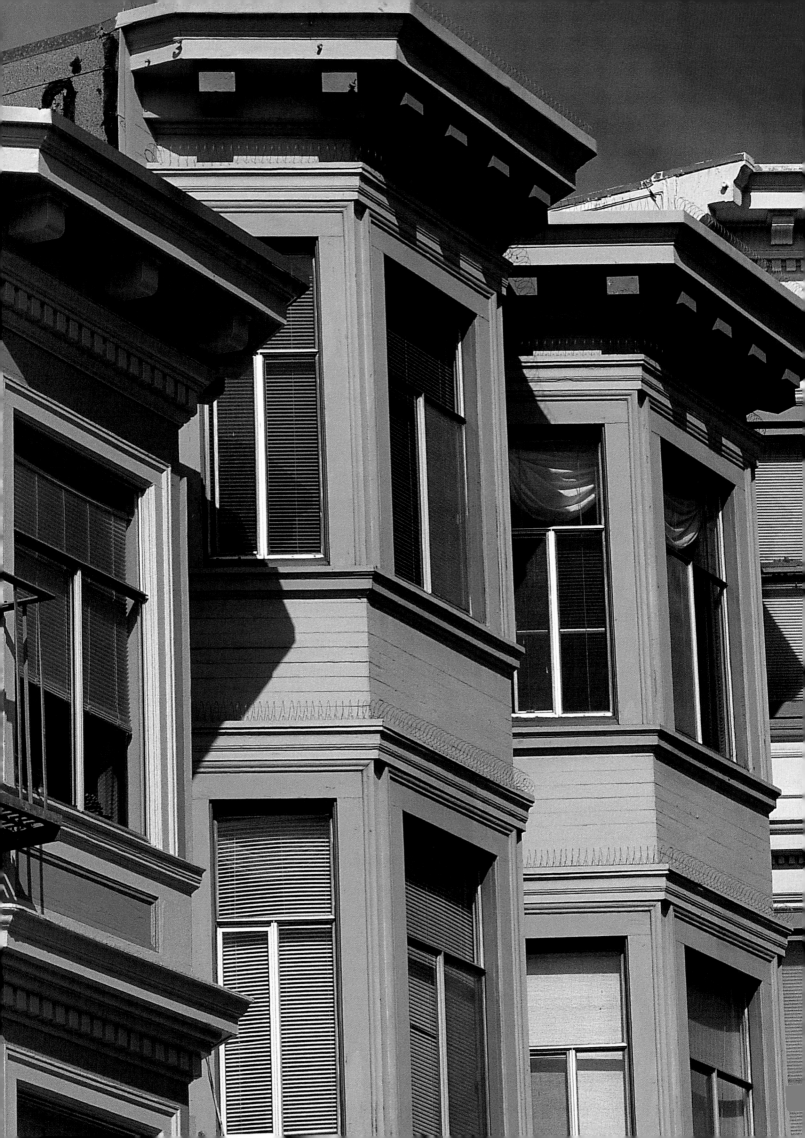

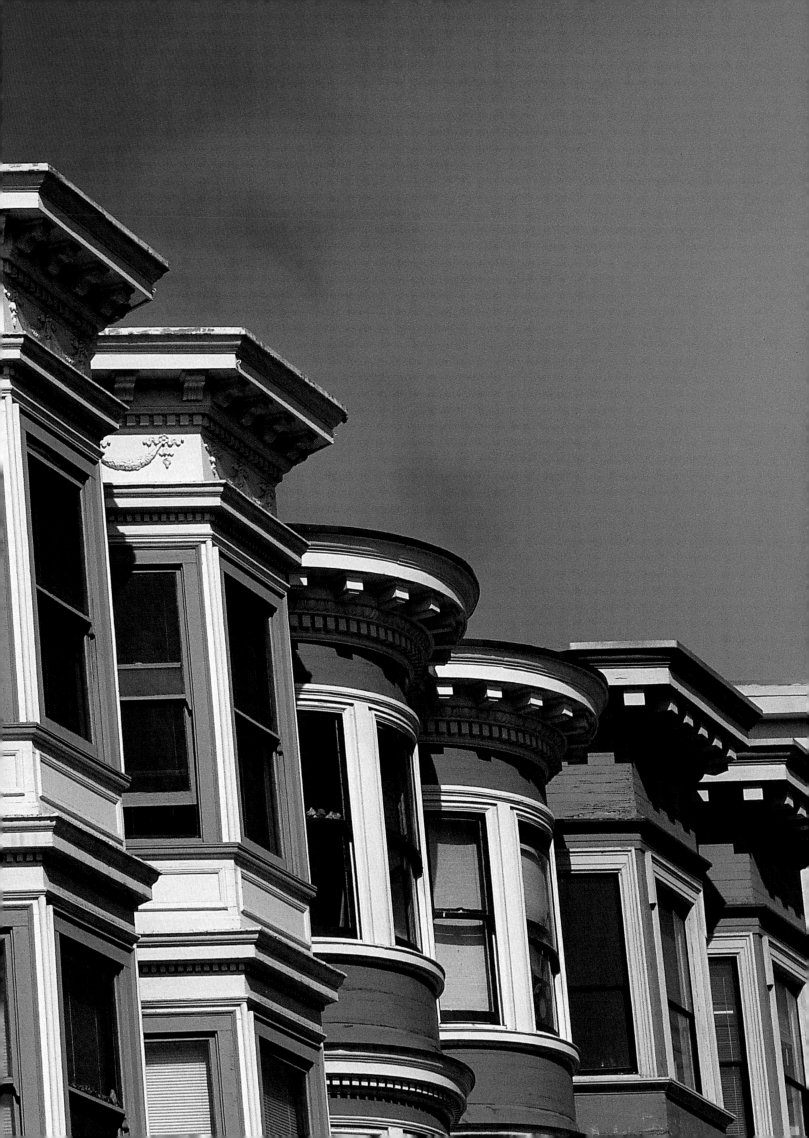

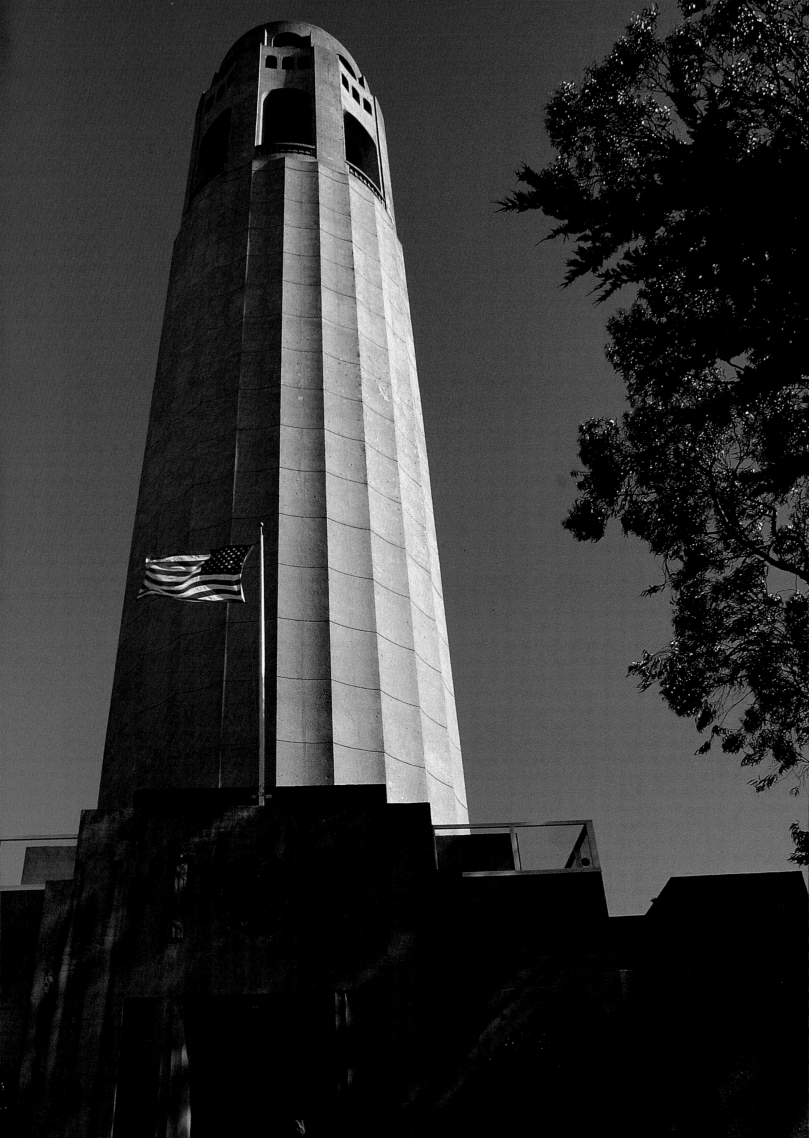

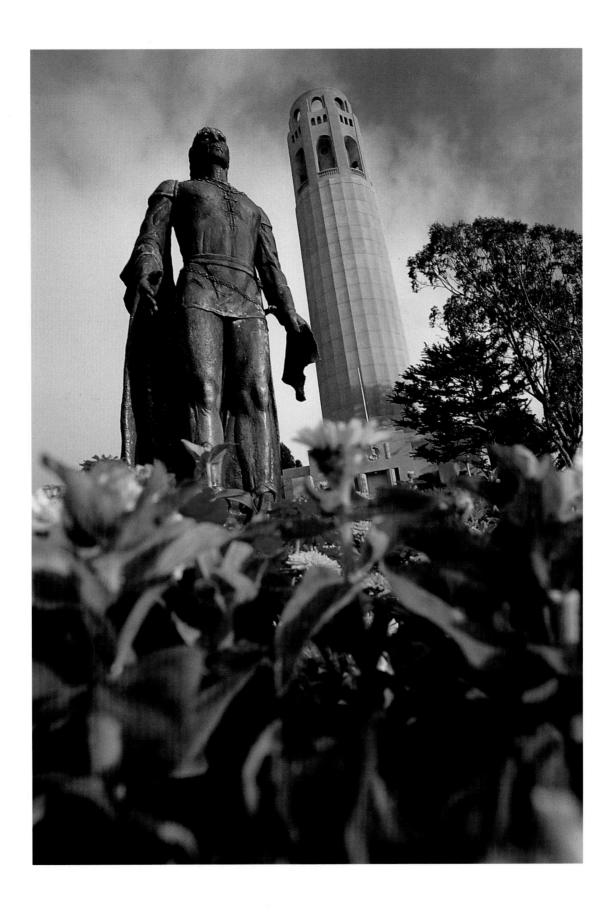

(left) Coit Tower. Erected in memory of the firefighters who have given their lives in the course of duty, Coit Tower dominates the northern tip of the San Franciscan skyline on top of Telegraph Hill.

(right) Telegraph Hill and Coit Tower.

(overleaf) Coit Tower and the Transamerican Pyramid.

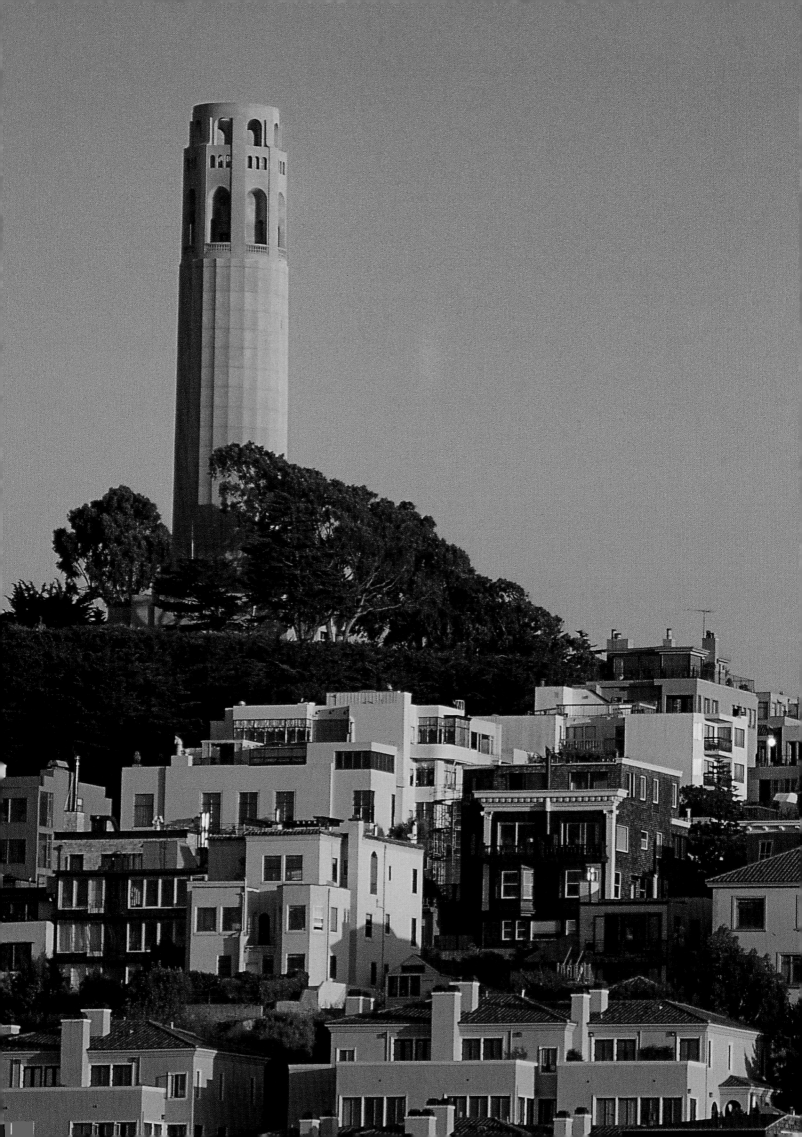

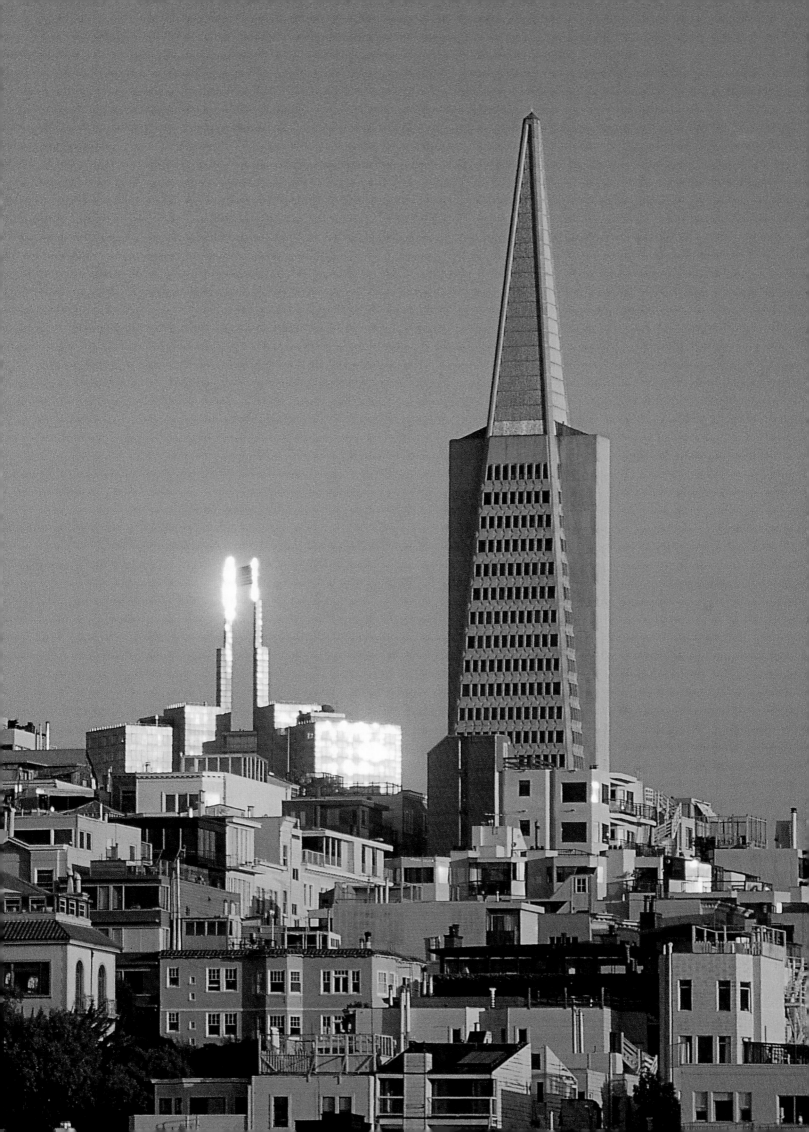

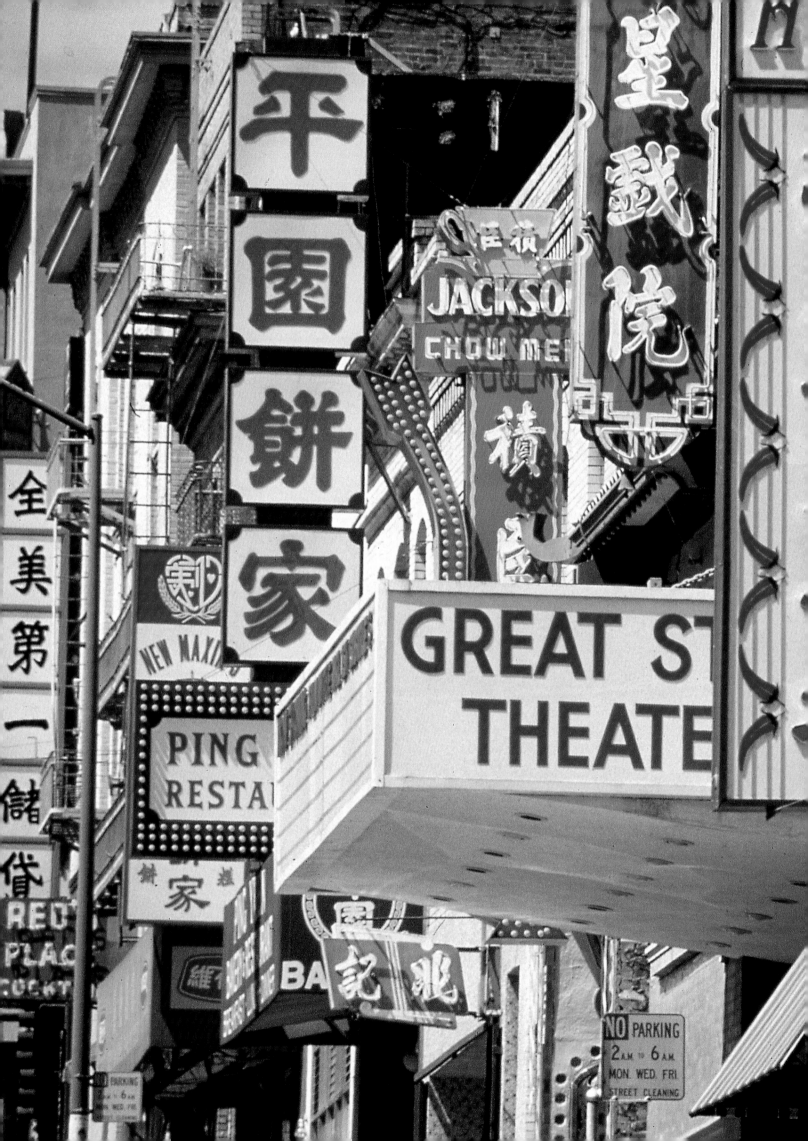

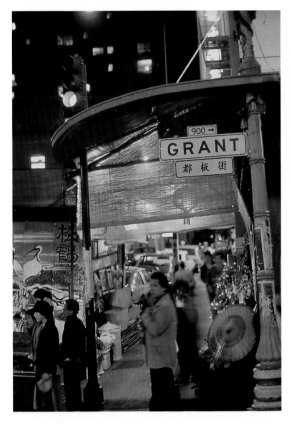

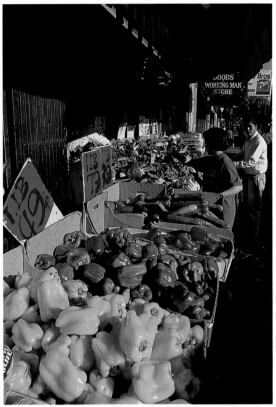

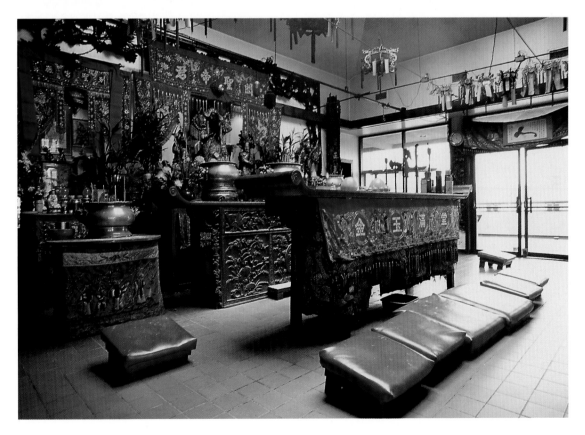

(left) Chinatown. Each February, Chinese New Year is celebrated on the streets of Chinatown with parades and festivities.

(above, clockwise from top left) Grant Avenue, street vendors with vegetables, and the interior of Kong Chow Temple.

(overleaf) Chinese Dragon.

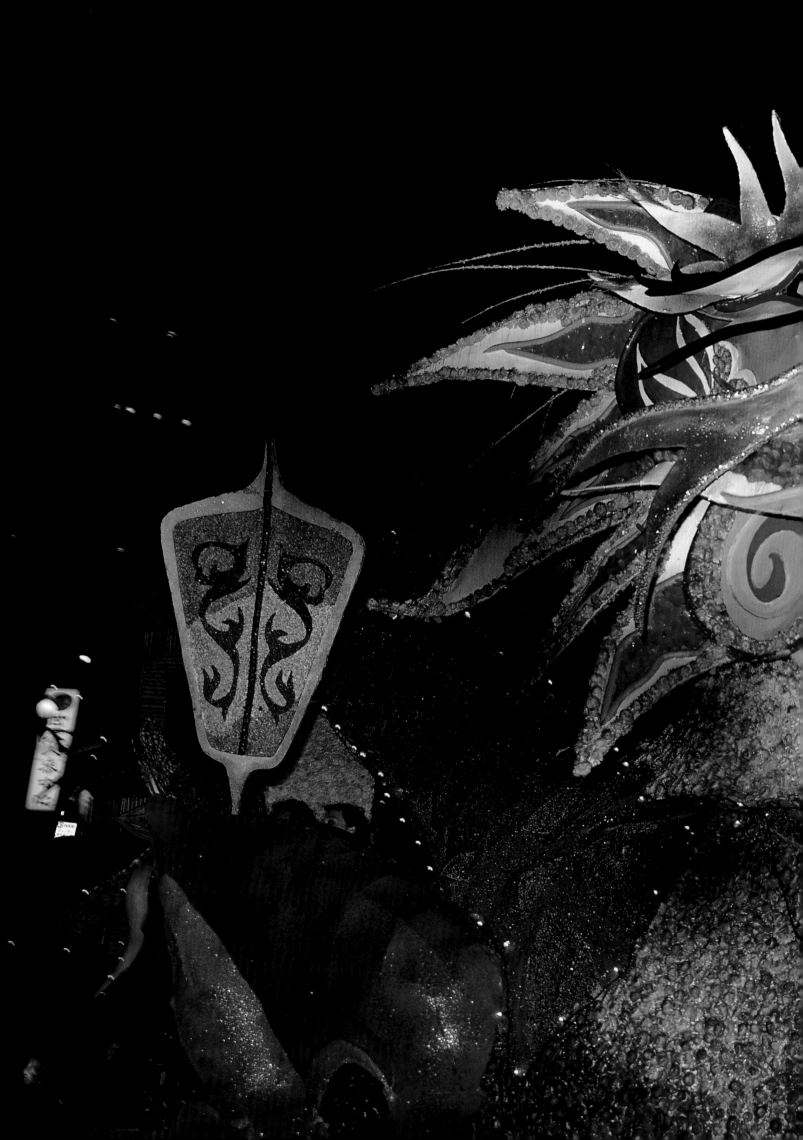

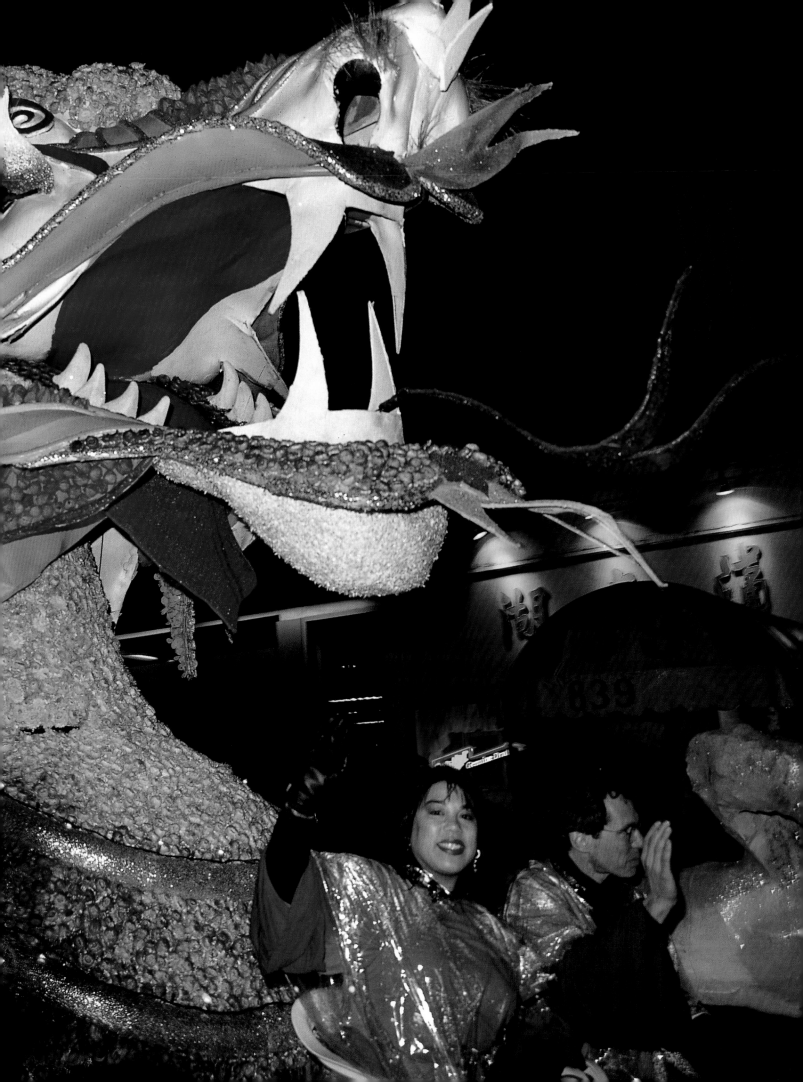

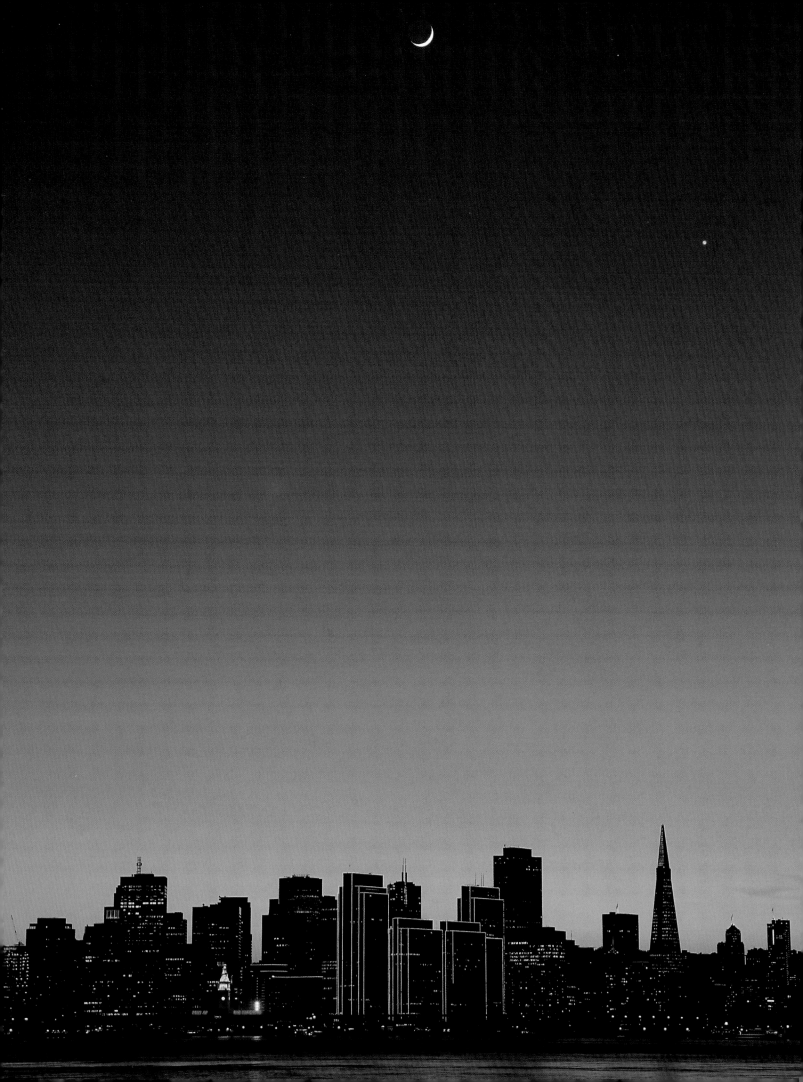

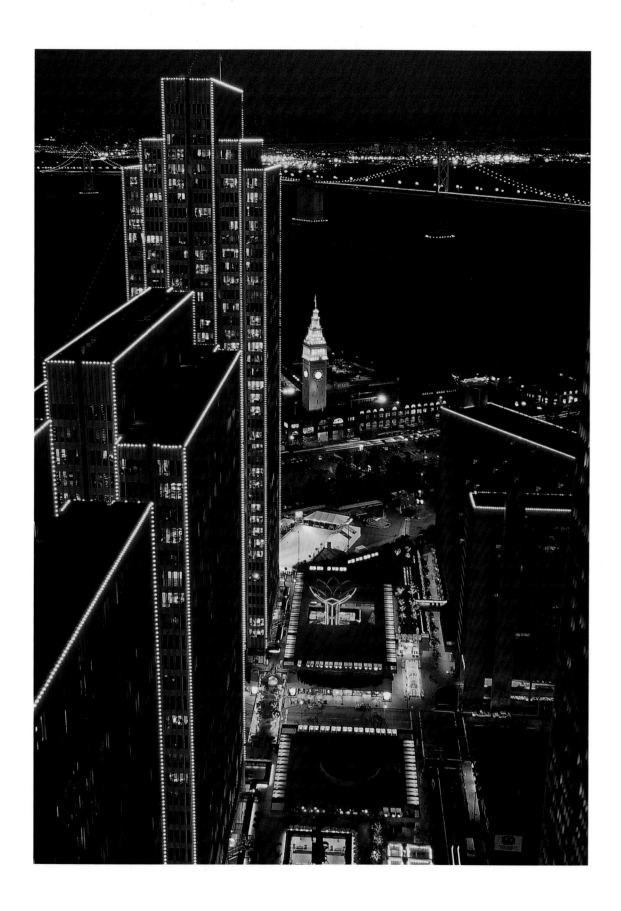

(left) The moon and Venus over downtown.

(right) Night skyline from Embarcadero.

(overleaf) Peace Pagoda in Japantown.

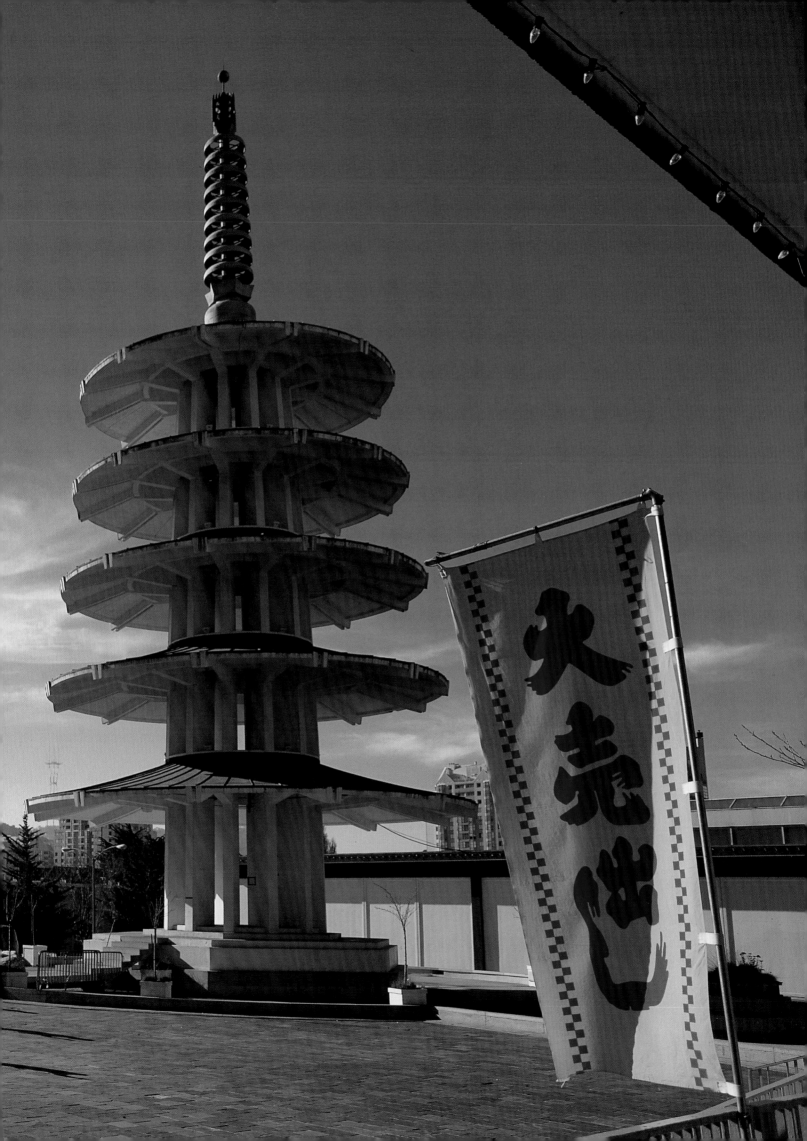

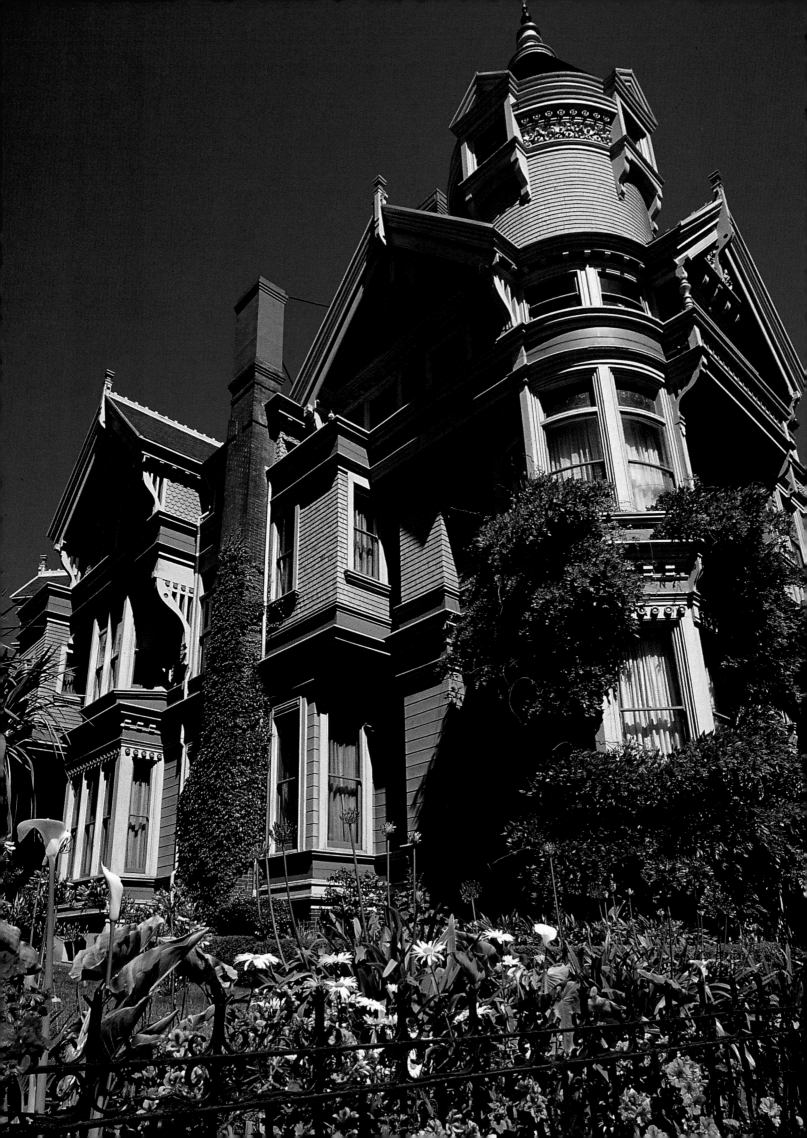

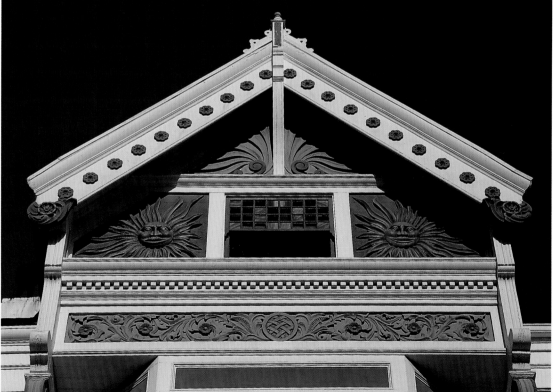

(left) Lilienthal House.

(above) Victorian House details.

(overleaf) Victorian Houses in Alamo Square.

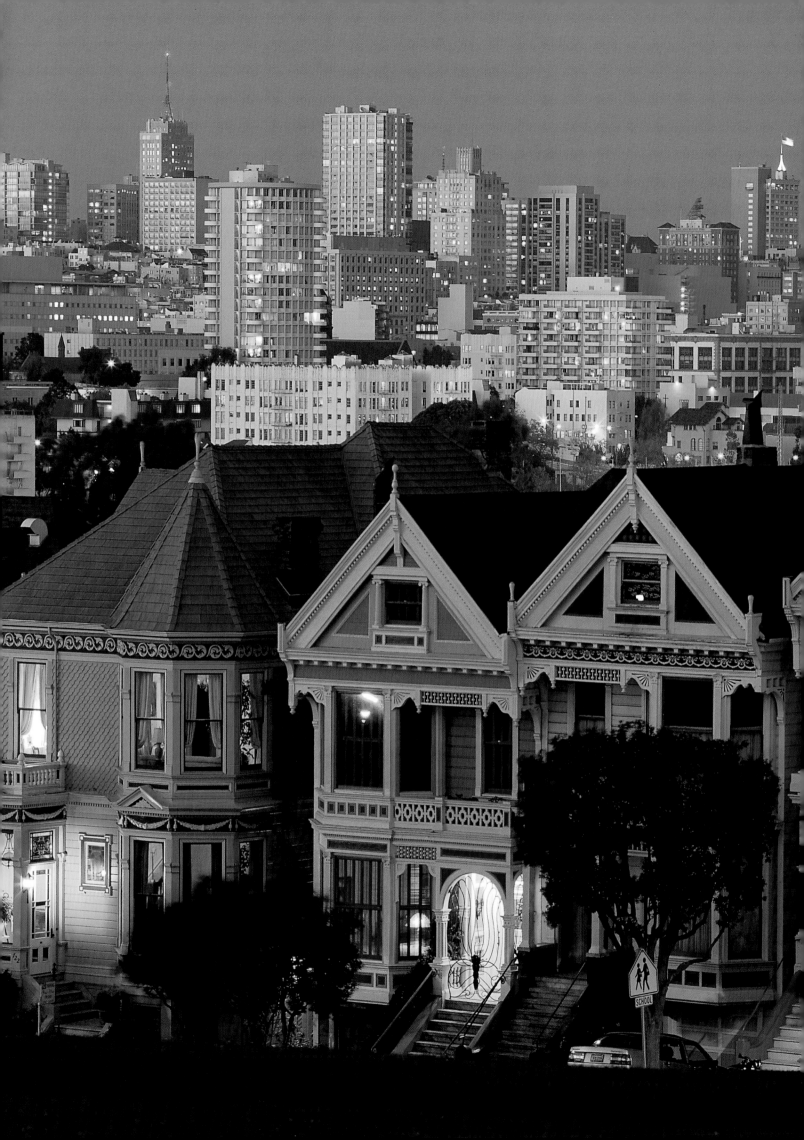

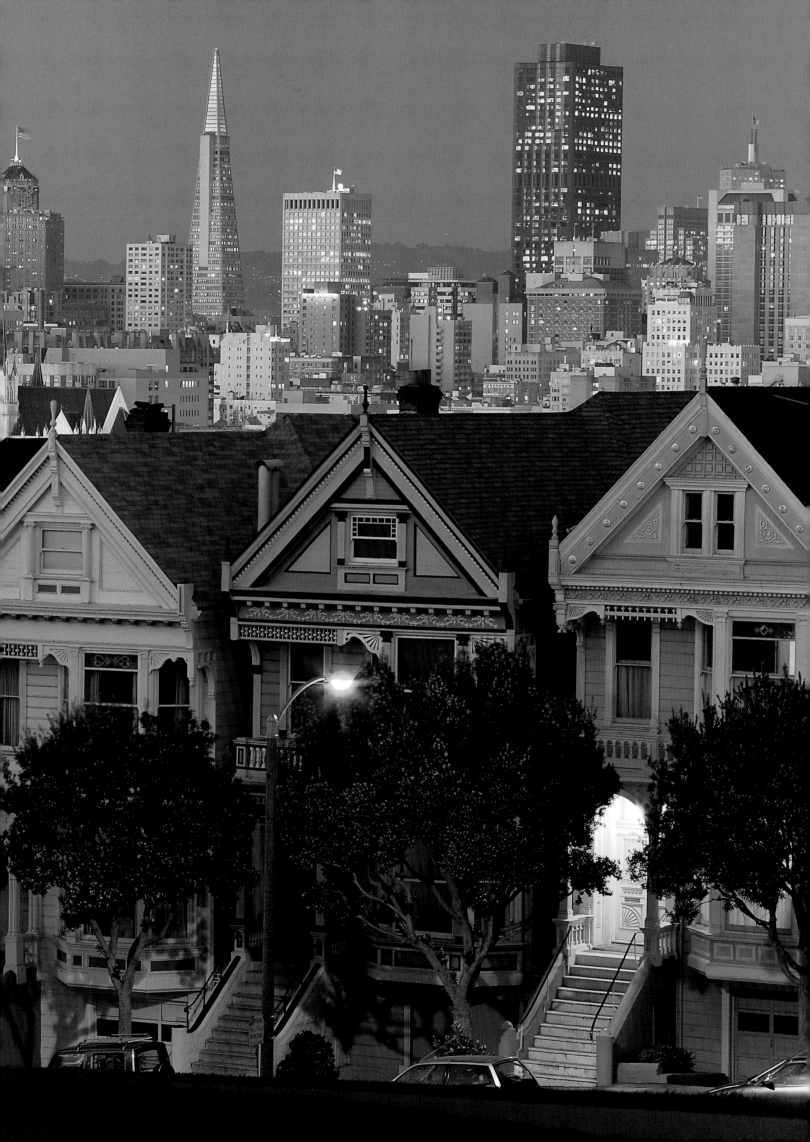

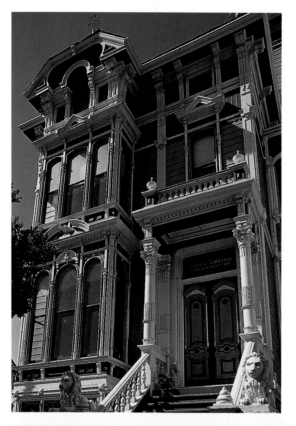

I was appalled when

the San Francisco ethic

didn't mushroom

and envelop the whole world

into this loving community."

—Grace Slick,
of Jefferson Airplane,
on the Sixties in the Haight.

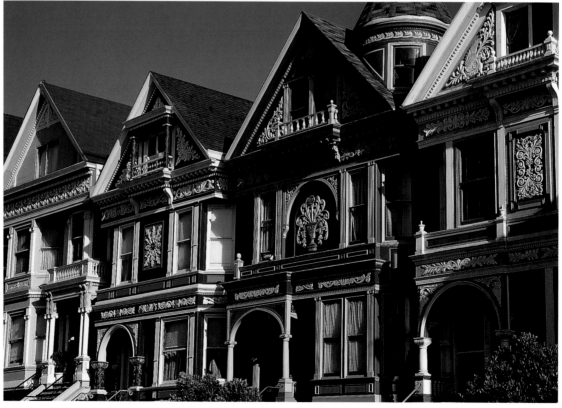

(top) Warner Bed and Breakfast.

(bottom and right) Victorian Houses.

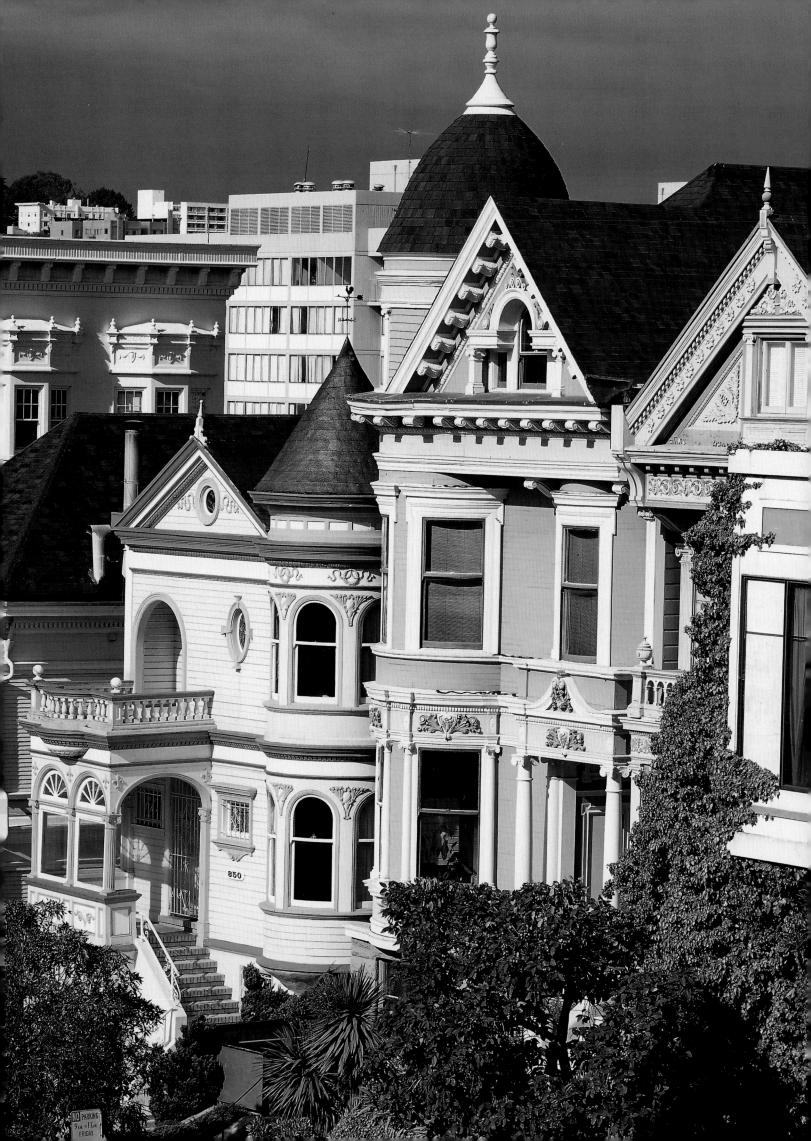

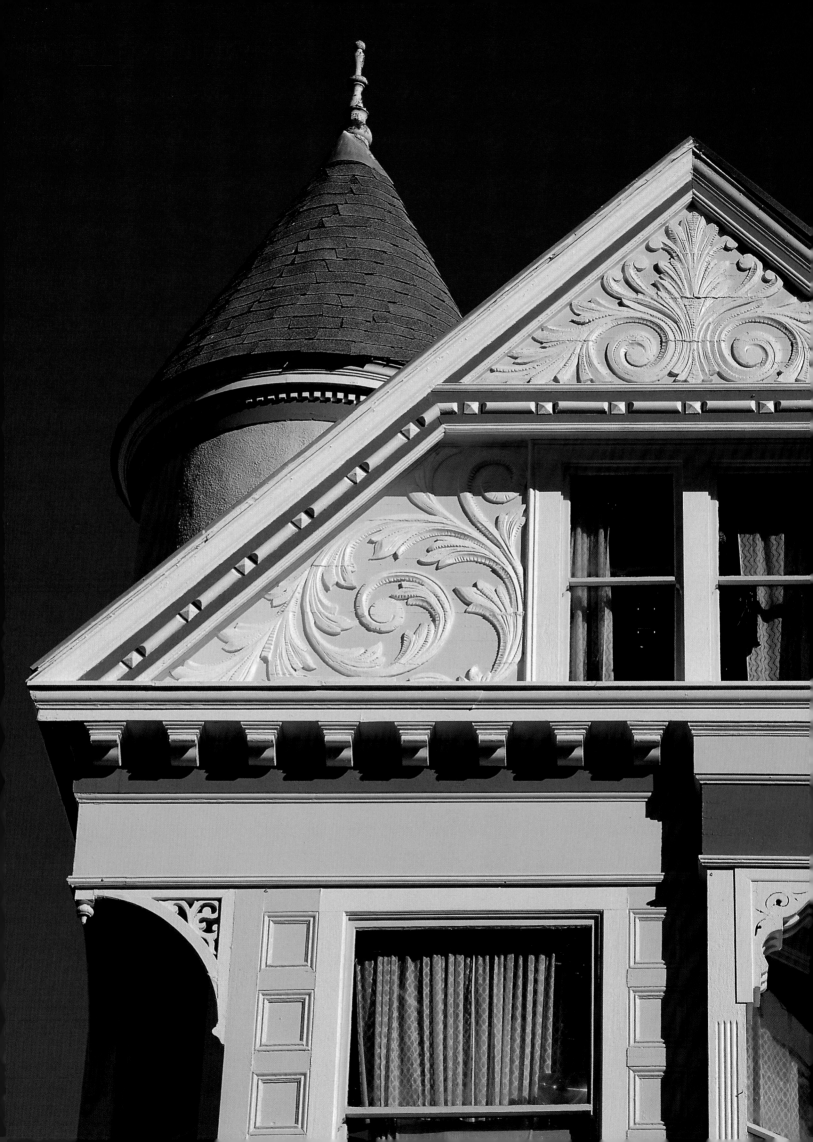

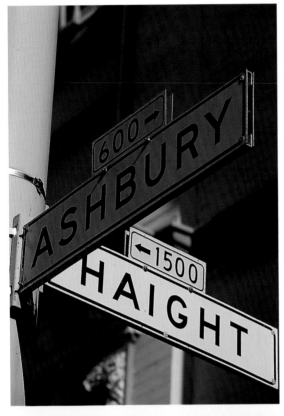

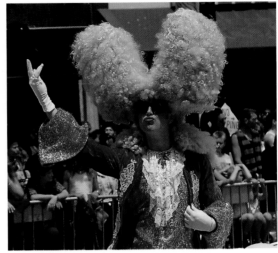

In San Francisco,

Halloween is redundant."

—**Will Durst, comedian**

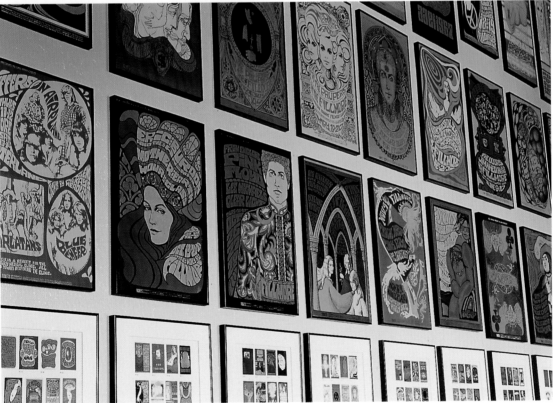

(left) Victorian House.

(above, clockwise from top left) Haight/Ashbury street sign, Freedom Parade, and show posters from Fillmore Theater. The Haight/Ashbury street corner became the nexus of the Hippie movement of the 1960s. When Jerry Garcia of the Grateful Dead died in 1995, the Haight was flooded with mourners from around the country paying tribute to him.

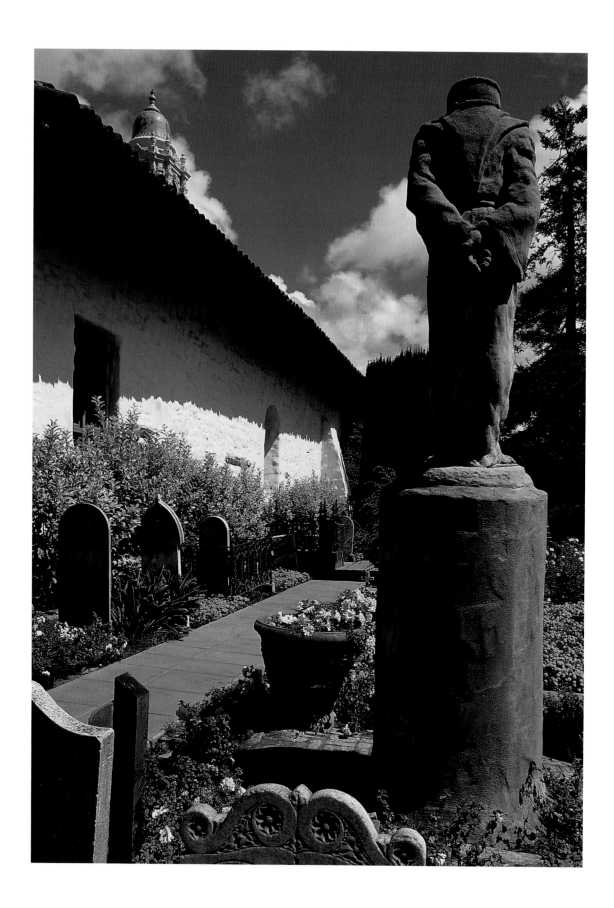

(above) Stature of Father Serra at Mission Dolores.

(right) Mission Dolores. The oldest standing building in the city of San Francisco, Mission Dolores has held mass since before the signing of the Declaration of Independence, and was the sixth of 21 missions founded by Father Junipero Serra and his Order of Franciscans.

(overleaf) Mission district.

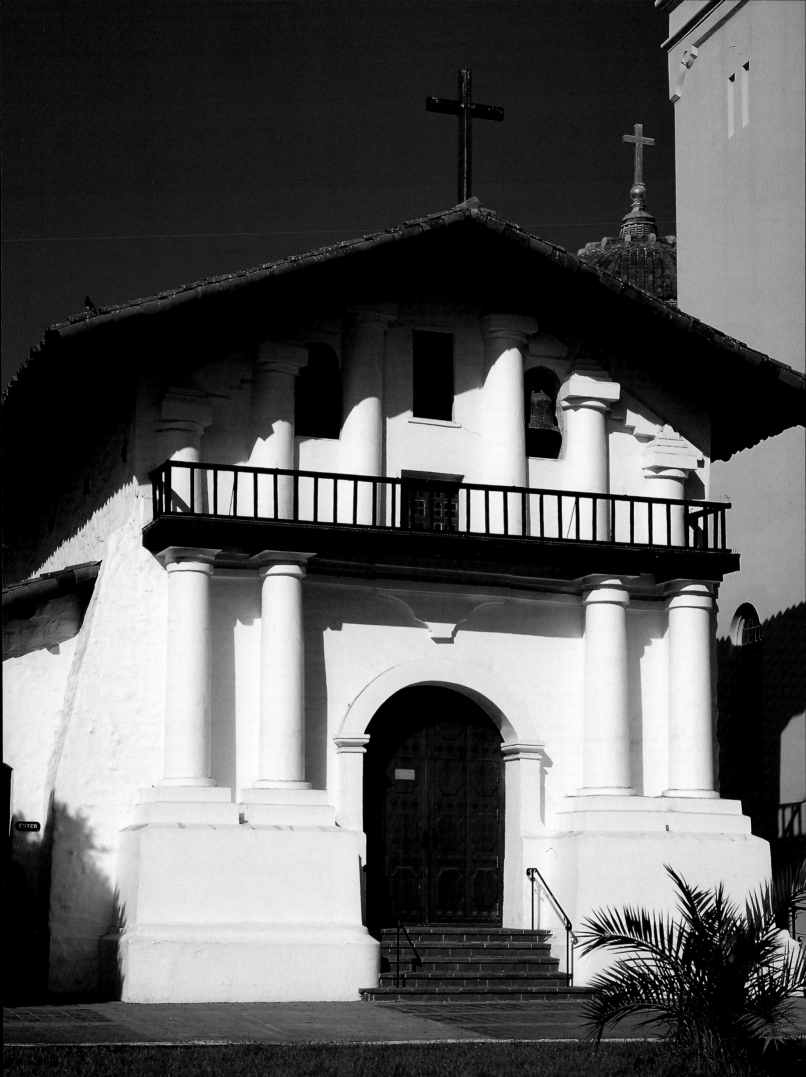

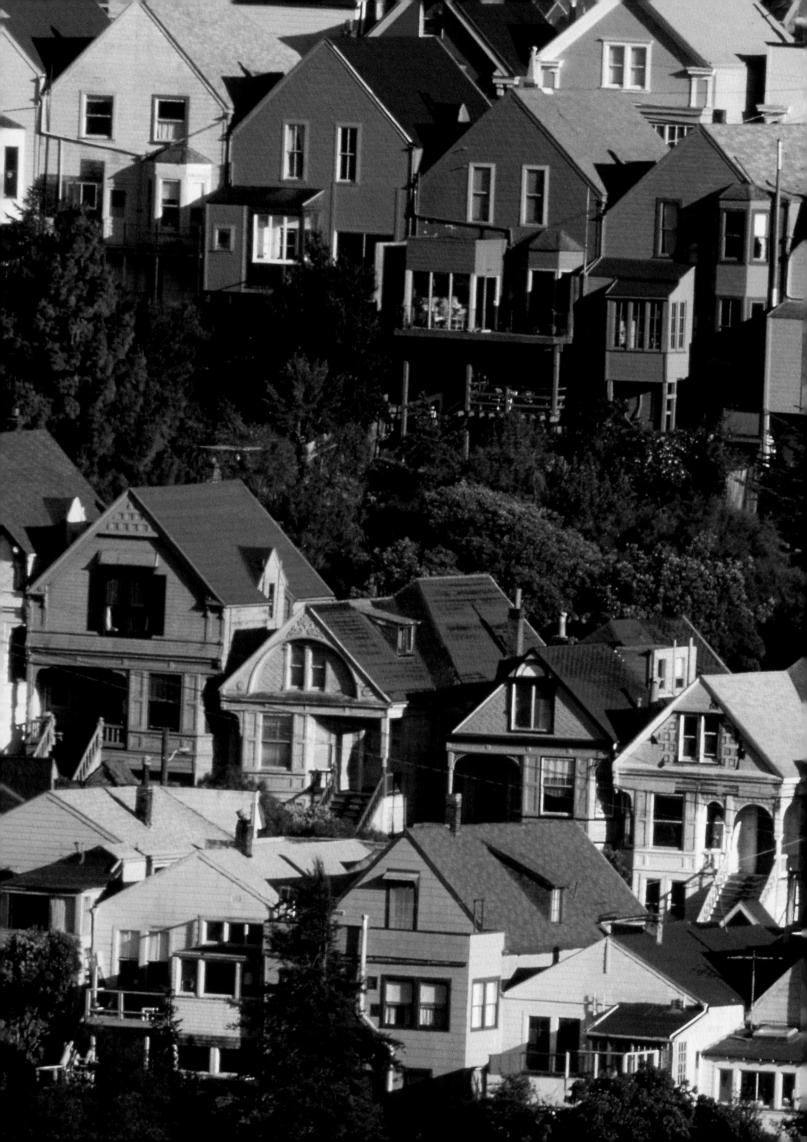

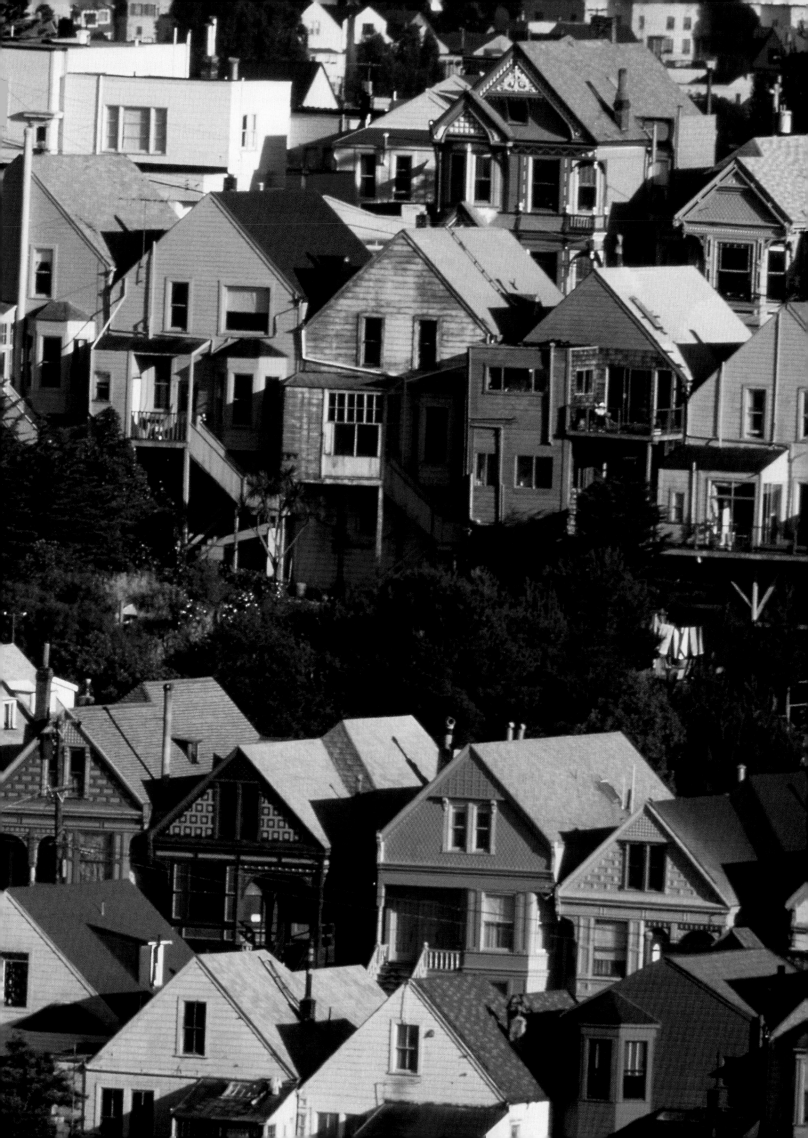

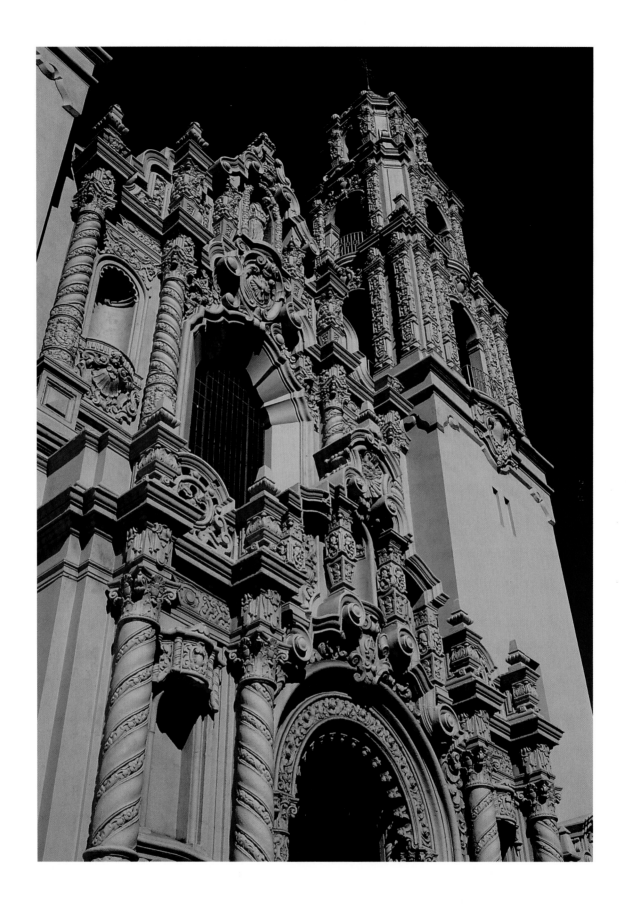

(left) Church on Dolores Street at 16th Street.

(right) Le Conte School mural.

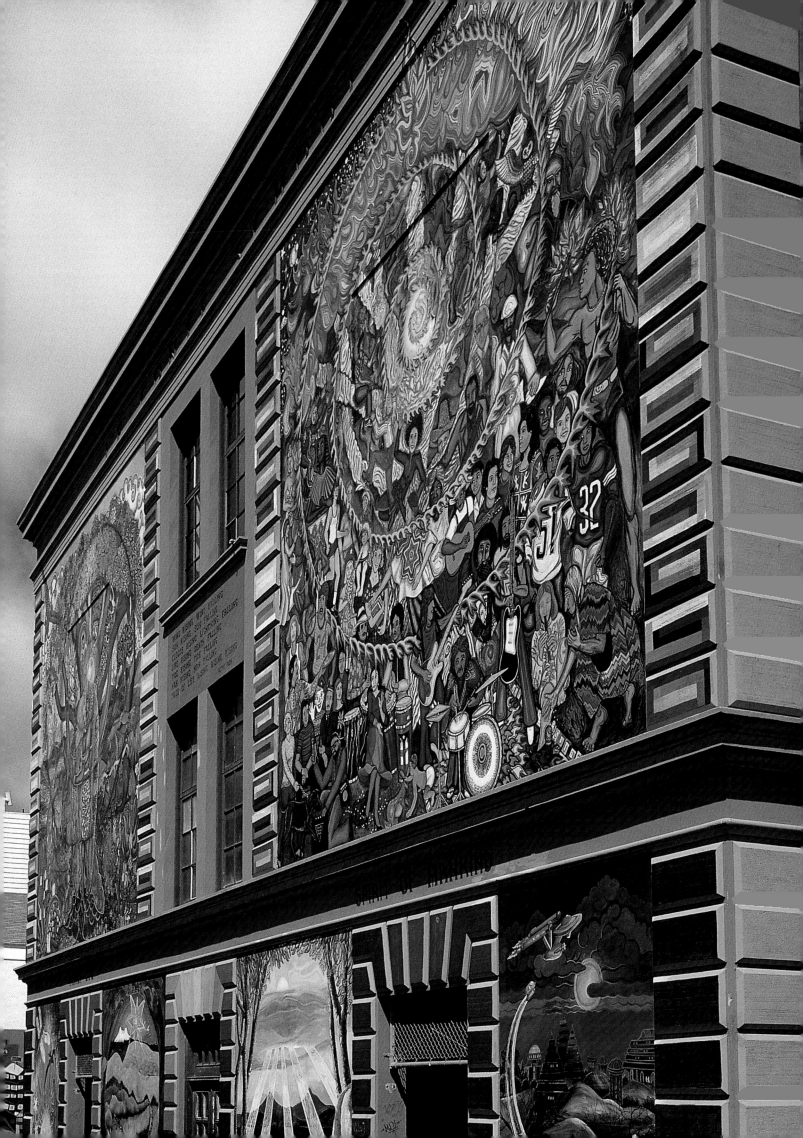

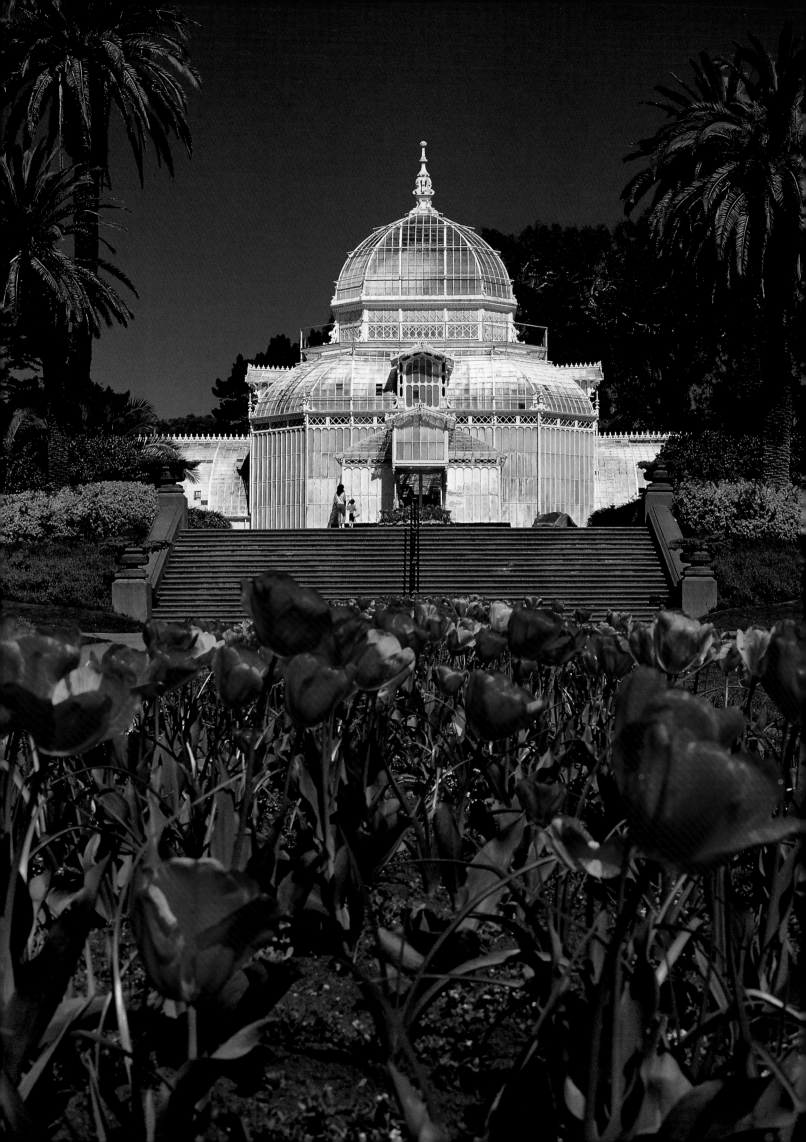

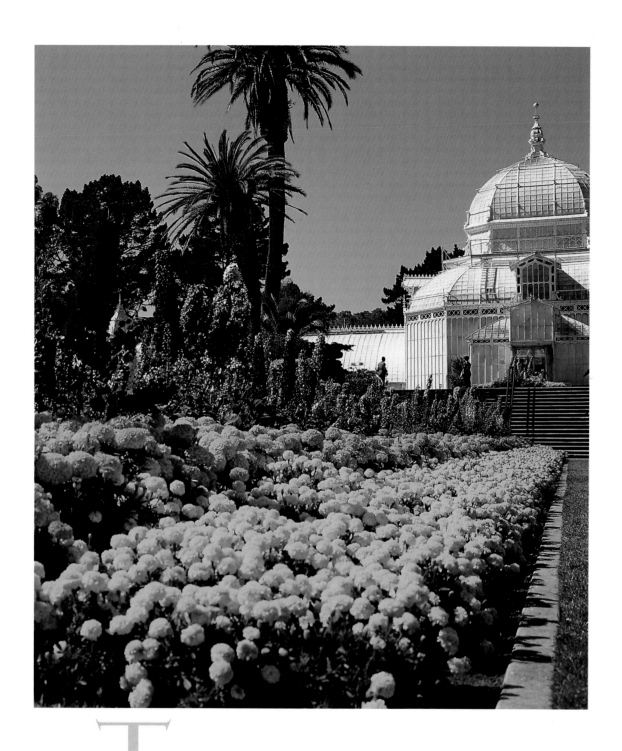

The coldest winter I ever spent was a summer in San Francisco."

—Mark Twain

(left and above) Conservatory of Flowers at Golden Gate Park.

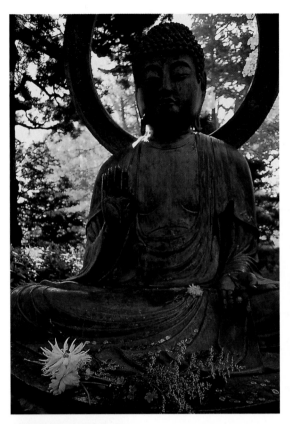

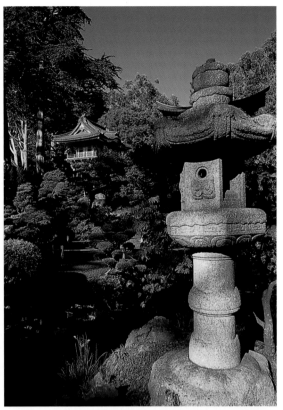

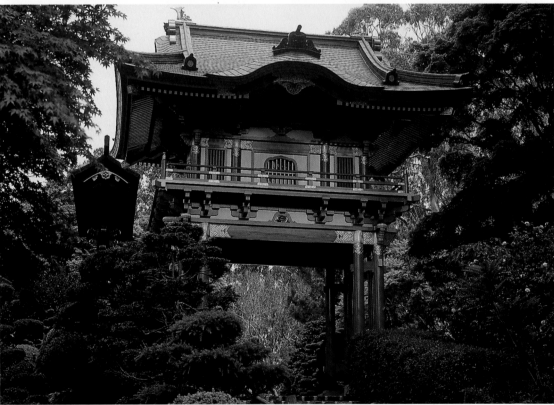

Golden Gate Park. Stretching 1017 square acres, Golden Gate Park's many delights include eleven lakes, the Asian Art and DeYoung Museums, scores of gardens including the Conservatory of Flowers, and plenty of open space to enjoy. Pictured here is the peaceful seclusion of the Japanese Tea Gardens and the quaint beauty of the Dutch windmill.

(above) Japanese Tea Garden.

(right) Dutch Windmill in Golden Gate Park.

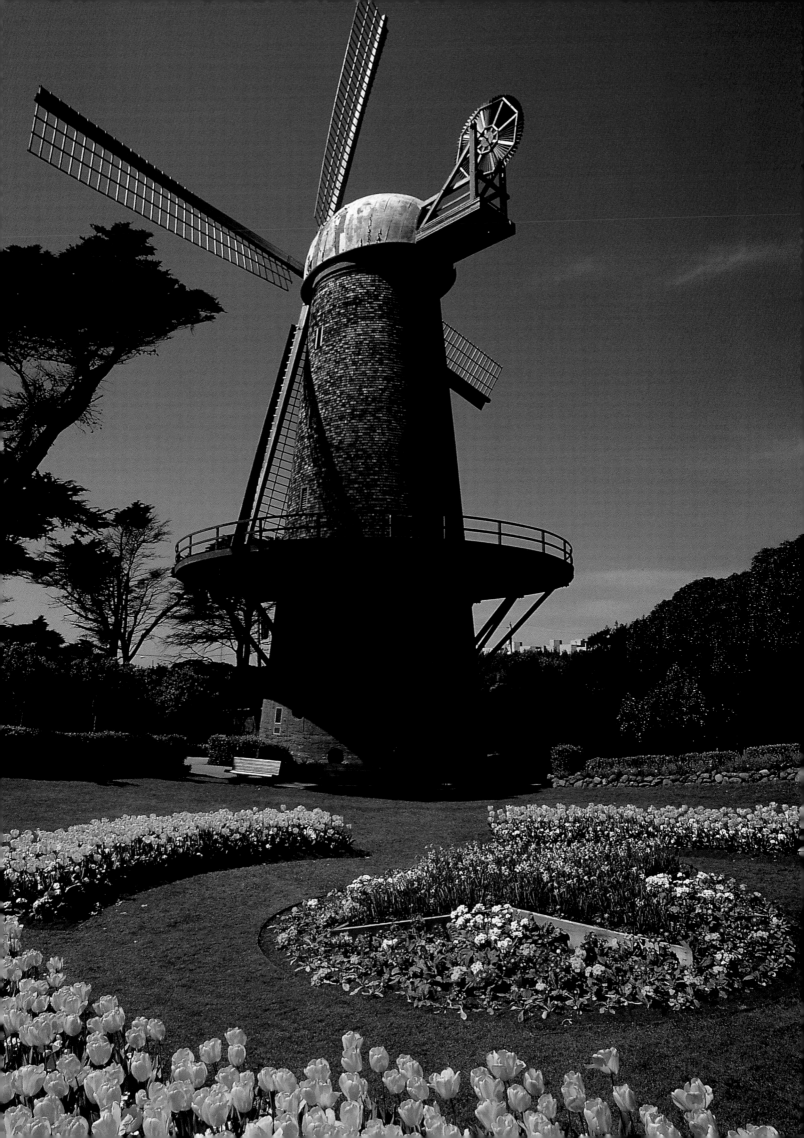

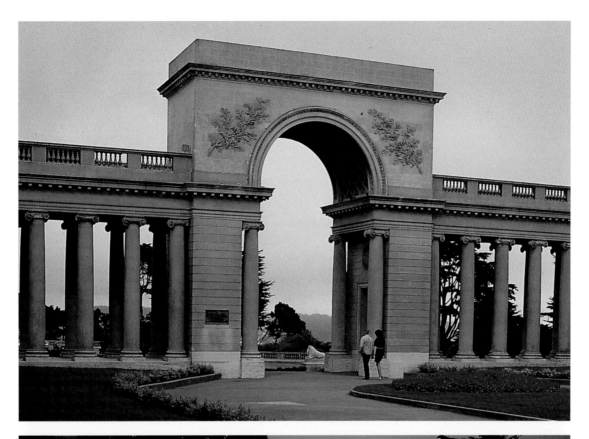

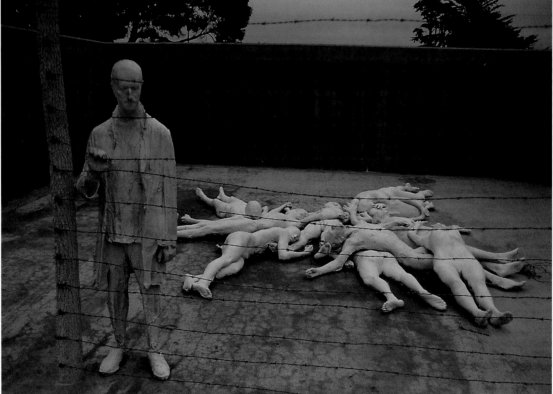

(above, top and bottom) Palace of Legion of Honor and Holocaust Memorial.

(right) Interior of the Palace of Legion of Honor.

(overleaf) Oakland Bay Bridge as seen from Yerba Buena Island.

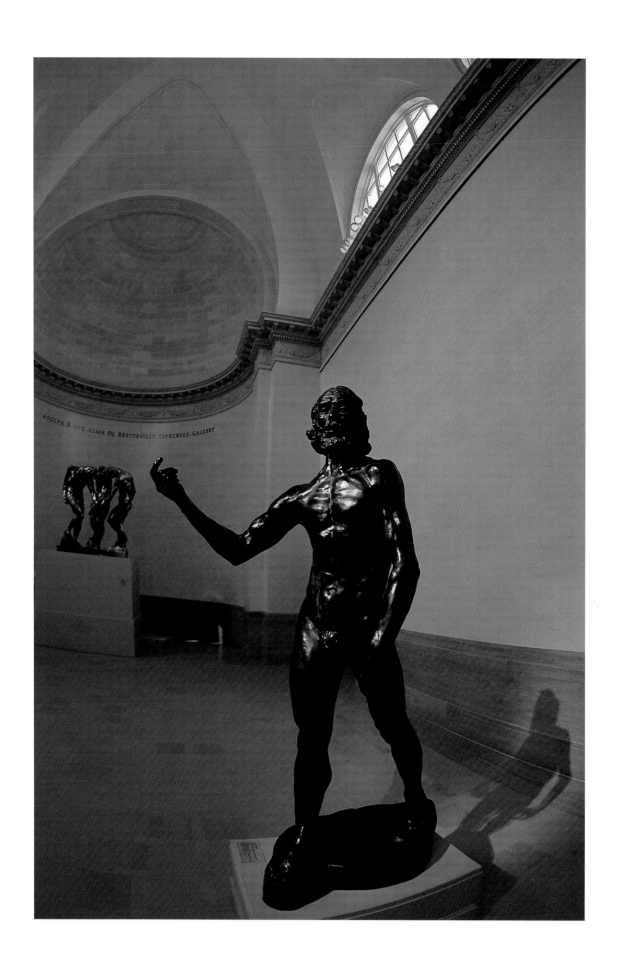

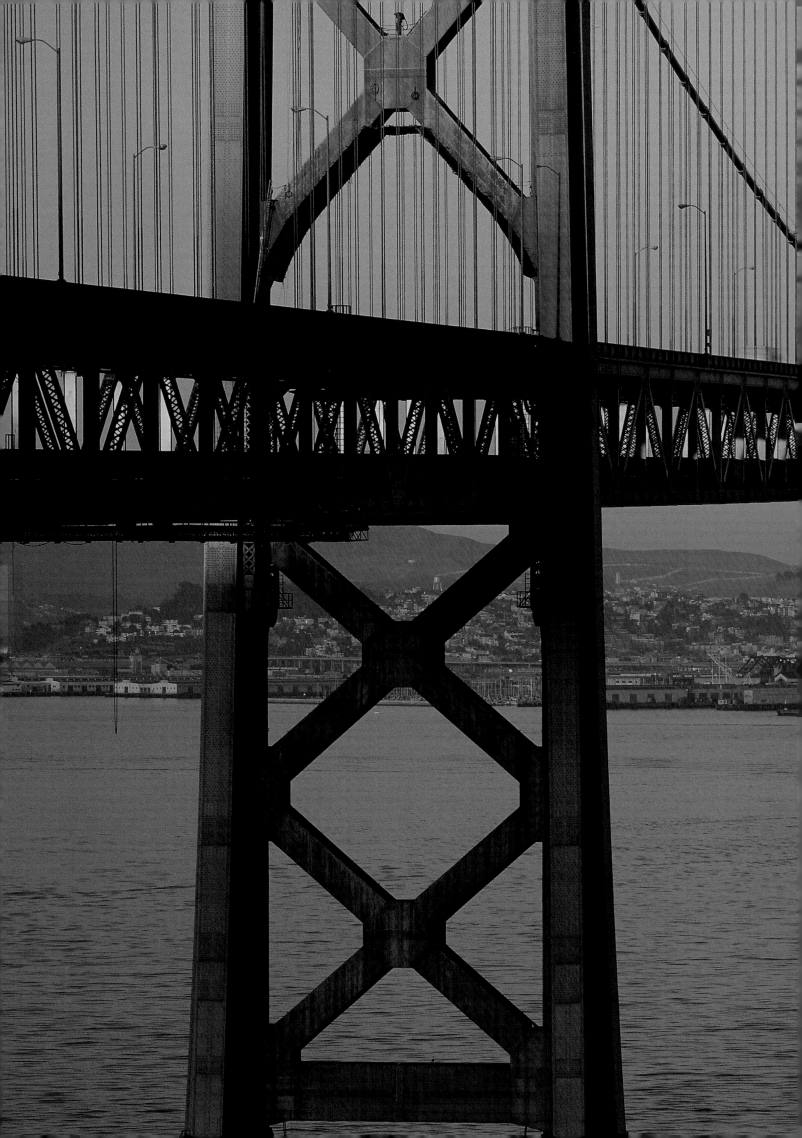

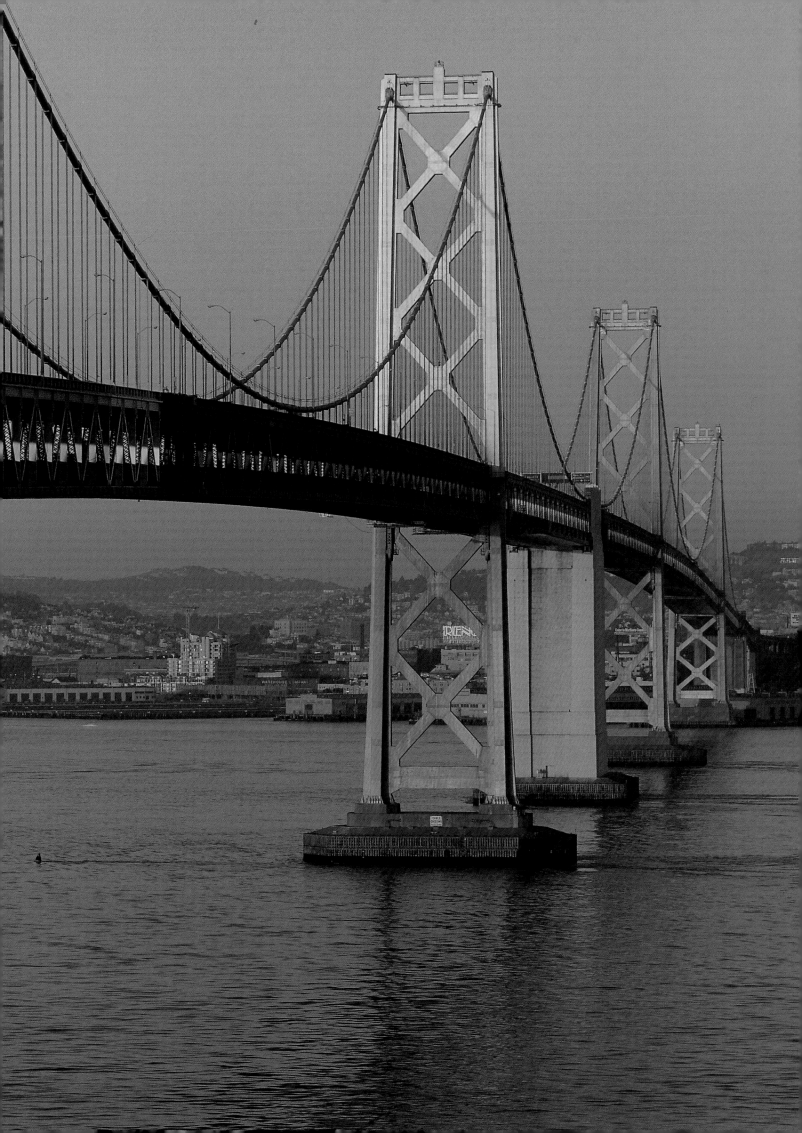

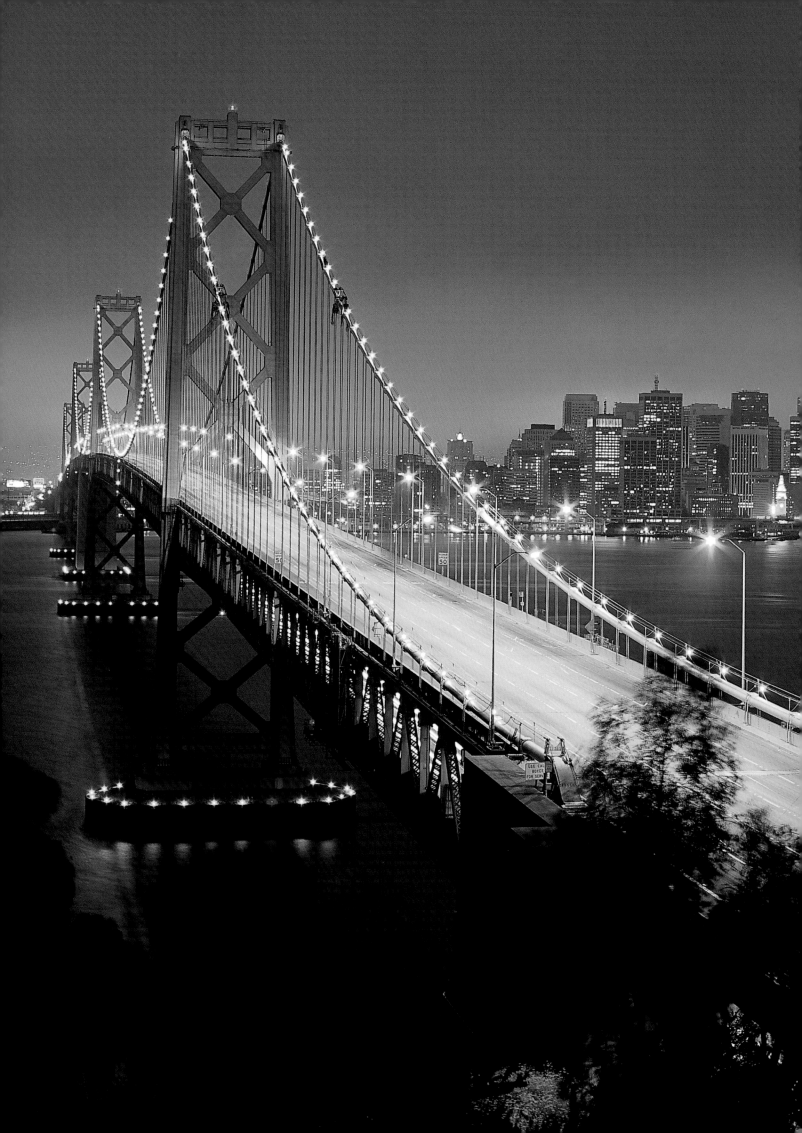

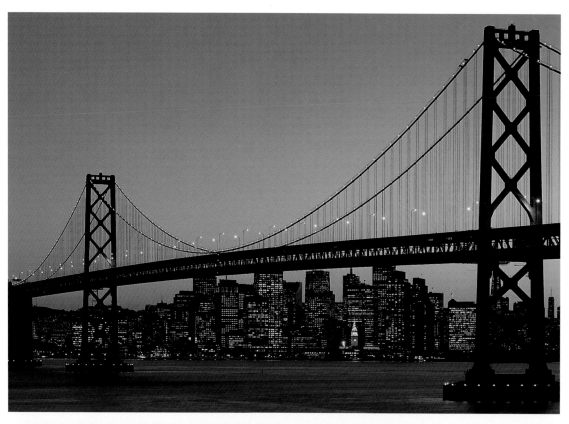

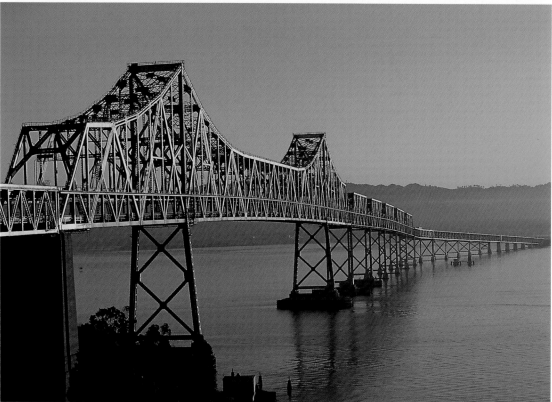

The Bay Bridge connects San Francisco and Oakland.

(above and left) Oakland Bay Bridge.

(overleaf) Lighthouse at dusk with Oakland Bay Bridge in background.

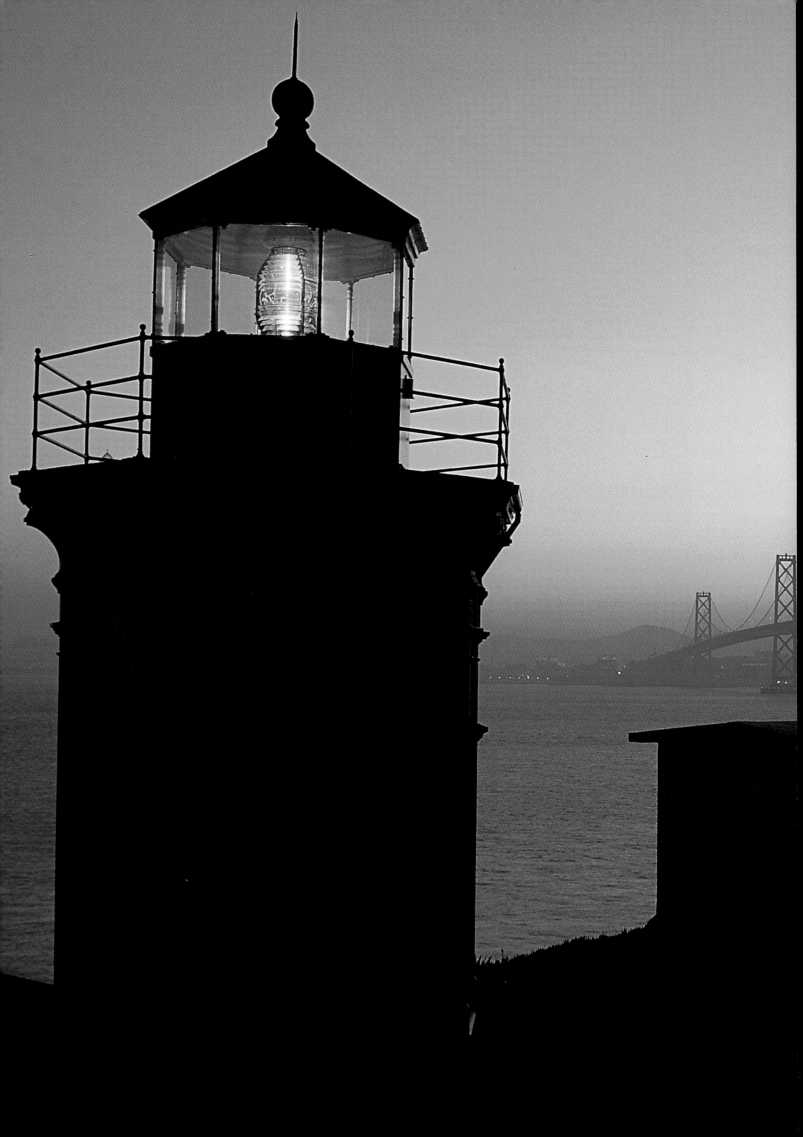

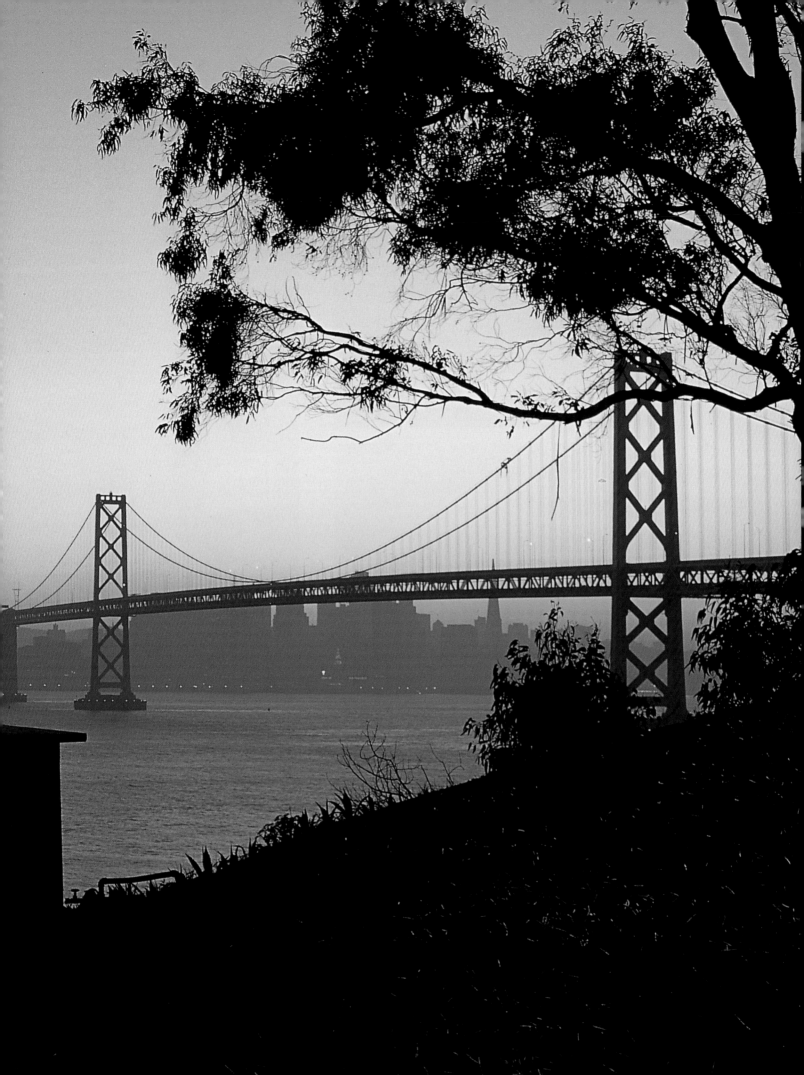

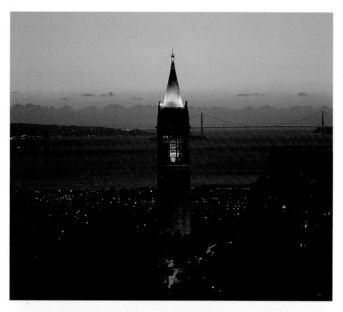

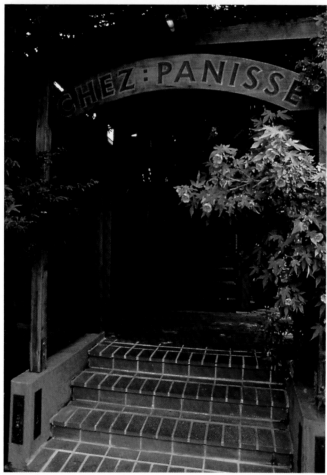

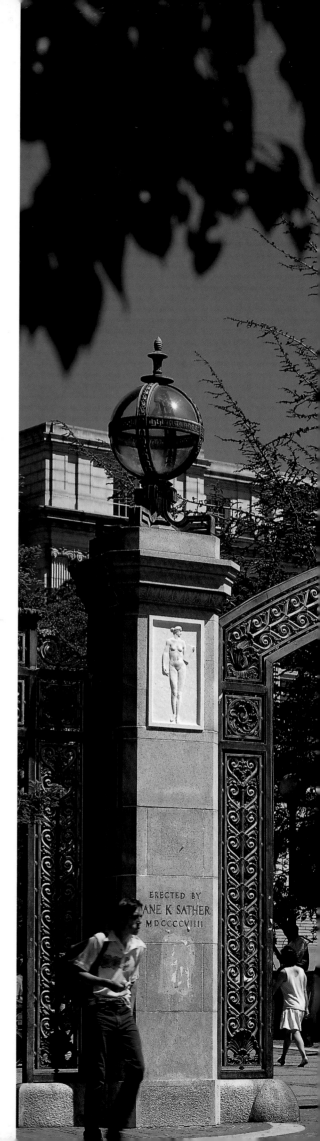

(left, top and bottom) Chez Panisse, a world famous restaurant in Berkeley, and a view from Berkeley, overlooking the bay.

(right) University of California, Berkeley. The University of California's flagship school is Berkeley, which consistently ranks among the top 20 colleges and universities in the United States.

(overleaf) Oakland Bay Bridge and Highway 24.

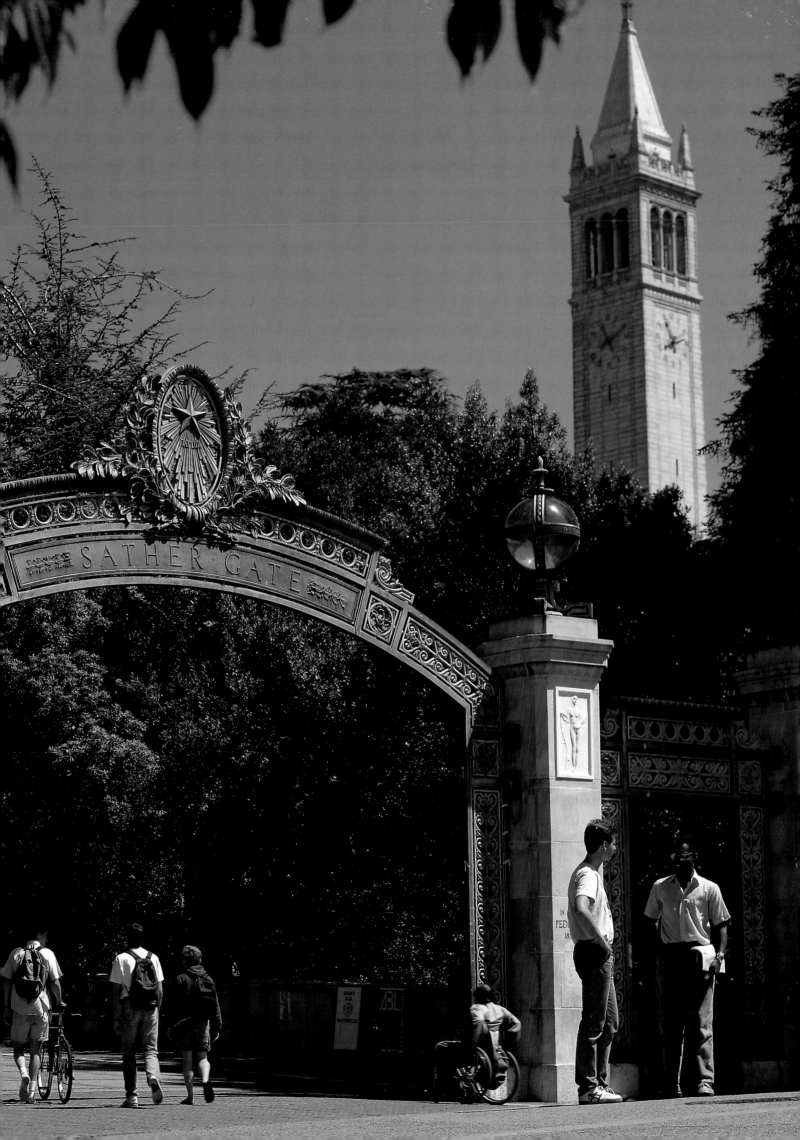

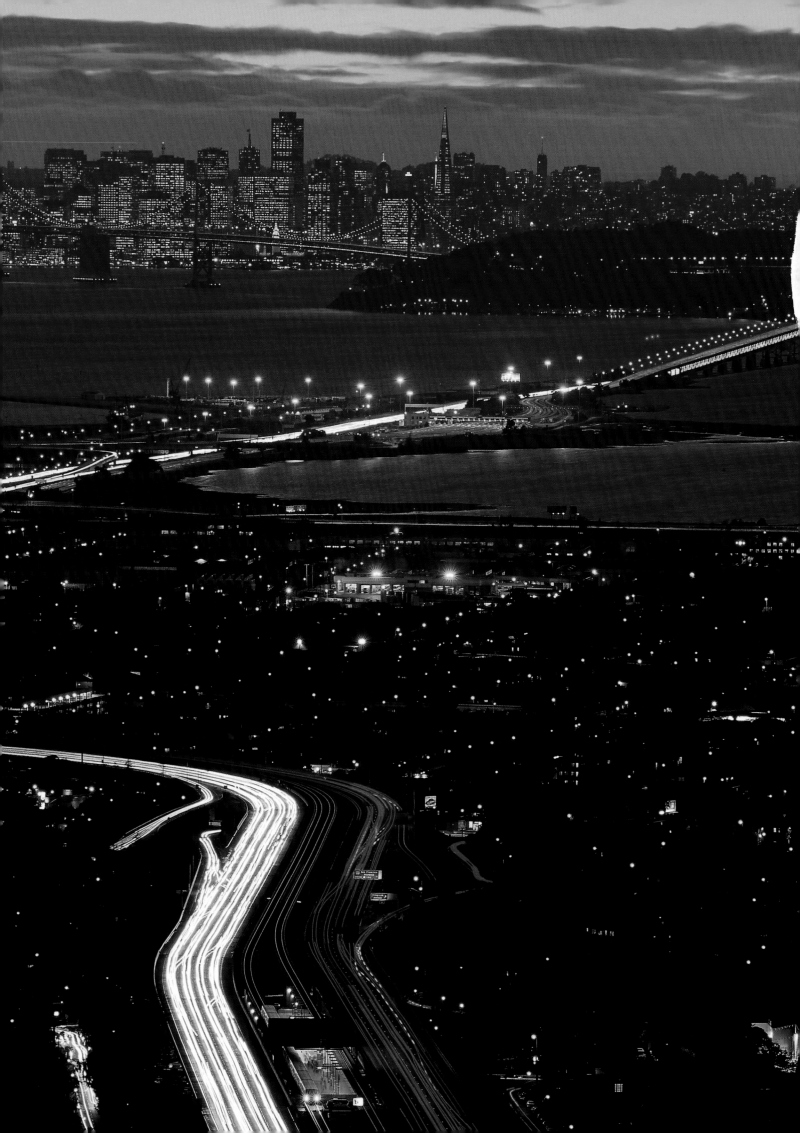